PAINTING
BIRDS & ANIMALS

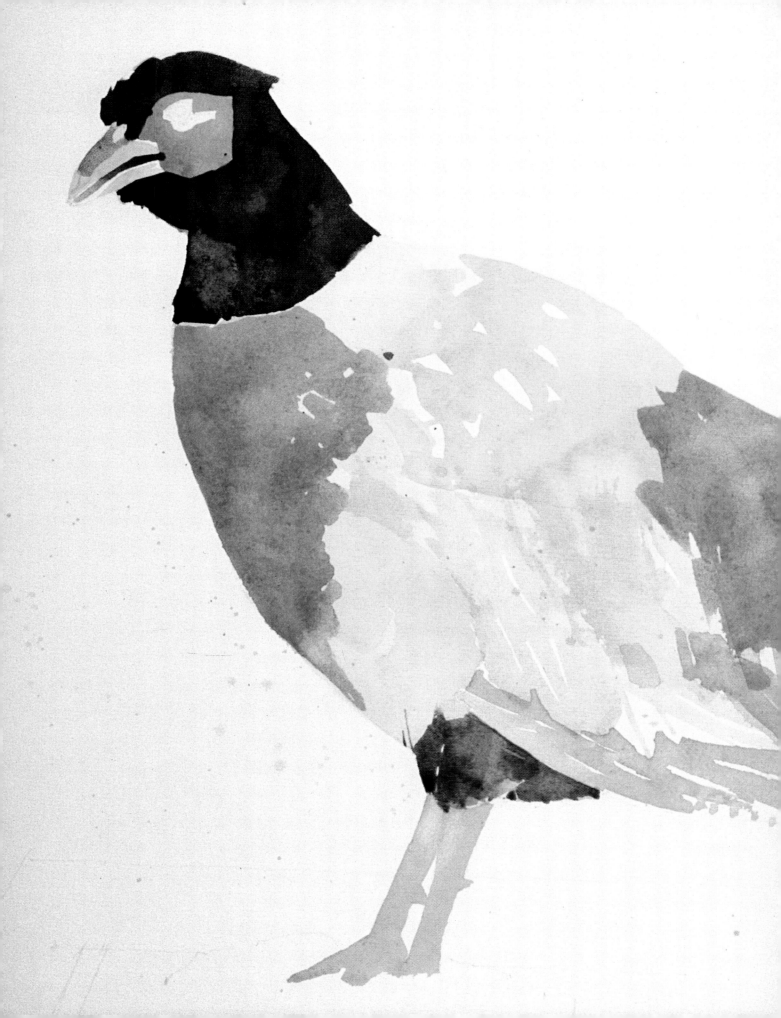

PAINTING
BIRDS & ANIMALS

22 projects for painting birds and animals illustrated
step-by-step with advice on materials and techniques

Patricia Monahan

CHARTWELL
BOOKS, INC.

Published by Chartwell Books
A Division of Book Sales Inc.
114 Northfield Avenue
Edison, New Jersey 08837
USA

Copyright ©1986 Quarto Publishing Ltd

A QUANTUM BOOK

This edition printed 2000

ISBN 0-7858-1144-3

QUMPAB

This book is produced by
Quantum Books Ltd
6 Blundell Street
London N7 9BH

Printed in Singapore by Star Standard Industries (Pte) Ltd

CONTENTS

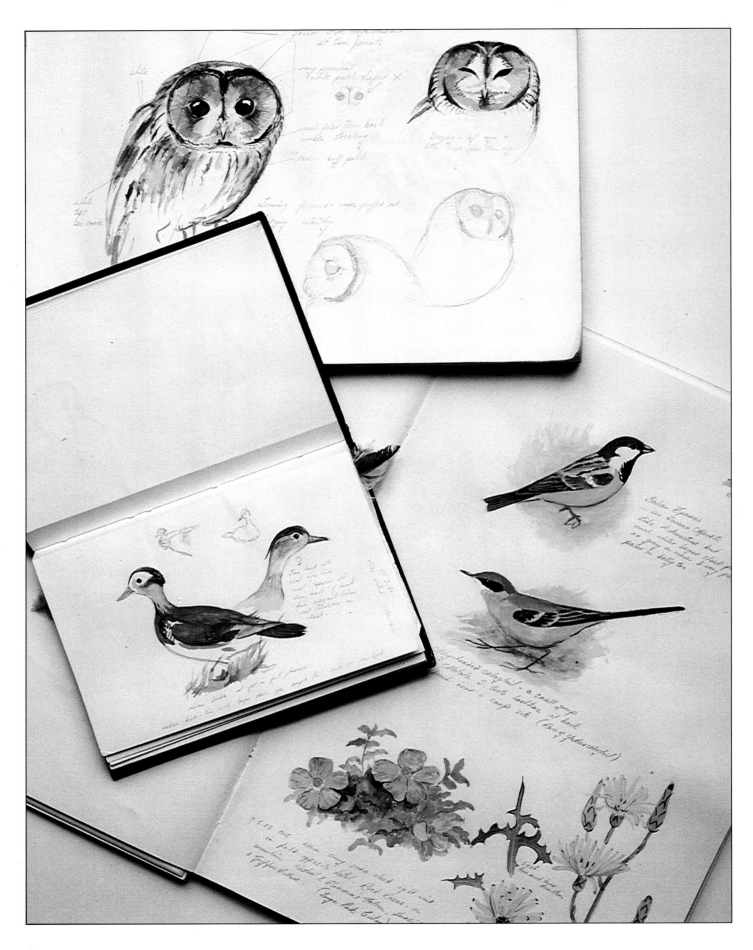

ANIMALS AROUND US

The human relationship with the animal world is an ambiguous mixture of admiration, love, mutual dependence, exploitation and barbarous cruelty. 'Sacred and symbolic', 'animals observed', 'animals beloved', and 'animals destroyed' are the phrases used by Kenneth Clark in *Animals and Men* to characterize the relationship. Many of us today lead an urban existence, and the natural world no longer plays a central part in our day-to-day life. Despite this and despite the loss of many species as a result of the heavy-handed intervention of the human race, we are now more conscious of our responsibility to the living world than ever before, and of our roles as guardians of the creatures with which we share this planet.

A sketchbook is an animal artist's most valuable possession. In the examples, *left*, the artist recorded the general forms and attitudes of birds seen briefly, details such as plumage and the kind of plants typical of their habitat. The drawings are amplified with annotations.

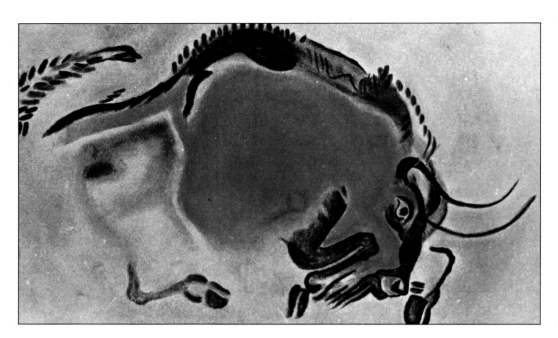

In the caves of Altamira in Spain, Stone Age people created this image of a charging bison, *left*. The colors were derived from naturally occurring ochers and from manganese black, ground up with animal fat or bone marrow on palettes of slate or bone. Here the artist has used an expressive black line which captures the vigor of the beast, filling this with freely applied washes of color which model form.

Our concern for animals is demonstrated in many ways — by the crowds visiting zoos and safari parks, by the numbers of tourists who travel to see exotic wildlife in its natural habitat, by the popularity of television wildlife programs and by the increasing numbers of people who belong to organizations devoted to the conservation and study of birds and animals. And although we no longer live our lives according to the seasons, the natural world is nevertheless woven into the tapestry of our everyday life in other ways — we share our homes with animals and our surroundings borrow and reflect patterns and designs of organic inspiration.

You may be an accomplished artist who has been tempted to tackle this new subject but has never done so, alarmed perhaps by the apparent difficulties and problems posed by the subject matter. Or you may be a committed student of the natural world and want to make records of a subject close to your heart. This book is intended to break down the barriers and, by looking closely at the approaches and working methods of experienced artists, to provide guidance and inspiration for the aspiring wildlife artist.

MAN AND THE ANIMAL WORLD

The human world and the animal world are deeply interwoven, impinging upon each other in a multitude of ways. Almost every society has its myths of a Golden Age in which Man and animals lived together in harmony.

Adam is often depicted in the lush setting of the Garden of Eden, naming the animals and recording them in a book. And it was a serpent, regarded as the cleverest and most untrustworthy of all creatures, that tempted Eve with the fruits of the 'tree of knowledge of good and evil' and so brought about the Fall of Man.

In many societies animals have been, and still are, regarded as sacred. This appears to stem from a recognition of certain powers or courage, which may be admired or even feared. Many tribes are very closely associated with a particular animal, even adopting the name of the animal, or regarding themselves as its descendants. Animals in other societies are believed to be the temporary home of the soul of the dead and are treated with appropriate respect. North American Indians often had personal guardian spirits in the form of animals. The appropriate animal was revealed to the individual in dreams during periods of fasting which were part of rites of passage. This animal had great significance and power during the life of that individual. Its likeness was painted on the body, on shields and on weapons, and belief in its protective capacity perhaps lingers in both the practice of tattooing the body and the use of animal forms in heraldry.

The animal cults of Ancient Egypt were a famous example of animals influencing human lives. Certain deities were associated with particular sacred animals, and were represented in the form of those animals or

were regarded as being incarnate in their bodies. Cats, hawks, rams, the scarab beetle and the serpent were all ascribed to different gods. In India the sacred cow is worshiped as a deity by the Hindu — and sacred cows are allowed to wander freely and are made small offerings of grass and flowers. Monkeys, birds, elephants and many other animals are associated with particular gods and are represented in sculptures and paintings throughout the Indian sub-continent.

Animals have featured in both pagan and Christian religions. They were included among the signs of the zodiac and they have continued to be used as Christian symbols. The lion, the ox and the eagle were gods in the pagan world, while three of the four evangelists are represented by these same animals — Mark, a lion; Luke, an ox; and John, an eagle.

Humans have always been fascinated by the animals with which they share the Earth. But apart from their symbolic significance, animals provide us with food, clothing, transport and companionship.

WHO PAINTS WILDLIFE?
People come to wildlife painting and drawing for different reasons. Some want to paint animals and birds because they are interested in wildlife and feel that painting will improve their powers of observation, provide a record of what they have seen and add a new angle to an existing interest. They are interested in recording the creatures they study, their habits and habitats. Many wildlife artists will tell you that their interest goes back to childhood, when they tracked wild animals and kept a menagerie of pets — hamsters, rabbits, cats, dogs and fish. Their adult interest in animals and art is backed up by direct observation and by the study of books, visits to museums, sketching and drawing. Animal painting and drawing demands a great deal of study and research.

Others are painters first and wildlife artists second, exploring other areas of art before coming to wildlife, attracted by the challenge and the great variety the subject offers. All artists bring their own personal attitudes to the subject. They may be interested in animals in their natural habitat, in describing the rigors of life in the wild, or they may be attracted by the romanticism of nature.

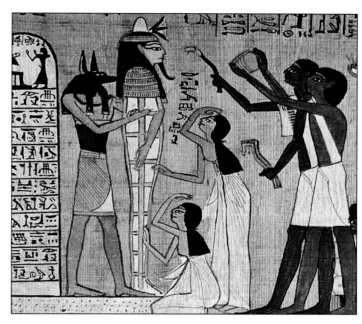

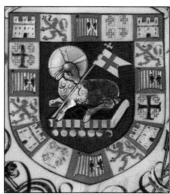

Illustration from the *Book of the Dead*, 1300 BC *above*, in which the ancient Egyptians depicted their gods.Here, the jackal-headed Anubis leads the dead to the underworld. In Christian iconography Christ is often represented as a lamb. The example, *right*, is from the coat of arms of Puerto Rico.

Approaches vary too. Some artists work in an impressionistic way, others seek a realistic result and are more interested in recording minute details, such as the color and position of each feather. But a wildlife painting is more than a scientific illustration — it must capture the essential qualities of the animal.

WHY PAINT ANIMALS?
There are as many reasons for painting animals as there are people doing so. One of the very simplest motivations is love. Love of animals is not a modern phenomenon — even great artists such as Leonardo da Vinci (1452-1519) were fond of animals. Giorgio Vasari (1511-74), the famous biographer of artists, tells of Leonardo keeping horses despite the fact that he was not wealthy. His horses 'gave him great pleasure as indeed did all the the animal creation which he treated with wonderful love and patience.' He describes Leonardo

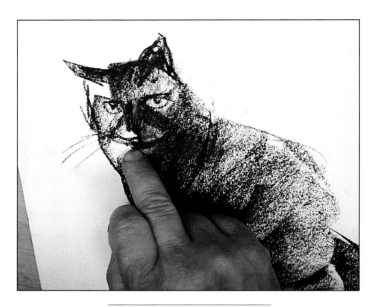

Your family pet is often your best and most cooperative model. *Above*, the artist makes a quick sketch in charcoal.

setting aside your preconceived notions of how the subject should look. Manual dexterity is fairly easy to acquire, but an artist's trained, selective eye is more important and more difficult to achieve. The true artist never stops looking and learning. Every single subject is a new experience, seen afresh no matter how many times it has been painted or drawn.

Admiration is another motivating force for many artists — what subject is more graceful than a bird in flight, what pattern more dramatic than the skin of a snake or the hide of a leopard or zebra, what color more sizzling than the parakeet's plumage or the peacock's tail, or more subtle than the camouflage of a lizard or a young deer? Many artists have been inspired by the simple grace of the gazelle, the strength of the lion, the majesty of the cheetah at full speed, the sinuous elegance of the snake and the iridescent colors of fish.

In the past artists were attracted to animal subjects because they allowed them the freedom to work realistically. Human models had opinions about the way they were shown. Their vanity had to be taken into account and they often insisted on an idealized representation. Animals, on the other hand, do not need to be flattered. The artist can study the subject impartially, indulging his or her curiosity without fear of offence. Such considerations probably influenced artists in the ancient world, where animal sculpture would undoubtedly have provided a welcome relief from the prevalent idealism of figure sculpture.

walking through the caged bird market and buying birds in order to set them free afterward, 'giving them back their lost freedom'.

You may want to paint pictures of your pets and they certainly provide excellent subjects as long as you avoid prettifying the images and resist cloying sentimentality. The great advantage of pets as subjects is their accessibility. Painting animals deepens your understanding of them. You may think you are familiar with your cat, for example, but no matter how much a part of your life it is, you will be surprised how little you know of it. Start by working in your sketchbook and as a very first exercise try making a drawing of it from memory — it's not as simple as it seems. Next, working in pencil, fiber pen or ballpoint, make a series of sketches from life. Keep the sketchbook somewhere to hand so that you can make quick drawings whenever the cat takes up an interesting pose — curled up asleep in its favorite armchair, gazing alertly out of the window, or stretched langorously in front of the fire. If you continue this exercise over a period of weeks, you will find that not only have you improved your drawing skills, you have also created a series of increasingly accomplished drawings which will be a valuable source of reference. Sketching forces you to look carefully at the subject,

ANIMALS AS SUBJECTS
One of the biggest problems facing the wildlife artist is the accessibility of the subject. Still lifes or portraits are under the artist's control and fairly easy to set up, and even the landscape painter knows that once he or she has journeyed to the subject, it will remain unchanged, barring the vagaries of the weather. The animals' world on the other hand, we glimpse only briefly and in passing, rarely having the opportunity to study the animal for a long time. Even if time is on our side, the pose will vary. Pets, of course, are less of a problem. If you are a beginner, you would be advised to start close to home, by drawing and studying the animals that share your home, be it a cat, dog, gerbil or rabbit. If you live in the country, then your range of domesticated subjects is

much greater. A herd of grazing cattle can be studied for considerable periods. They will be in a confined space and whether they are grazing or chewing the cud, they will not move a great deal. You will have both standing and reclining subjects, in a great number of poses and from a variety of angles. Likewise the zoo and the safari park can provide living models.

When walking in the country or even in the suburbs you may come across dead birds and small animals, perhaps the victims of road accidents. If they are fairly fresh specimens and you are not too squeamish, take them home and study them. They will provide you with plenty of information. Drawing from life or from a specimen is an essential exercise for the wildlife artist. As you work you are forced to look at the subject far more carefully than you would under any other conditions. You cannot make assumptions, you have to know how the fur grows and how it looks, in order to find a mark which will represent it with any conviction. Similarly you have to understand how the limbs are attached to the main part of the body, or the drawing will look wrong, even to the untutored eye. So not only are you building up a collection of reference drawings for use at a later date, you are also imprinting the information firmly on your mind. Finally, only by handling and by seeing around an animal can you hope to get a feel for its volume. The artist Henry Moore (b 1898) filled an entire sketchbook with drawings of the sheep which graze the field just outside his studio.

If you are unfamiliar with animals, like any other subject they can prove very daunting. You may find yourself reluctant to make your first marks, but remember that drawing is an exploration and that the lines you make do not have to be definite. Each project is a new challenge and each must be looked at and studied from life as if seen for the first time. So do not worry if your first tentative marks are incorrect.

If you are lucky enough to have a specimen to draw from, make as many reference sketches as you can. Build up the complete form, constantly measuring distances by eye, checking and comparing. See how the distance between the eyes relates to the length of the forelimb, how the length of the tail compares with the backbone and so on. At the same time record details, such as the ear, the eye, the feet, claws and areas of fur or feathers

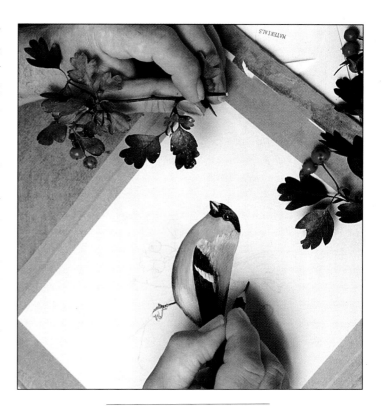

The best way of producing a really accurate painting or drawing is to work from nature. *Above*, the artist works from a sprig of hawthorn.

from different parts of the body. Drawing is a constant process of looking, making a mark, measuring and checking. Continue even when you are tired or think that the drawing has gone irreparably wrong. If the specimen is in front of you, it is simply a case of practice makes perfect. After all you have only to draw what you see. The difficulties of correcting a painting that is going wrong in the field or in the studio are much greater — you may have to return to the subject or rely on reference sources, such as books or museums.

Don't work for long periods or you will become overtired and your concentration will suffer. Rather work for short concentrated periods, breaking off every now and again to have a wander around, stretch your legs and rest your eyes and brain. Then return to the subject refreshed. This is an effective method of working which lessens the problems of stress, backache and stiff joints, which are inevitable if you sit hunched over your work for considerable periods of time.

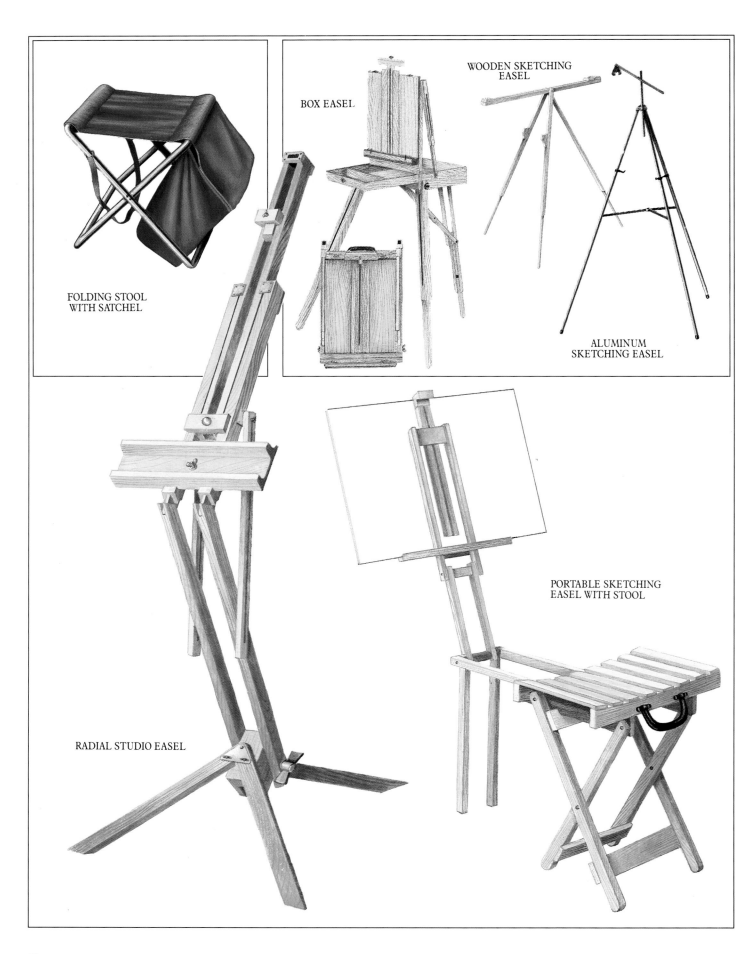

FOLDING STOOL
WITH SATCHEL

BOX EASEL

WOODEN SKETCHING
EASEL

ALUMINUM
SKETCHING EASEL

RADIAL STUDIO EASEL

PORTABLE SKETCHING
EASEL WITH STOOL

INTRODUCTION
TO
MATERIALS

The wildlife artist has a wide and inspiring range of media and supports to choose from. Don't be alarmed by the choice and stick to what you know, or you will miss the excitement of experimenting with new materials and techniques. Oil paint is probably the most popular medium in use today, but for outdoor work it is cumbersome and, because it is slow-drying, it is particularly inconvenient for painting live animal subjects. That said, there are many artists who use nothing else. Acrylic is a new and often underestimated medium which is popular among wildlife artists. Its main advantage is the speed with which it dries — if you are working outdoors, it enables you to take home a dry painting at the end of the day. Watercolor is also suitable for working outdoors. The materials are easy to carry and the equipment is simple. Pastel, pencil, charcoal, pen and ink have been around for centuries, but colored pencil, watercolor pencil and the various felt-tipped and fiber-tipped pens are new to the artist's repertoire.

An easel will probably be the most expensive single purchase you make, so think carefully before you splash out. If you intend to work out-of-doors you will need one of the lightweight sketching easels *left*. A sturdy studio easel is useful if you work on large canvases.

SKETCHING MATERIALS

For most people attempting to capture the animal world in any graphic medium is a daunting prospect. Sketching and drawing is an important starting point for all artists, however. It increases manual dexterity, improves hand-eye coordination, and, most important of all, it forces the artist to *look* at the subject. It is only by looking and by becoming familiar with the small details of the subject that you can achieve the confidence which enables you to create paintings and drawings with real conviction. The sketchbook has another role as an important source of reference material, a reservoir of ideas, images and small details to which you can return again and again. Information can be recorded in a variety of ways and can be taken to any level of finish, so that the book contains not only sketches, but notes, finished drawings, thumbnail sketches and details of surface texture and background. Opportunities for sketching animals from life are limited, so make the best possible use of every occasion. Explore the various sketching materials and develop a technique that enables you to make marks and record events without thinking about the mechanics of what you are doing. In this way you can concentrate on the subject, knowing that the information received through the eyes is being transferred accurately to the sketchbook.

There are a great many tools suitable for sketching purposes and what you choose will depend on personal taste, your method of working, the subjects you intend to deal with, convenience and portability and possibly cost. One of the first considerations is whether you intend to work at home or outdoors. If you are painting or drawing in the field and anticipate hiking all day across fields or up hillsides, you will not want to be burdened with a great deal of equipment. Another consideration is the scale at which you prefer to work. Some people automatically work on a large scale and very freely, even when sketching, while others work best on a more restricted area. The size of the marks should relate to the size of the support, so a very thick felt pen or drawing pen would be inappropriate and difficult to work with in a $5\frac{1}{4}\times4$in sketchbook. If you are going to carry your equipment, choose a fairly small sketchbook and a medium such as pencil, watercolor, sketching pen and ink, colored pencil, ballpoint or one of the new pens.

Pencil is still a very popular medium and is hard to beat for flexibility, convenience and cost, and as you will see if you glance through the projects in this book, it is very popular with working artists. Drawing pencils are available in various qualities and prices, and in grades of softness which are indicated by numbers and letters engraved on the wooden holder which encloses the lead. Hard grades are H, 2H, 3H, 4H, 5H and 6H, with 6H the hardest. The softer grades are HB, B, 2B, 3B, 4B, 5B and 6B, with 6B the softest. You will also need an eraser, and again there are several types to choose from. The most useful is a soft, kneadable putty eraser which erases without destroying the paper surface and can be molded to a fine point so that with it you can stipple chalk, crayon, pencil, charcoal and pastel. Most manufacturers also produce art erasers which are made of a soft gum and these too are suitable for fine artwork. Your eraser is not just a tool for correcting mistakes, it is also a creative drawing tool.

Pen and ink is a very pleasant medium to work with creating sinuous, flowing lines and providing the artist with a combination of thicks and thins with which to convey forms. The old-fashioned dip pens are cheap and

COLORED
PENCILS

WATERCOLOR BOX WITH
WATER RESERVOIR

satisfying to use, but a fountain pen with an ink reservoir is probably more suitable for working in the field. Washes of color can be combined very effectively with line, the color being provided by ink or watercolor.

The relatively new fiber-tipped and felt-tipped pens are also useful. There are many kinds on the market and it is worth spending some time in a good artist's supplier, experimenting with the range on offer. Some reproduce the quality of a fountain pen, others a fine unvarying line suitable for technical drawings, and some, called brushpens, produce a brushlike stroke.

Drafting pens, such as stylo-pens, are really a designer's or draftsman's tool, but are often used by fine artists. They produce a fine, unvarying line, and the nib units are available in a great many sizes. The advantage, as with fountain pens, is that the pen has its own ink reservoir, thus avoiding the necessity of carrying bottles of ink and the risk of spillage.

Charcoal is a simple, expressive medium which can be used to lay in broad areas of tone or fine linear details. The soft charcoal powder can be smudged and worked into the support with a finger or a torchon to create subtle tonal changes. Charcoal is available in several forms — as thin sticks of willow charcoal, blocks of compressed charcoal and charcoal pencils. If you do use charcoal, you will also need fixative as it is a very messy medium.

Conté crayons have long been popular with artists. They are soft and responsive and are available in white, black, sanguine and gray.

If you are sketching in black and white, annotate your sketches with color notes. Alternatively, if you are studying the colors of the subject, you may prefer to use a colored medium.

SKETCHING WITH COLOR

Colored pencils and watercolor pencils have their limitations, but give the artist in the field the opportunity to record color quickly and accurately. They are also convenient to carry. Pastels again provide the artist with color and are simple to use and easily transported. There are two types of pastel — oil and soft pastel. Soft pastels, which are soft and powdery as their name implies are available in a glorious range of colors. They are difficult to handle at first, but in the hands of an experienced exponent can create vivid and exciting images. The students' quality soft pastels tend to be harder than the artists' quality.

Fiber-tipped, felt-tipped and brushpens are all available in a great variety of colors and are useful for color sketching. They are used very effectively by visualizers in graphic art studios. Some types are water-soluble.

PAINTING MEDIA

The main painting media available to the artist are oil, acrylic, watercolor and gouache. Oil painting first became popular in the sixteenth century, although oil had been used as a binder several centuries earlier. The main binding media today are linseed, poppy and safflower oils. Oil paints are available in two qualities — artists' and students'. Artists' quality has a larger range of colors, but for most purposes students' quality is quite adequate. Oil paint is a very flexible medium which can be used in many ways: thickly or thinly, applied with a brush or a knife, worked wet-into-wet slurring the colors into each other, or wet-into-dry for sharper, more defined effects. The artist can work 'alla prima', finishing the painting in one session, or the painting can be

ARTISTS' SOFT PASTELS

GOUACHE

developed as a series of thin scumbled or glazed layers. The disadvantage of oil is that it is slow-drying. Many artists therefore use other media for working in the field and oil back in the studio. One way is to start the painting in acrylic, creating a polychrome underpainting, and then to work over the underpainting in the studio.

Acrylic paint has been around since the early part of the twentieth century. It contains the same pigments as the more traditional media, but the binding agent is a polymer and the paint is water-soluble. Acrylic is underestimated by many artists. They compare it to the more traditional media and find it lacking, rather than exploring it for its own special qualities. Acrylic is very versatile, with several advantages. Its most outstanding quality is the speed with which it dries, which makes it particularly suitable for wildlife artists. A detailed animal study has to be worked wet-into-dry. In oil this technique involves a great deal of drying time, whereas in acrylic the artist can work each layer almost directly onto the next. Acrylic can be thinned and used like watercolor or gouache, or it can be used in an impasto technique which resembles oil. The speed with which acrylic dries can sometimes be a disadvantage, as the artist has little time to change his or her mind. To counteract this, acrylic has excellent covering qualities and mistakes can very easily be obliterated. For wildlife artists who produce their work for reproduction in magazines, on calendars and on cards, acrylic has a further advantage. The density of color and its imperviousness to water once dry make acrylic paintings highly suitable for reproduction. Artwork done in acrylic can also take fairly heavy handling without suffering damage.

Watercolor is a delightful medium. There are two types of paint which can be described as watercolor.

Traditional watercolor is a transparent medium. The color is built up as a series of thin washes which allows the white of the paper to shine through, giving it a translucence unmatched by any other medium. The second type of watercolor is gouache — another water-soluble medium. As with pure watercolor, the pigments are bound in gum arabic. Gouache, however, has the additional quality of opacity. Because it contains white pigment, it works well on a colored ground and the artist can make corrections, overpaint and create fine details. The flat, opacity of the color and the ability to work on a small scale and with great accuracy make gouache particularly attractive to the wildlife artist.

EASELS

There are many easels on the market, so you are bound to find one that suits your requirements. There are many points to consider when choosing an easel. The first is space. Studio easels are large and do not usually fold down, so you need a large, permanent space to store one. They are sturdy, easily adjustable and almost essential if you work on a large scale. Radial easels are large studio easels with tripod legs which can be folded away for storage. They are slightly less stable than the H-based easels, but are nevertheless a good solution if you don't have a huge studio space but do have enough room to work on a large canvas. If you are really short of space, a table top easel is an ideal solution. Watercolor artists need to work on a horizontal surface and be able to tilt the support to create a graduated wash and other special effects. A drawing board on a table will do, but watercolor easels have been designed so that they can be used in both a vertical and a horizontal position.

The next important point to consider before investing

ACRYLIC PAINT, FLOW
FORMULA

what may be a considerable amount of money, is portability — do you intend to work outdoors? One of the cleverest designs available is the easel sketchbox which combines paint box and easel. When folded down it holds all your materials and a canvas can be attached to the side for easy carrying. When erect it has three or four legs making it very stable, and a drawer, which provides access to materials and a useful work surface. Folding sketching easels are light and cheap, and one design has a special handle which allows the easel to be used upright or horizontal for watercolor. Folding easels are also made in a lightweight tubular aluminum — these are exceptionally light, easier to erect than the wooden models and slightly more expensive.

If you are anxious to avoid extra expense you can use sketching blocks and work on your knee. Indoors you can use a wall by hanging the canvas on nails, or supporting it on a ledge made from a narrow length of wood pinned to the wall.

OTHER MATERIALS

A bag or box for carrying your equipment and a folding stool are useful additional items. The type of bag you opt for will depend on the material you use and how you travel — if your painting expeditions are by car you can be less selective than if you are going to carry all your equipment yourself. A small, lightweight backpack is useful and small plastic toolboxes with trays that fold out are light, compact and easy to work from. Wooden paintboxes are available in many sizes, and are designed to hold most of the necessary equipment including a palette. They are available either empty or complete with materials, but it is usually better to buy the box empty and select the contents separately. It is cheaper and

allows you to select the materials which suit you and your requirements. Watercolor boxes are invaluable, especially for sketching outdoors, where the lid of the box can act as a palette for mixing solutions of color. Again the box and its contents can be bought separately. Manufacturers of art materials have expended great ingenuity and design flair on creating paintboxes, and it is very easy to be seduced into parting with more money than you intended. There are delightful watercolor boxes which combine a water bottle, paintbox, palette and a water container; others are tiny with jewellike cubes of color that look good enough to eat. There are hardwood boxes with lids which lift to reveal the colors and brushes, and drawers which contain a palette. You will soon establish a method of working and can then decide just what you require in the way of materials and equipment. Painting is probably an interest which you will follow for life and the best materials will give the best results and years of use and pleasure.

OIL PAINT

OIL PASTELS

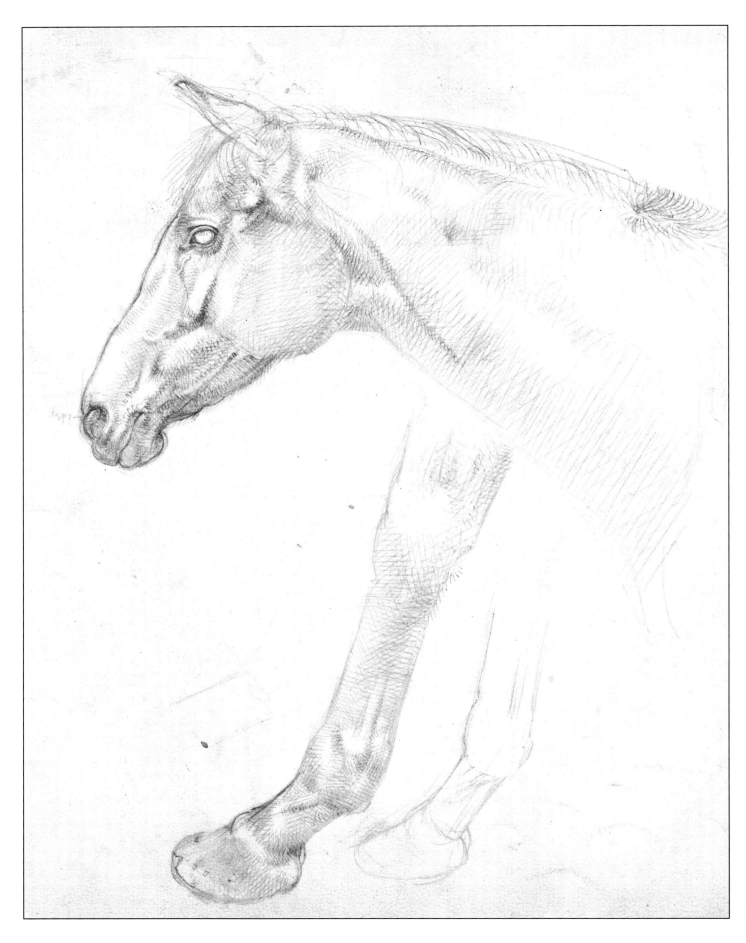

CHAPTER THREE

Anatomy and Movement

This chapter looks at the skeleton, musculature and surface texture and colour of animals from the standpoint of the artist. It is not necessary to have a detailed knowledge of the subject, but you should know what to look for, otherwise the assumptions you make will be incorrect and your paintings and drawings will lack conviction. An understanding of and feeling for what goes on beneath the surface is as important in animal painting as it is in figure painting. But don't be alarmed − once you train yourself to look at the animal world with a questioning eye you will find that you learn rapidly. All creatures, whether animal or human, obey certain rules and if you understand the broad underlying structures you will begin to understand how the forms work, how the animals move and will be able to depict them in motion and capture their characteristic attitudes. To acquire the necessary understanding and familiarity you can study animals in your home or garden, on trips to the countryside, zoo or museum, by studying reference books and by watching nature programmes on television. You will learn by sketching, drawing and painting, but above all you will learn by using your eyes.

There are many ways to improve your knowledge of animal anatomy, but drawing and sketching from life is undoubtedly the best. *Left*, the artist has used pencil for these detailed studies of the head and leg of a horse.

Anatomy and Movement

THE IMPORTANCE OF ANATOMY

There is disagreement among artists about the desirability or otherwise of acquiring a deep knowledge of human anatomy. Whether or not students of figure drawing are encouraged to get to grips with the subject is a matter of fashion and, while some art schools devote a considerable part of the timetable to a detailed study of the human skeleton and musculature, others give it only passing attention, maintaining that all the artist requires is a basic knowledge of the broad structures of the human form. It would, however, be a mistake to become so concerned with scientific studies that they distract you from the creative process — for the artist the study of anatomy and physiology is a means to an end. What you need is sufficient information to allow you to create the images you wish — a lack of knowledge can come between you and your inspiration, slowing down the creative process at best and frustrating your intentions at worst. You will have seen paintings and drawings which irritate because they are so tentative, the artist's lack of conviction permeating the wooden figures. There are many gifted artists who rely on empirical observation, but despite declarations to the contrary you will find that these people do indeed have considerable knowledge of the way the human figure reacts in different circumstances, a knowledge probably acquired over years of observation. Similarly artists who paint animals or birds need knowledge to create successful images — even more so than figure painters. At least when we paint a human figure we work from a familiarity with our own bodies.

You may well come to painting from a study of wildlife and already have considerable knowledge of the way animals are made, how they move and their habits and habitats. All this information is filed away and can easily be called up when required. Your problems are more likely to be concerned with painting techniques. Other readers may have considerable knowledge of the technique, but feel unsure of their ability to tackle the subject. In the following pages we discuss very briefly some basic concepts which will provide a starting point for your own investigations.

APPROACHING ANATOMY

There are something like one million animal species on our planet, from the simplest unicellular Protozoa to

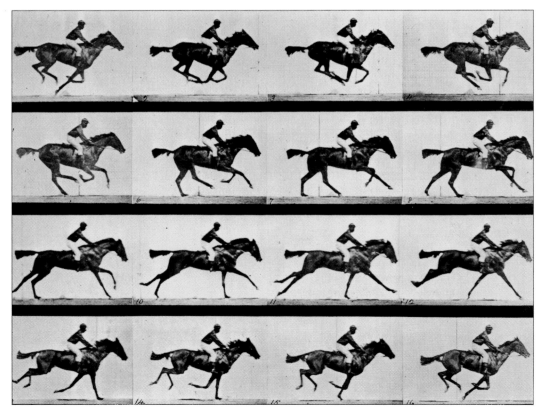

Above A woodcut by Thomas Bewick (1755-1828) shows that it was believed when a horse galloped, at a certain point all four legs were fully extended and off the ground. *Right,* detail of *Eclipse* by George Stubbs (1724-1806), who realized that horses have a 'rotary' gallop. *Left,* photographs by Eadward Muybridge (1830-1904) revealed that at certain stages of the gallop, the horse's legs were off the ground but were bunched under its belly.

large, complex animals such as *Homo sapiens sapiens* or the elephant. One very simple division of this bewildering variety is into vertebrates and invertebrates. The vertebrates include most of the animals with which we are familiar — mammals (including ourselves), birds, amphibians, reptiles and fish of all kinds. The four-legged members of the animal kingdom — the quadrupeds — have always been of particular interest to the artist, and the following sections on anatomy deal largely with them. If your particular interest is reptiles or insects, however, these sections will give you an idea only of how to approach an anatomical study of them.

For those who have had little exposure to the study of zoology the details of the way in which animals are constructed may be a mystery, and the possibility of making sense of the skeletons in museums and the diagrams and drawings in textbooks may seem remote indeed. The concept of Man as the measure of all things may seem deplorably self-centered, but in this case it may provide us with a helpful peg upon which to hang our brief study of animal anatomy. So we shall look at the anatomy of animals and birds by comparing them with our own. Despite apparent differences, many animals have organs which share the same basic structure and have the same relationship to other organs, and develop in the same way in the embryo. These organs do not, however, always have the same function. If you examine the skeletons displayed in a museum of natural history you will find, for example, that despite superficial differences the bones of the whale's flipper, the bat's wing and a human hand all have the same basic pattern. These appendages are found in the same part of the body in each case and develop in similar ways, but are used to carry out quite different functions.

THE SCAFFOLDING

The skeletal structure is important because it is the basic framework around which the animal is constructed. The most obvious feature of a bony skeleton is the rigidity of its constituent parts, like the components of scaffolding. With the exception of young animals which are still growing, the bones are fixed in size and they cannot bend or stretch. The only movement is at the point where they meet, so that each element articulates against those upon which it impinges. The degree of articulation is limited by other factors so that some sets of bones are

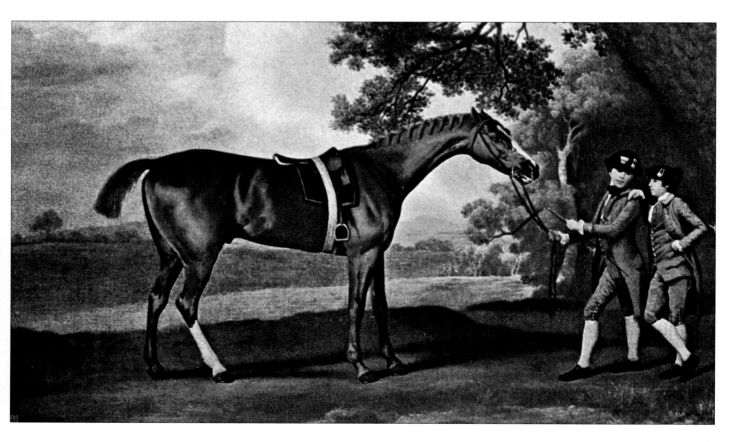

capable of considerable movement while others are much more limited. Take a bird, for example. Its head can turn through 360 degrees, allowing the animal to look behind it, but turn your own head and you will see that you have only half that amount of movement.

Like humans, other vertebrates have a spinal column, attached to which are the rib cage, shoulder girdle and pelvic girdle. The forelimbs are attached to the shoulders, the legs are attached to the pelvic girdle and the bony case which protects the brain is carried on the top end of the spinal column.

One of the most obvious differences between humans and quadrupeds is the fact that we walk upright. To accommodate this unnatural upright posture the human spine has become S-shaped. In four-legged animals the spine curves between shoulder and pelvis. Most have, like us, a neck made of seven vertebrae — the exceptionally long neck of the giraffe results from a lengthening of the individual bones rather than extra vertebrae. Many animals have tails, a continuation of the spine beyond the pelvis in which the individual vertebrae remain mobile. In the human this consists of nine vertebrae which have grown together to form the coccyx. Some animals have more vertebrae in the back which explains their proportionally longer trunks. The spinal column is the key to the whole anatomy. Look for this and you will be able to understand the arrangement of the pelvic and shoulder girdles.

The forelegs and hind legs of quadrupeds perform different functions. The hind legs provide the power for forward movement. If you look carefully at animals you will see that the greater bulk of the body is at the front and the forelimbs primarily provide support for this. In the horse, for example, two-thirds of the weight distribution is in the front half.

The method of locomotion is reflected in the skeleton of animals. Hoofed animals, for example, walk on the tips of one or two toes, sometimes more. Speed of movement is important for most animals and by minimizing the surface area in contact with the ground they are able to move more quickly. This, together with the need to be always ready to jump clear of danger, has resulted in the many bends which are particularly noticeable in the hind legs. A sudden movement forward is facilitated by stretching the leg joints, like releasing a

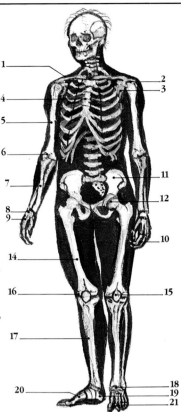

In many ways the similarities between the skeletal structures of Man and the other animals are more important than the differences. All vertebrates are bilaterally symmetrical with a head at the front end. The end contains the brain and many of the sense organs are concentrated in this area, as are the feeding and breathing orifices. The diagrams *right*, draw your attention to the similarities and differences. **1** collar bone, **2** shoulder joint, **3** shoulder blade, **4** breast bone, **5** upper arm, **6** elbow joint, **7** forearm, **8** wrist, **9** hand bones, **10** finger bones, **11** pelvis, **12** hip joint, **14** thigh, **15** knee cap, **16** knee joint, **17** shin, **18** ankle joint, **19** heel, **20** metatarsal bone, **21** toes.

spring — think of a runner crouched to start a race.

In animals such as the horse, the bends in the forelegs are not visible on the surface — this is because most of the bones of the upper forelegs lie hidden under the skin of the trunk. In order to understand the joints of these limbs you need to study the skeleton. You will then see that the curve in the forelimbs is restricted to the point between the shoulder blade and the lower part of the leg, the section concealed within the skin. The difference between the forelimbs of these quadrupeds and those of primates is reflected in their function. While the limbs of the former are designed for support and movement at speed, the arms of humans, apes, monkeys and lemurs are required for work, for lifting, pulling and pushing. When you are trying to understand the shape of any body, or part of a body, it is helpful to think of its function, for it is generally true to say that the shape is dependent on the function. In simple movements such as hinging and leverage there is usually a simple visual explanation. To capture other more complex movements, you must rely on drawing accurately what you see, without a clear understanding of what is happening at deeper levels — in the skeleton and musculature. Alternatively, you can set out to find out what is going on. A combination of close observation

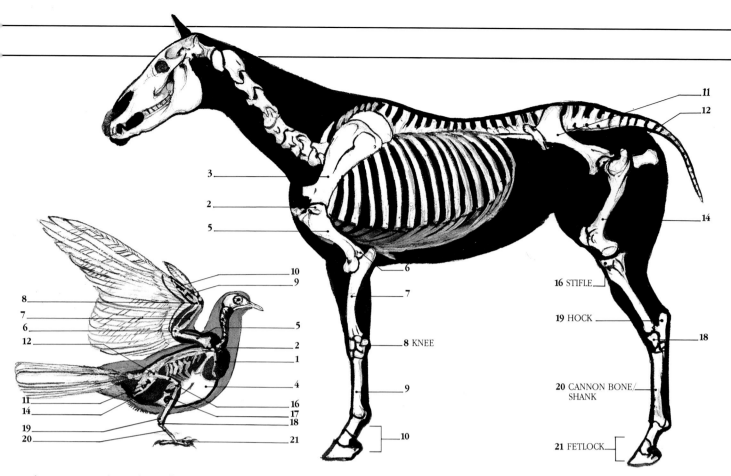

The way we use our forelimbs is reflected in the structure of the shoulder girdle — in humans the forearm is firmly anchored to a collarbone giving it a considerable range of movements. Explore these by swinging and rotating your own arm. It is the collarbone which lifts the arm attachments from the rib cage and thus allows this degree of flexibility. Other animals that use their forelimbs for work — monkeys and moles, for example — also have collarbones, whereas animals which rely on these limbs for running and for support of the trunk do not have a collarbone. They do not require the rotary movements which are essential for work and these limbs are capable only of the scissor action required for running.

Understanding the habits of animals can often give you a clue to the way they are constructed, for example we find that herbivorous mammals have a wide pelvis, whereas carnivores which need a springing action in order to leap upon their prey have a much narrower pelvis. Similarly the grazing animals are characterized by long necks which allow them to crop the vegetation while moving.

Compare the position of our heads and those of the quadrupeds. The human head is supported over the center of gravity — held in position by a combination of gravity and muscles. In fact very little energy is required to maintain it in this position, but if the muscles do relax the head drops sideways. You'll have seen this happen when your fellow passengers start to nod off on a long plane journey. In the horse, on the other hand, the head is in front of the spine rather than on top of it. The head is cantilevered and held in position and moved by powerful muscles assisted by a strong ligament. This explains why a horse nods its head as it walks. The movement occurs mainly between the skull and the highest neck vertebrae, although the neck is brought into play to some extent.

THE TAIL AND PELVIS

This is an important shape to look for and get right, for it differs considerably from animal to animal. In cattle and horses it is high and square, whereas in lions, elephants or bears it slopes away steeply. The tail is also characteristic of particular species and should be studied carefully. It has several possible functions, acting as a balance, a rudder or a fly whisk, and is also used to express feelings. Dogs, for example, wag their tails when they are pleased, hold them upright to show aggression and put them between their legs when they are afraid.

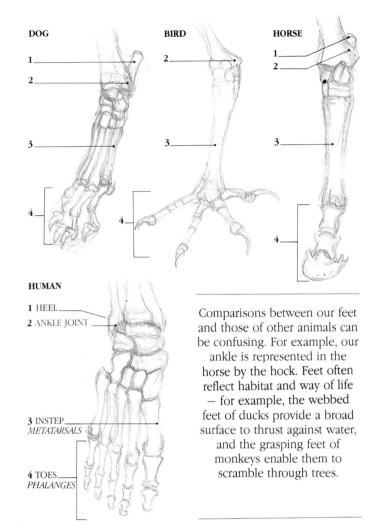

DOG

1 ____
2 ____
3 ____
4 ____

BIRD

2 ____
3 ____
4 ____

HORSE

1 ____
2 ____
3 ____
4 ____

HUMAN

1 HEEL ____
2 ANKLE JOINT ____
3 INSTEP ____
METATARSALS
4 TOES ____
PHALANGES

Comparisons between our feet and those of other animals can be confusing. For example, our ankle is represented in the horse by the hock. Feet often reflect habitat and way of life — for example, the webbed feet of ducks provide a broad surface to thrust against water, and the grasping feet of monkeys enable them to scramble through trees.

THE SKULL

The human brain is generally larger than that of other animals, and therefore the size of the human face and head is proportionally larger. The shape of the skull depends to a great extent on the lifestyle of the animal, especially the manner in which it finds its food. The position of the eyes is important. Carnivores look directly ahead because they need sharply focused eyesight to locate their prey, and as they have few enemies they do not require a wide field of vision. Rabbits, on the other hand, which have many predators, have eyes on the sides of their head which they can turn to give them a 360-degree field of vision.

MUSCULATURE

The musculature covers the bony skeleton and it is this which gives animals their range of movements and attitudes. The muscle layer also serves to define the shape of animals, creating the detailed curves and forms, the outlines and volumes by which we recognize creatures. All muscles work by shortening only — the thickening of muscles is incidental.

SURFACE

The surface of animals has two aspects — texture and color. It is the final layer — the glossy, patterned gift wrapping on the parcel. Human skin is smooth and is characterized by a limited range of skin tones from dark brown, through various golden shades to a very pale pinky white. Texture is provided by the layer of hair, fine and downy in most areas but denser and more colorful on the head. Much of the excitement of animal painting comes from the infinite variety of surface finishes — animals can be furry, woolly, spiny, scaly, rough or smooth, wet or dry. One of the first things we notice about animals is their coloring and pattern. Think of the iridescent hues of a mallard, the speckled throat of a thrush, the patterned skin of the snake or frog, or the coat of the zebra. The reservoir of pattern is vast and has provided painters and designers with inspiration.

ANIMAL MOVEMENT

Most animals have to be able to move quickly or effectively. Different species have evolved different features to cope with this need. Animals which live in wet

THE FOOT

The human foot has developed as a very efficient shock absorber. It is constructed like two arches, one in cross-section and one lengthwise. The little bones which make up the foot are fairly flexible and act like a spring, absorbing the shock of impact as the foot hits the ground and saving the inner organs from damage. Other animals which walk on their soles such as bears and monkeys do not have this arched structure. Monkeys and apes have feet which are more like hands, and they use them to scramble through the treetops. Most mammals tend to walk on their toes and in hoofed animals the toes have merged to become either one or, as in the case of cattle, which have cloven hooves, two. Carnivores on the other hand still have all their toes because they need to grip their prey. They have thickly cushioned feet both to protect the claws from damage and to be able to move quietly, creeping up on their prey unheard.

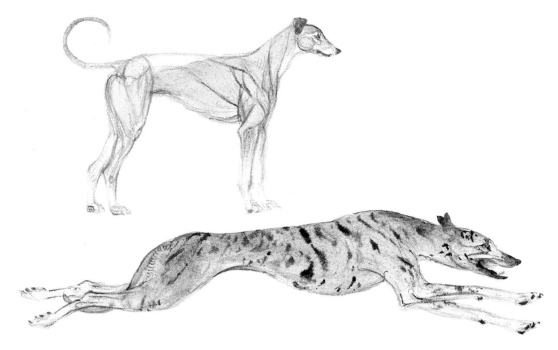

The problem faced by four-legged animals when moving is how to support their bodies while taking a limb off the ground in order to move forward. The sequence in which their limbs move varies with the speed of movement and also with the kind of animal. Smaller, lighter animals such as dogs have two periods of suspension during which all four feet are off the ground — when they are bunched under the body and when outstretched in the 'rocking horse' position.

or swampy areas have developed webbed feet. The webbing distributes the animal's weight, allowing the limbs to thrust against a larger area, a device mimicked by snow-shoes. Animals such as monkeys which spend their lives in the tree canopy have grasping feet and hands, while animals which depend on speed for their survival, such as deer, tend to have hooves.

Animals move differently under different conditions and it is only fairly recently that what actually happens has been understood. It was in the late nineteenth century that Eadweard Muybridge became fascinated by a puzzle which had mystified people since the time of ancient Egypt — whether or not the four feet of a moving horse were ever off the ground at the same time. Muybridge set up a series of time-lapse cameras. The resulting photographs revealed that at certain stages of a gallop the horse's feet were indeed all off the ground, but they were bunched under the horse's belly rather than being stretched out with forelegs forward and hind legs backward, as had previously been assumed. To people at the time the photographs looked odd, for they contradicted the conventions for representing motion in art — reality looked less real than art.

When a four-legged animal moves forward slowly the body is supported and impelled forward by three legs, while the fourth leg reaches forward ready for the next thrust. If the body is to be adequately supported at all stages of the movement, the legs must move in a particular sequence — right hind leg, left foreleg, left hind leg, right foreleg – so that there is always a triangle of support. When the animal picks up speed the sequence remains the same but the animal will be supported by only two legs at certain stages of the movement. The trotting movement is characterized by the animal being supported by two diagonally opposed legs. In a galloping movement the animal is supported first by the two front limbs and then the two back limbs, although each foot may be lifted slightly before the other and before the next one touches the ground so that only one foot is actually in contact with the ground at any one time. Or at certain times, as Muybridge's photographs showed, no feet at all may be in contact with the ground. Smaller, lighter animals such as dogs have two periods of suspension with all four feet off the ground at once.

The way an animal moves may change with its environment, thus frogs swim in water, but jump or walk on land, adding further variety to an already complex subject. Fortunately the artist is usually interested in representing a completed movement only, so an understanding of the distribution of the muscles and bones involved in the completed action is sufficient. You must learn to look for, and depict, the rhythms and counter-rhythms by which movement in one part of the body is compensated for by movement in another.

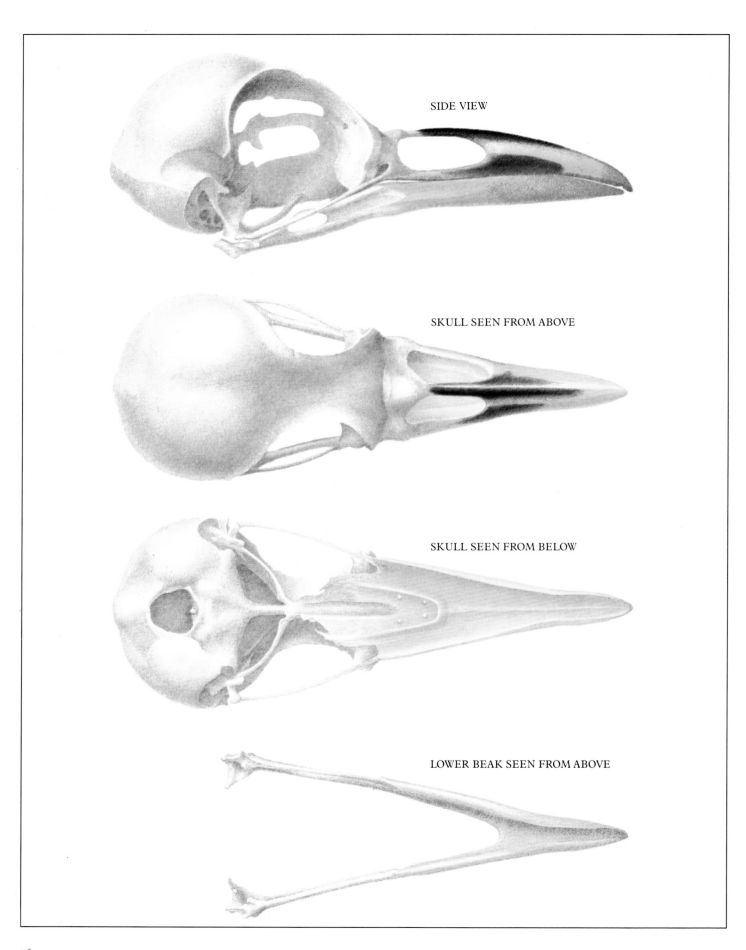

SIDE VIEW

SKULL SEEN FROM ABOVE

SKULL SEEN FROM BELOW

LOWER BEAK SEEN FROM ABOVE

CHAPTER FOUR

ANATOMY
OF
BIRDS

Our fascination with birds has a long history and has been expressed in the art of almost every civilization. They were depicted in the tombs of ancient Egypt more than four and a half thousand years ago and can be found on the pottery and artifacts of Mycenae which date back three and a half thousand years. For the artists of the early Christian world, animals and birds represented Man's lost innocence and we find parrots, cranes, peacocks, magpies and pigeons depicted in the pages of illuminated bibles and other manuscripts, sometimes realistically and sometimes so stylized that they are almost abstract. The eagle of St Mark and the dove which represents the Holy Spirit are recurrent images throughout Christian art. Later painter-naturalists such as John Audubon (1785-1851) combined scientific and artistic interest in the subject to create images of outstanding beauty, a tradition which has continued ever since. In this chapter we look briefly at the anatomy of birds and in particular at their adaptations for flight, which distinguish them from other members of the animal kingdom.

The skulls of birds are built to carry a beak, the upper part of which (unlike the upper jaw of humans) is not fixed, but can move. *Left*, the skull and beak of a European blackbird is shown, enlarged by 230 percent of its actual size.

THE SKELETON

Almost all birds can fly and, apart from their feathers, their wings are their most conspicuous feature. Wings are actually forelimbs modified for flight. Birds evolved from lizard-like ancestors and the evolutionary process selected those features which are especially suited for flying. The bird's skeleton is light, strong and rigid, with the weight distributed around the center of gravity. Their bones are hollow and many have fused together. This fusing of the bones does not save skeletal weight but it does reduce the amount of muscle and ligament required to hold bones in position. The rib cage and the backbone have almost fused to form the firm structure necessary for the attachment of the wings that provide the motive power for flight.

The feathers mask the form of the bird so that its silhouette is very different from its skeleton. While the smaller feathers and down follow the contours of the body, the tail and wing feathers extend beyond the soft parts of the body and are an important aid to flight, as they vary the weight distribution of the soft parts of the body. Drawing birds accurately at first can be difficult because you are unable to discern the trunk, spine and leg bones through the feathers.

In many ways the skeleton of a bird resembles that of a human — another biped. The skeleton of a bird at rest has a lot in common with that of a human crouching on tiptoe, but in the bird the vertebrae, rib cage and pelvis are less flexible, although still jointed. You can see this in the carcass of a roasted chicken.

Birds require a firm support for the heavy work of the wing which lifts the body on the downward beat. The breast bone has developed into the large, flattened bone called the keel which provides the attachment for the enormous flight muscles. The 'wishbone' is the V-shaped part of the keel. Absence of the keel is an almost certain sign that the bird is not capable of flight. The plump breasts of most birds are composed of these powerful muscles which power the wings during flight — they may account for 15 percent of the entire body weight, and amount to 30 percent in some of the tiny humming-birds. On other parts of the body the muscle layer is thin, following the contours of the skeleton and molding the form into an aerodynamically efficient shape.

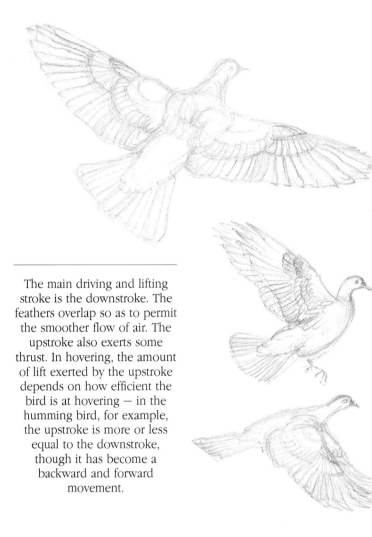

The main driving and lifting stroke is the downstroke. The feathers overlap so as to permit the smoother flow of air. The upstroke also exerts some thrust. In hovering, the amount of lift exerted by the upstroke depends on how efficient the bird is at hovering — in the humming bird, for example, the upstroke is more or less equal to the downstroke, though it has become a backward and forward movement.

THE SKULL

The skull of a bird is relatively small in proportion to the rest of its body and when the skull is stripped of feathers, skin and flesh it appears to be all beak and eye-socket. This is hardly surprising because sight is the most important sense for birds and the beak is one of its most important organs. Acute vision allows predatory birds to pinpoint fast-moving prey from a great distance, and even non-predatory birds have large eyes so that they can spot potential enemies. Each species of bird has a beak which has evolved specially to suit its particular diet and method of obtaining food. Hawks have large, cruelly hooked beaks for tearing at flesh, while chickens have small, curved beaks for picking up small seeds.

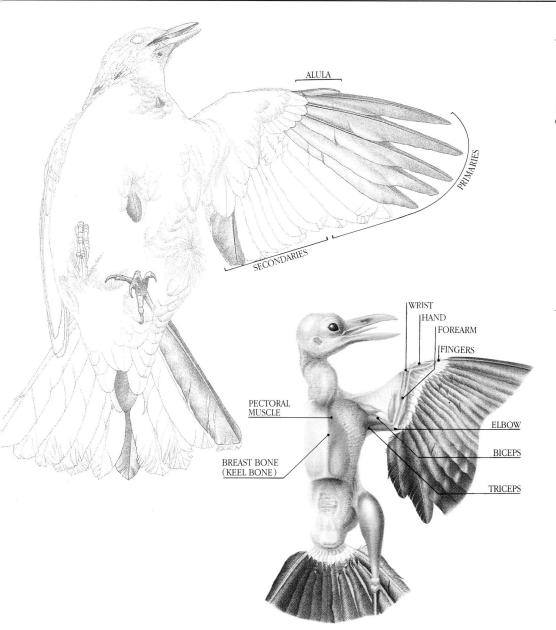

The drawings of a blackbird, *left*, illustrate the way in which feathers mask the form of the bird: the tail and wing feathers extend beyond the contours of the body.

ALULA

PRIMARIES

SECONDARIES

WRIST
HAND
FOREARM
FINGERS

PECTORAL MUSCLE

ELBOW

BICEPS

TRICEPS

BREAST BONE (KEEL BONE)

LEGS
The 'leg' of a bird is equivalent to the arch of the human foot, except that it is comprised of one bone rather than several. The joint at the top of the leg, often incorrectly called the knee, is strictly the ankle. A bird's foot generally consists of four toes, one of which points backward. Birds that climb, however, have two backward pointing toes, water birds have toes that point forward and some birds have two toes only. The number of knuckles also varies.

Humans walk upright, supporting themselves on two legs positioned under their center of gravity. Most birds on the other hand have two different methods of locomotion — either walking and flying or swimming and flying. In order to be able to perform these functions efficiently, a bird needs to have both the wings and legs positioned close to the center of gravity. The shortening of the spinal column and its increased rigidity have helped to achieve this aim.

WINGS
The arm bones of flying birds have become wings, entirely adapted for flight. If you look at the skeleton of a bird's wing you will see that it looks rather like a human arm. Most of the handbones have been lost or fused and only parts of three fingers remain. Great pressures are exerted on the wing during flight, and massive and very powerful muscles would be needed to hold them in the

correct positions, but this requirement is obviated by the construction of the joints which insures that movement is possible only in the plane in which the wing is folded. The joints at the elbow and wrist do not allow the wing to bend in the plane of the wingbeat.

The wings provide both forward motive power and the lift required for flight. They are aerodynamically designed with a blunt fore-edge which parts the air efficiently, the thin, blade-like back edge allowing the wing to cut through the air at speed. The underside of the wing is slightly concave like a shallow dish and this also assists lift. The upper surface of the wing is more rounded so that the air flows more rapidly over the upper surface than over the lower surface, producing reduced pressures on the upper surface and hence lift. The amount of lift produced by a wing relates to the speed at which it is traveling, the surface area and the angle of attack between it and the horizontal. An increase in any of these three areas leads to an increase in lift, but if the angle of attack becomes too steep the airflow becomes turbulent, lift is lost and the bird stalls. There are flight feathers on the 'forearm' and on the 'hand', but none on the upper arm. All these feathers are used in flight and are joined to bones.

GLIDING
If a bird in flight stops flapping its wings it will not fall to the ground. There are two ways in which it manages to prevent itself dropping like a stone. One way is by gliding steadily downward, without loss of speed. Gravity is used to overcome the drag, the resistance which the body and the wings present to the air. Alternatively the bird could continue to maintain height, but eventually drag would begin to slow it down. But remembering that speed is an aspect of lift it is obvious that this slowing down would cause the bird to lose height. It could compensate for this by increasing the angle of attack of the wing, increasing lift, but eventually this would lead to stalling. The first type of gliding is used by soaring birds which use thermals to maintain lift, compensating for the tendency to glide downward. The second type is used by birds coming in to land — by slowly losing speed they land with least possible shock.

In flight the inner part of the wing maintains the airfoil shape giving constant lift. The downbeat of the wing propels the bird forward and provides extra lift. There are many different wing patterns. The vulture has a broad wing giving the bird a lot of lift which it exploits to soar on thermal currents. The albatross travels large distances at speed. Its narrow, thin wings present little drag and allow the bird to glide for long distances across oceans, but it could not stay airborne on thermals as the vulture does. Short broad wings are good for rapid maneuvering. Many aquatic birds beat their wings under water. Their wings are small and this reduces the amount of work required to move them forward. However, these small wings mean that the birds must beat their wings rapidly to stay aloft, making landing and take-off rather ungainly. And, of course, some birds have lost the ability to fly altogether.

FEATHERS
One of the most important factors in the bird's ability to fly is the feather. The microscopic structure of a feather is a marvel. The central spine supports side shafts called barbs, subdivided into barbules, which are, in turn, divided into barbicels many of which terminate in microscopic hooks. This complex and elaborate construction creates a firm but flexible mesh. Run your finger along the barbs of a pigeon feather and you will find that they separate quite easily. Run your finger in the other direction and you'll find that they close up again, just like a zipper.

There are three different kinds of feather. Some birds have soft feathers with a very slight shaft, called down, which have no definite shape and provide warmth, acting like the coat of a quadruped. Larger feathers, called filoplumes, have weak shafts and short barbs. The largest feathers, called flight feathers, are more defined in shape. Feathers are light and very strong, more flexible than skin and easily repaired or replaced. The large feathers have a central shaft which provides the necessary rigidity, yet is flexible towards the tip. This is important for it is this which insures that the bird can maneuver swiftly, changing direction in seconds.

Feathers produce a regular patterned effect, rather like the scales from which they have evolved, for birds are close to reptiles in evolutionary terms. You will need to look carefully to identify the different shapes and sizes of feathers from the various parts of the bird.

BIRD SHAPES

You must learn to look for the features that distinguish one bird from another. They may be plump or slender, large or small. Their wings may be slim and pointed, short and rounded or large and broad. Bills, too, vary considerably in shape depending on diet, from the hooked beaks of birds of prey to the short strong beaks of seed-eating birds. Look carefully at their tails, for these too come in a variety of shapes and sizes, the deeply forked tail of the swallow contrasting with the short blunt tail of most waterbirds.

BIRD BEHAVIOR

Some birds are most easily recognized by what they do and where they do it. The treecreeper creeps up trees, hugging the trunk, with its stiff tail pressed against the bark. The nuthatch on the other hand climbs in any direction but does not use its tail as a prop. Blackbirds feed on the ground and have a bright alert stance. Jackdaws walk rather sedately, whereas sparrows hop, and dunnocks shuffle along slowly.

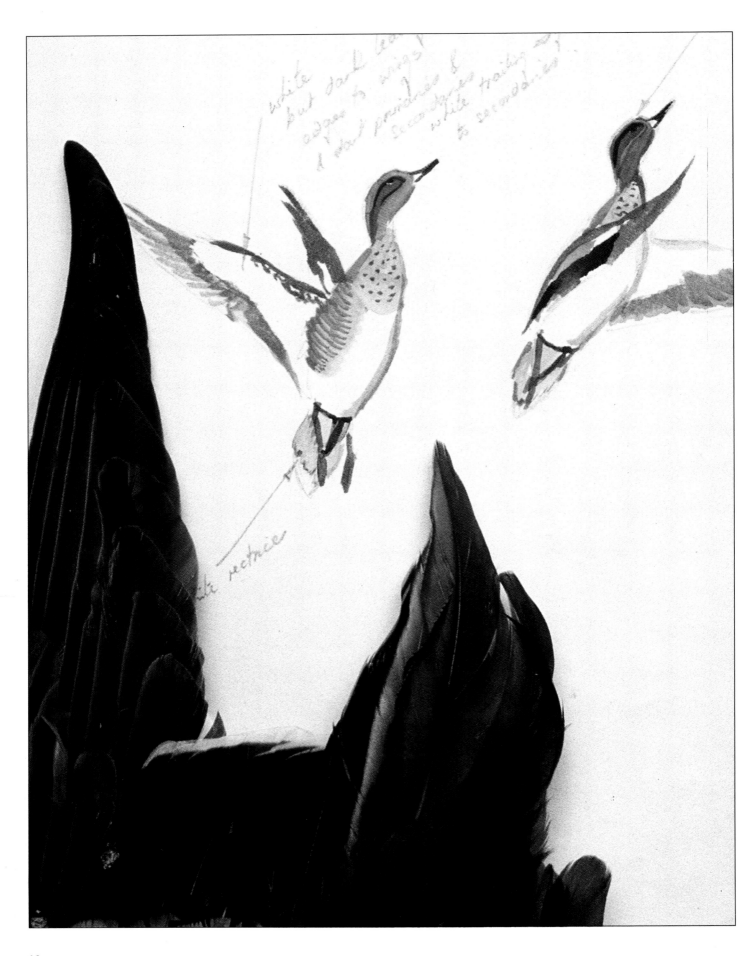

Making
A
PICTURE

There is more to making a picture than creating a likeness in two dimensions of a particular subject. The world around us is the raw material from which the artist sifts and selects the elements of a composition. In many ways the subject of the painting is unimportant, the 'creative' part of the exercise being the organization of the various elements within the picture frame, producing in the process an image which encapsulates a personal vision. In an 'ideal' composition no part of the image could be changed, no matter how minutely, without sacrificing the perfect harmony of the whole. However, there seems to be no agreement on what constitutes the ideal composition so this critical balance is rarely achieved, although some paintings are undoubtedly more satisfying than others. This chapter examines the ways in which you can collect and assemble the material for your paintings and drawings, and draws attention to some of the considerations which will help you create paintings and drawings which are more than just good likenesses.

The wildlife artist gathers information in many ways: by calling upon his or her memory and knowledge of the subject, supplemented by the sketchbook information and by found material such as feathers, dead birds and animals and plant specimens *left*.

HOW WE SEE ANIMALS

In the human head, the eyes are positioned at the front of the skull, limiting our field of vision to a cone of about 17 degrees, and because we can turn our heads on our shoulders through about 180 degrees only, the amount of a particular landscape that we can take in at any one time is limited. Many other animals, birds being a good example, have eyes on the side of their heads, combined with much greater movement in their necks, so that they can very easily bring the entire 360 degrees of the scene into view. When we are interested in something in the complex and confusing world that surrounds us, our eye automatically focuses on that object, or on part of it, depending on the distance between the object and the viewer. The ability to detect movement is essential for most animals and has been a positive factor in natural selection. For many animals movement implies either danger or potential food. In fact it may be that only the higher animals can detect objects when movement is absent. Small animals and birds often blend in with their surroundings as they seek to avoid detection from predators. Their methods of doing so are diverse and include camouflaged coloring. When we are studying wildlife outdoors, a bird or animal is often revealed to us by a movement which betrays its presence and helps us to distinguish it from its background. When we do catch sight of a wild creature our eye automatically focuses on one small part, often the eye, and we see a sharply defined central area, the rest of our field of vision blurring toward the margins. The animal on which our attention is fixed will appear clearly against the background, the brain automatically selecting, shuffling and rejecting information. Bear this in mind when you approach a painting in which a small, distant or moving subject is set in an extensive scene. The image will gain conviction if it mirrors reality. Miniatures can be painted with the entire picture area in the same sharp focus but a large painting handled in this way can become meaningless and tiring for the eye, the mass of detail distracting from the subject of the painting.

GATHERING INFORMATION

There are many ways of collecting material from which to paint and draw and the approach you choose will depend on your knowledge of the subject, your experience of painting and drawing, the calls on your time and where you live. If you are a student of natural history or a committed spare time bird watcher or naturalist, you will not be short of material and will merely have to develop the necessary manual dexterity and an artist's eye. This is not as difficult as it sounds — it's just a question of doing it!

SUBJECTS IN YOUR HOME

Gathering material can be a problem for anyone with little or no access to animals in everyday life. Birds and animals are by nature shy of humans. The best place to start is near to home, where you can find subjects that you are really likely to tackle and so that the 'excuse' that you would paint if only there was something to work on is undermined. Let us start by assuming that you live in an urban environment, somewhere near a city center. Well, maybe you or one of your friends or neighbors have a pet — a cat, a dog or even a tank of goldfish. If you do have a pet, you should get into the habit of keeping a sketchbook and your favorite sketching tool near to hand. It is important to experiment with different drawing implements but it is best to keep the one you are happiest with for everyday work. Sketching is really an exercise in looking, so you should minimize any impediments that will come between you and the image on the page. Your objective is the continuous, smooth transfer of information from your eye to your drawing surface, so that transient moments can be studied and recorded. Imagine someone who has decided to make their first drawing of their cat. They bustle about locating a sketchbook, then they have to find a pencil, but unfortunately it's blunt so they have to find a pencil sharpener. That can't be located in its normal place with the rubber bands and pieces of string on the sideboard, but they find a razor blade and the pencil is finally sharpened. Our hopeful artist settles down with a sigh only to find that the uncooperative cat has become bored and gone into hiding. The practiced artist seeing a possible subject will either have pens, pencils and sketchbooks lying together somewhere readily accessible, or will pick up the nearest scrap of paper, the back of an envelope if necessary, and will record the subject with a few brief lines in ballpoint, felt pen or anything which will make a mark. There are really no

Birds and animals can be seen as simple geometric shapes. This method provides you with a way of simplifying what you see so that you can make rapid sketches from life *above*.

Do not worry about making a 'finished' drawing. A simple sketch like this, *right*, can be a useful record of a particular feature, pose or personality.

rights and wrongs when it comes to painting and drawing — any subject, any tool and any place and time are right. The search for the perfect subject, ideal lighting or the right materials is often displacement activity, an excuse for not making a mark. The only way you will ever learn to draw and see with an artist's eye is by doing it.

Other subjects are close to hand. No matter where you live there will be birds to be seen at certain times of the year. You may be deterred from starting because you feel sure that you will not be able to achieve the high standard you have set yourself. For the real beginner the blank page is very alarming, but as with many things, the first mark is the most difficult and nothing is ever quite as alarming again. Try to dismiss the final image from your mind and concentrate instead on the subject. Ideally you should keep your eye focused on the subject, glancing at the drawing only occasionally to check progress. This concentrated looking is the best way of improving your visual awareness and soon you will find that you are producing accurate drawings.

An excellent source of material for painting or drawing is the local fresh fish store — there you will find all manner of stimulating material. Fish are pleasing subjects, presenting the artist with a spendid range of shapes and a brilliant array of shimmering colors, from the rich pinky tones of red mullet to the colorful iridescence of the humble mackerel. If you decide to eat the fish afterward, keep the carcass and study the fish's bony structure. As you begin to understand its internal structures you will gain insight to the way it moves and the way the exterior forms are arrived at. Shellfish too provide the artist with a plethora of delightful shapes, delicate colors and fascinating textures, a challenge to even the most accomplished artist. If you are lucky enough to have a supplier of game nearby, there will be further opportunities for gathering challenging subjects. You can choose pheasants with their richly colored plumage, or quail's eggs with their beautifully speckled shells. Have a look, and you may be surprised at the wealth of material that can be found quite close to hand.

WORKING IN ZOOS AND MUSEUMS

These days we are blessed with many excellent zoos and wildlife parks, while most museums have vastly improved their presentation of material in the past few years. Do not overlook these in your search for subjects. Zoos usually allow you to get quite close to the animals, so that you can see them far more clearly than you would in the wild or even in the setting of a safari park, where you are usually asked to stay in your vehicle and keep moving. The real problem with working in a zoo is other people. Anybody with a sketchbook attracts attention, and if the schools are on vacation it can be a nightmare for all but the stout-hearted. When you first start sketching outside you are bound to feel shy, so choose your time carefully and if possible go with a friend — you will feel less conspicuous if you are part of a group. Again the best approach is to make up your mind that you are going to have a try and then just do it. You will probably find the experience more rewarding and less alarming than you had imagined. Go well-prepared and use your time effectively. Don't take more equipment than is absolutely necessary, choose a sensibly sized sketching book and pack your equipment in a small bag which is easy to carry. A small backpack is ideal. A useful luxury is a small sketching stool, a lightweight folding stool which allows you to perch fairly comfortably wherever you wish. The object of the exercise is again to make marks no matter what the outcome — you often learn more from a drawing which doesn't merit a place on your wall than from a carefully rendered image. There are all sorts of sketching techniques which you can use for an expedition such as this. Pencil is the simplest and also one of the most versatile. Many people like the feel of felt- and fiber-tipped pens which can be used to render a sketch quickly and effectively. Pen and ink is a delightful technique but for working rapidly outdoors, use a fountain pen with a reservoir. Pastels give you color but are slightly messy. Colored pencils are very useful and can be used in combination with lead pencil. Watercolor is a lovely medium to work with, although many people think it is difficult, a reputation which is unjustified but understandable. A great deal of myth has developed about the right and wrong ways to use watercolor, but if you experiment with them and find a technique that you feel happy with you should use them, even if your

paintings do not resemble classical watercolors. A very useful technique involves just a few tubes of oil color, a rag and a few sticks of oil pastel. You squeeze a little oil color onto your paper, choosing the color nearest to the local color of the subject, then looking carefully at the subject you smear the paint onto the paper with your finger or with the rag, so that the patch of color approximates to the broad outlines of the subject. With an oil pastel, draw into the area of color, establishing the contours of the subject. With this technique you can create effective color sketches in a matter of minutes using only a few materials.

WORKING FROM PHOTOGRAPHS

Painting from photographs is often frowned upon — for good reasons — but they are an important source of information for the artist interested in wildlife. The major disadvantage is that the camera does the selecting for you and there is a temptation to stick closely to the composition created by the photographer. You may also be surprised at how much the camera can flatten and distort an image. Photographs of the white cliffs of Dover taken with a simple camera are a good example of the difference between what the eye sees and the memory recalls, and what the camera records. The cliffs often appear in vacation snaps dimly and mistily as a narrow gray strip on the horizon. In the mind's eye, however,

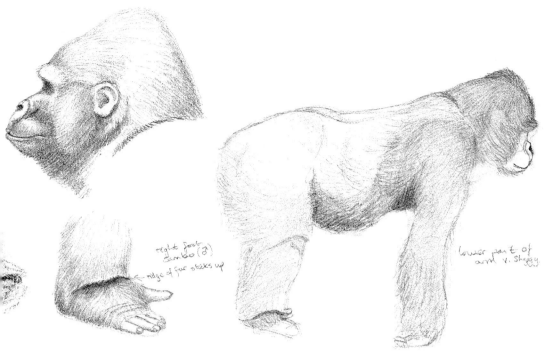

right foot Jumbo (♂)

ridge of fur sticks up

lower part of arm v. shaggy

they tower impressively, the white chalk dominating the scene — and that is how an artist would portray them. A sketch done on the spot can capture the difference of scale and highlight interesting features, whereas a simple camera would be unselective, treating each element with the same degree of attention. That said, good photographs are useful for reference and provide a starting point for a picture, provided that you exaggerate, highlight or distort in order to 'create' your own image. For detailed wildlife photography you need to invest in more sophisticated equipment.

The animal artist can use photographs to verify details, so take a series of shots which record different aspects of an animal and its movements. Use a telephoto lens to take close-up details of the head, eyes, horns, fur and so on. These points will otherwise have you scratching your head back at the studio.

You can use photographs to supplement your drawings and paintings when you are working in the field, particularly if you are short of time and want to work direct. Make initial drawings, and lay in the broad outlines or complete an underpainting on the spot. Complete the painting in your own time in the studio, using both sketches and photographs as an *aide mémoire*. Your work can thus retain the directness and freshness of a painting made *en plein air*, and you can also take it to whatever degree of finish you wish.

PHOTOGRAPHING ANIMALS

You need patience to photograph wildlife — the best results are achieved by waiting and watching. You will soon discover good spots for seeing birds and animals. You will also find that the car is a surprisingly good place to wait, because animals seem to ignore them. Alternatively you can lure creatures to your garden — even a city garden will yield a selection of birds from blue finches to greater spotted woodpeckers, and small animals, such as squirrels and hedgehogs. Think carefully about what photographic equipment you need — mistakes can be very expensive. Get advice from a good camera shop. You will need a 35mm SLR body and a selection of lenses. Remember that you will have to carry all your equipment so keep it to a minimum. Lenses for long shots are the most important. A 200mm lens is fairly fast and useful at dawn or dusk when the light is poor. You will also need a lens in the 300, 400 or 500mm range to get reasonable wildlife pictures. If you do invest in a lens above 200mm, you will need a tripod and faster film — ASA 200 or faster depending on the light. But the faster the film, the more grainy and less detailed the result. In most cases you will need a high shutter speed — remember that if you can see the animal it can see you! Kodachrome ASA 25 or ASA 64 are good general speeds, with Ektachrome ASA 200 or 400 when extra speed is required.

SKETCHING ANIMALS

Start by studying the subject carefully, looking for the simple forms, for the directions in which they can travel and the limitations of movement. In vertebrates the spine is the central column around which the rest of the body articulates. Your drawing will have more conviction if you are aware of the skeleton even when it cannot be seen. The polar bear is an example of an animal in which the underlying bone structure is completely masked by the layers of fat, muscle and fur which overlie it. Compare this with the much more obvious skeletal structures of the horse or cow.

The best way of making rapid drawings of animals is to start by reducing the form to a number of geometric shapes — ovals, rectangles and triangles. These broad forms provide the artist with a simple visual shorthand for recording attitudes, moods and capturing the essential personality of the animal. Compact forms suggest relaxation and contentment whereas open, spiky, angular shapes imply alertness, and angles in opposition create a sense of aggression. Think of the compact curves of a snoozing cat and the upright, ears-pricked attitude of an alert animal; or the arched back, flattened ears, open mouth and elongated shape of a snarling cat, drawing itself to its maximum height with fur on end and tail fluffed out to make it appear larger in order to frighten off an intruder. By a combination of concentrated looking and ruthless selection you can record the essentials of these attitudes with a few telling lines. Study the profile of the animal very carefully — this will tell you a lot very quickly and you, in turn, can use the profile to make simple but effective statements about the animal. An angular silhouette devoid of curves will suggest anger or fear, while hunched shoulders and an open mouth signal threat or warning.

In sketches of animals the head can be represented as a single shape attached to the neck which is, in turn, attached to the trunk. The position of the limbs and the angles at which they meet the body are also important. Treat each of these major elements of the body as single shapes, constantly cross-checking one with the other to achieve the correct proportions — look particularly for the angles between the different parts. Once you have captured the main shapes you can start refining the forms and outlines, and add details such as texture.

The head is obviously a very important part of any drawing and the eyes in particular can give life and realism to a study. Tackle the head by first putting in the line which runs between the eyes and bisects the nose. Next put in a horizontal to locate the position of the eyes.

Remember too that when the animal changes attitude, the entire body will move — there will be a ripple effect which affects the whole body.

When you are sketching use the drawing tools and materials with which you are most at ease. These drawings are for your use only and so you need not concern yourself with what other people think and can concentrate on achieving the kinds of images which will be most useful. Make changes whenever necessary and leave the original marks, for these tell you where you went wrong and a contour composed of several lines can be very expressive. Erasing wastes time, damages the paper and smudges the image. Very few artists can put down the single perfect mark first time, and those who can have been through these tentative, exploratory stages themselves. Your sketchbook is one of your most valuable possessions, and used properly it will be both a record of day-to-day events and a reservoir of useful material, ideas and details. It can also be used to explore compositional arrangements and formats. You may work with watercolor, or one of the other colored mediums, but if not you can annotate your drawings with information about color and light effects. You can also add small dabs of color to refresh your memory.

COMPOSITION

All good design is based upon an underlying grid which provides the scaffolding upon which the other elements are arranged, and it is this unseen grid which gives all good painting or drawing coherence and a sense of harmony. Composition is an aspect of painting and drawing which many inexperienced artists neglect, but once you are aware of it, its importance becomes obvious. The clever artist uses composition to draw the viewer's eye into the painting and to create mood or movement within the painting. The shape and size of the support should be considered carefully — a square canvas suggests stability and compactness, a long landscape shape suggests calm, and an upright portrait format suggests strength and power. These are

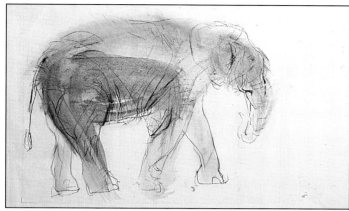

generalizations which will be modified by other factors such as the scale of the painting and the way in which the canvas is used.

All paintings have edges and it is the relationship between the edges and the elements of the composition which generates energy within a picture. The artist manipulates these tensions to set up rhythms and stresses within a composition. In some paintings all the interest is focused in the center while the outside edges are empty, in others the areas of activity are concentrated in the corners, in one corner, at the top, at the bottom, or even scattered over the entire picture area. This affects the way the viewer looks at the painting. The eye may be led in a careful way, into and through the painting, or it may be allowed to wander excitedly over the entire picture surface with no particular place to rest. You should resist the temptation to 'fill in' every part of the canvas. The empty areas of the painting are positive shapes and have an important role in the geometry of the painting — they can act as effective foils for busy areas or can provide dramatic backgrounds which draw attention to the subject of the painting. There is no correct way to handle composition but you should be aware of the way that each mark you make is affected by all the other marks, and that the size of the different elements, their position in relation to each other and to the edges of the canvas, are all aspects of the art of picture-making.

These aspects of composition are particularly important in animal painting if you are to create the effect you intend. If you wish to show a lion stalking its prey, for example, or crouching in long grass before the final burst of energy that brings down its victim, the image will have more impact if the animal is placed low

Speed is essential when drawing animals from life. This study of a leopard, *above left*, was made by applying dilute oil paint with a rag. The sinuous contours and patterns were drawn in with pencil and oil pastel. A similar technique was used for the elephant *above*.

Below, the artist makes a series of studies of pheasants — your local poulterer or fish seller will provide a rich source of such material — exploring the possibilities of a variety of media: charcoal, *below left*; gouache, *below right*; watercolor, *bottom left*; and pastel *bottom right*.

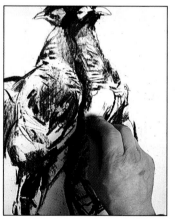

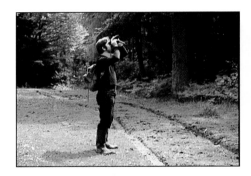

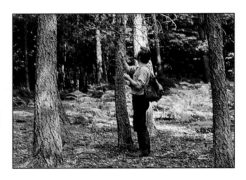

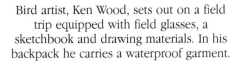

Bird artist, Ken Wood, sets out on a field trip equipped with field glasses, a sketchbook and drawing materials. In his backpack he carries a waterproof garment.

Here the artist is drawing a sparrowhawk's nest — he is a long way from the tree because it is illegal to disturb birds in the nest.

Habitat information is important. Here Ken gathers a sprig of larch for reference — do not dig up plants, and avoid protected species.

down in the picture area where it will appear to be both near to the ground and near to the viewer. In this case, the lion is not the most dominant part of the picture, the eye will see it only incidentally, as it would in reality. If, on the other hand, you want to paint an impressive picture of a stag, for example, you should place the animal in the central position with its head toward the top, so that it dominates the whole composition. Experiment with different arrangements of the subject within the picture area before you commit yourself. With these ideas in mind, look at the way in which the artists have resolved the problems of composition in the step-by-step demonstrations later in this book. And try to find time to study the work of the great masters in reproduction in books or, even better, in galleries and museums where the scale of the work comes into play.

BACKGROUNDS

Backgrounds are an important part of wildlife painting — they are as varied as the subjects and need an imaginative approach. Some subjects will require only a simple wash of color which does not detract from the main elements of the painting; or you might want to portray an animal in its natural habitat, where a complex tracery of leaves, flowers, branches and grass would be more appropriate. You might decide to treat the background impressionistically while rendering the animal in sharp focus, an effect which mimics a photograph taken with a telephoto lens. The background can provide additional information, such as a factual description of the type of countryside that the animal inhabits. It might indicate the time of year or the season. It can be atmospheric, with color and pattern combining to create a mood — a sense of conflict, of urgency or of calm.

APPROACHES

There are as many ways of approaching a painting as there are artists. While one will paint impressionistically with loose rapid brushwork which leaves parts of the canvas uncovered, another will seek a more detailed, realistic and highly-finished image. Some artists have several painting techniques, adapting them to suit the particular subject and the purpose for which the painting is intended. Many animal artists paint commissions for collectors or for reproduction in books, magazines, or on cards or calendars. The client will often indicate exactly what kind of image and what degree of finish is required. Whatever the purpose, the artist needs a knowledge of perspective and colour, how warm and cool colours can imply space and how paint and line can be manipulated to achieve particular effects.

Shadow can be used effectively to imply a sense of depth in a painting, creating a pattern of lights and darks which hide and reveal form. Deep shadow can be exploited as a foil for a pale subject which requires a clearly defined outline in order to make an impact. Shadows can suggest weather conditions, the time of day and even give a clue to the season. Bright summer sunshine casts deep, short shadows at noon, and long shadows in early morning and late evening when the sun is low in the sky. Under an overcast sky shadows are

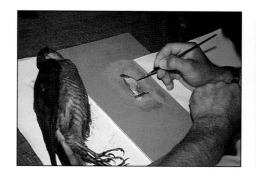

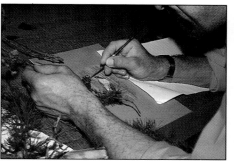

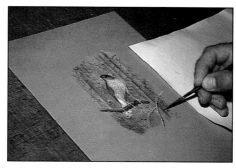

Ken sometimes uses skins for reference. They are useful for measurements, proportions and for an accurate color guide to feathers.

In the studio Ken arranges the composition. He works from memory, preliminary sketches and from skins, feathers and plant specimens.

Ken puts the finishing touches to a painting of a sparrowhawk. He shows a typical pose and habitat, with the bird perched alert and erect in a larch.

more diffuse, their margins less clearly defined.

CAPTURING MOVEMENT

The stance of an animal at rest and in motion is best understood by taking two lines of gravity, one running down the foreleg and one down the hind leg. Animals such as dogs and even-toed ungulates have a transverse gallop. They begin a forward movement with a hind leg and immediately afterward, almost simultaneously when running, move the opposite foreleg forward to offset the change in gravity. A few quadrupeds are exceptions to this rule. Horses, for example, have a rotary gallop. Movement in animals is dependent on structure but, as Muybridge's studies of animal movement revealed, we have often misunderstood the way that animals, and the horse in particular, move. Horses had been depicted with the front legs stretched out in front and the hind legs stretched out behind, so that all four legs were at full stretch and off the ground. The artist George Stubbs (1724-1806), who made detailed anatomical studies, had already discovered that their legs moved in a rotary cycle — Muybridge merely confirmed his conclusions.

All animals including humans have a characteristic movement. You can often recognize friends by their gait long before you can distinguish their features, by the way they carry their head and shoulders — similarly with animals and birds. A fox trots alertly across a frosty field, whereas a rabbit is characterized by a scurrying dish with a flash of white tail. Birds too have distinctive flight patterns — swifts, for example, have narrow curved wings and a fast whirring flight, whereas the sparrow-hawk dashes along, hugging the hedgerow.

Movement can be implied in many ways and a knowledge of anatomy and the way muscles work helps. Relaxed muscles are flat and smooth, for example, and flexed muscles are bunched and taut. Movement consists of tensed muscles in opposition to relaxed muscles, the one flowing into the other. You must look for these groups of muscles and depict them accurately in order to explain visually what is happening under the skin. Only then will your paintings have authority.

The way you apply your paint or the quality of your line can also be used to convey a sense of motion. Brisk expressive brushwork and broken agitated lines suggest energy, while flat, untextured paint and smooth, flowing lines can create a feeling of stability and inertia. The way you position the animal within the picture area can also help to imply direction and motion. If an animal is depicted on the right of the picture, facing toward the left, the suggestion will be that it is coming into the picture; this impression will be heightened if it is cut by the picture frame.

Movement is one of the most difficult yet fascinating aspects of portraying animals. Not only do different animals move in different ways but the action changes as the animal increases speed or slows down. You will have to study your subjects carefully, observing the way they move, the way the weight is shifted from one part of the body to another and the way the angles between the different parts of the body change during the course of the movement. But all painting is about illusion and you soon learn how to imply what you cannot describe.

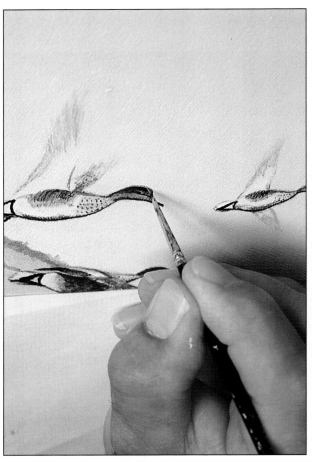

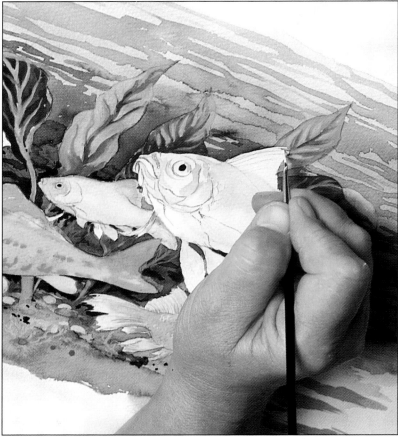

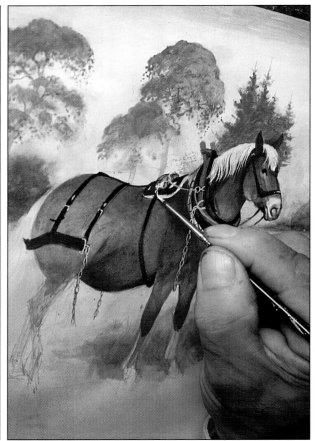

ABOUT THE ARTISTS

This chapter offers a brief insight into the lives and work of four professional animal and bird artists who painted some of the demonstrations in the later sections of this book. Their backgrounds are very· different and they have come to the subject by a variety of routes. This is reflected in the subjects they choose, the materials they use and their methods of working. An animal painting is not an alternative to a photograph — the artist does not merely produce a representation of an animal, but also tells us about the animal and his or her response to it. Some artists are inspired by the sheer beauty of animals and the almost infinite variety of their forms, others marvel at the way animals and birds have adapted to their sometimes harsh environments, and at the fine-tuning of their ecosystems. We all approach a new subject with diffidence, unsure of our ability to cope with new challenge. Perhaps this glimpse into the minds and working methods of the professionals will lessen any anxiety you may feel and inspire you to get out there and paint. There is no short cut to success but, at the same time, there is no one 'right' way but several.

There are many reasons for painting birds and animals and as many ways of approaching the subject as there are wildlife artists. Each artist is fascinated by a particular part of the animal world, *left*.

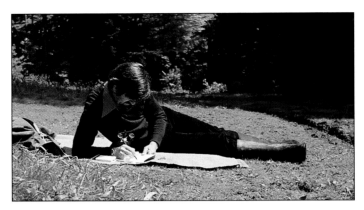

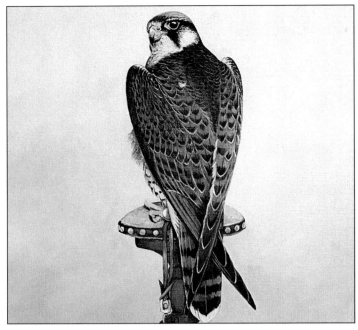

Ken Wood's particular passion is birds of prey and he paints them frequently. The *Lanner Falcon, above,* is a fine example of his work.

KEN WOOD

Ken Wood is an example of a part-time painter turned professional and has also managed to turn a lifelong obsession with birds into a paying proposition. He does not come from an artistic background, but has always been able to draw and even as a child this was combined with a fascination for biology and natural history. He started in a small way, exhibiting locally, but soon the commissions began to build up and in 1971 he was more or less forced to give up his full-time job to devote himself to painting. His paintings are meticulously accurate, painted from his own experience, from studies made in the field and from dead specimens.

Ken's special love is birds of prey, the aristocrats of the bird world — fearless and aloof they acknowledge no master. His technique is almost miniaturist, the paint applied with a tiny sable brush, the fine strokes building up to create a smooth paint surface and the brushmarks accurately capturing the appearance and texture of the feathers.

He spends a lot of time observing birds in the field, making rapid sketches of birds on the wing and at rest, and more detailed studies of landscape and background, of feathers and other matter found lying around, of insects and plant life. His sketchbooks are full of fascinating information, sketches and sometimes extensive notes about what he has observed, the conditions at the time and ideas for paintings. These sketchbook notes, together with his knowledge of birds and an excellent memory, are the raw material for his paintings. Back in the studio this information is sifted and organized. He produces two main kinds of work: large paintings of birds set within a characteristic landscape, usually in acrylic, and smaller, more detailed studies of single birds, usually in gouache. Ken paints in a generous spirit, eager to convey to the viewers some of the pleasure he gets from seeing a particular bird, rare or common. But his concern is not just with ornithological accuracy but also with atmosphere and the special sense of place. He often uses photographs for reference for backgrounds, but never for the birds themselves. When painting portraits of birds he always tackles the head and eye first, because if those are correct the painting will be a success, but if he is not satisfied he will scrap the painting at this stage and starts again.

Ken is Secretary of the Society of Wildlife Artists and a keen and active member of the Royal Society for the Protection of Birds. He is an expert on birds of prey and a member of the British Falconers Club. His work has been widely exhibited and he has had several successful one-man exhibitions. A great deal of his work has been published in books and award-winning calendars. Ken's interest takes him to many places to watch and paint birds, including Britain, Germany, Austria, Borneo and Crete.

RICHARD TRATT

The visitor to Richard Tratt's studio is in for a real treat, because this talented young artist has three distinct artistic personalities. In one persona he is the creator of exquisite, meticulously observed paintings of butterflies. In another he paints lush and evocative landscapes. In the third he produces abstract works which have been described as 'impossible sculptures' — large, convincingly concrete objects with beautifully encrusted surfaces.

Richard Tratt moved to the country as quite a young child and it was there that he developed the consuming interest in natural history and the countryside which permeates his work. He started observing, collecting and studying butterflies with a committed enthusiasm which he has carried into adult life. His delight in the subject is obvious to anyone who spends time with him, but is most apparent in his life-size studies, with their brilliant jewellike colors. He began to paint in his teens and went on to study art at various colleges. He found that he needed to produce a body of work before he could get shows and attract the interest of the public. He financed his art by working in the computer industry, doing work which paid well, was fairly congenial but above all allowed him to work flexible hours — for three days of the week he was a computer programmer and for the other four he was an artist. In 1979 he took the plunge and began to paint full-time, a decision which he has never regretted.

Richard has had one major setback in his career — a few years ago he developed an allergy to one of the constituents of oil paint. This forced him to experiment with acrylic paint, and he applied himself to the task of getting to know the medium with characteristic thoroughness and imagination. He is now entirely committed to acrylics, exploiting its rapid drying times to produce contrasting areas of thin translucent paint with areas of deeply saturated color. He uses many of the acrylic mediums, to moderate the behavior of the paint so that he can achieve the results he desires.

The butterfly paintings are created in the studio, using field sketches, notes and his knowledge of the subject. His sketchbooks are full of rapidly drawn pencil sketches which capture the attitudes rather than the details of markings. He also makes careful drawings and jottings about backgrounds, vegetation and so on, because each species of butterfly has a characteristic habitat and feeds on a narrow range of plants. Richard is a stickler for details, and will check to insure that all the plants depicted in a particular painting would indeed be seen in the same place and at the same time of year. The next stage is a detailed pencil drawing in which he resolves the composition, and the image is then transferred to canvas. His working methods are illustrated in the demonstration on p 111.

Richard has had several one-man shows and his work is regularly exhibited. He was elected a member of the Society of Wildlife Artists in 1981.

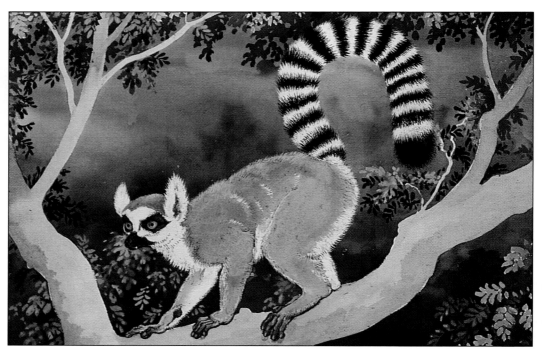

Sally Michel works in a variety of media including pastel and watercolor. The *Ring-tailed Lemur, right*, is a watercolor.

SALLY MICHEL

As a young student of illustration wood engraving and typography, Sally Michel could never have predicted the directions her career would take. When she graduated she took a job in an art studio. Her work was extremely varied and her job description could probably be encompassed by the term graphic artist/illustrator. The studio taught her a great deal, particularly the value of time and scheduling, the importance of using a particular technique for particular purposes and, like so many artists in the 'commercial' area, she was exposed to far more materials, techniques and equipment than her 'fine art' colleagues were. In her studio days she tackled a variety of work, from producing drawings for hot metal dies to showcard design and typography. She also worked freelance illustrating children's books, particularly for the educational market. This is demanding work, because the artist is required to work to a tight brief. Text and illustration are mutually interdependent and the illustrator must liaise with author, editor and designer who will have very clear ideas what they want, though they may not always be in agreement or be able to communicate them to the illustrator. This sort of work demands a lot of research and the artist may have to provide several roughs before agreement is reached to go ahead. A further limitation is imposed by the requirements of the printing processes.

When Sally took up exhibiting paintings in the 1970s her career took a new direction when her income from bookwork decreased and she was, instead, making her living from easel painting and commissioned drawings. She paints landscapes and is known for her architectural drawings of country houses. She works to commission but also sells at exhibitions locally and in London.

Her emergence as a wildlife painter was unplanned, it just happened — her first paintings were of toads! She was elected a member of the Society of Wildlife Artists in 1979. Most of her studies of animals are in watercolor and pastel and she has a reputation as a painter of portraits of cats and dogs. She always works from life, though she sometimes takes a polaroid as a record of a particular pose. She draws and sketches constantly, and her sketchbook is a very full record of life in the countryside around her. Her farming friends know her interests and telephone to offer the carcasses of dead lambs, squirrels, weasels and birds, for which she is always grateful, because it gives her the opportunity to study the subject closely — she produces fine, carefully observed drawings of these subjects. Sally has written and illustrated several beautiful and informative books on drawing and painting animals and pets.

Maurice Wilson has a profound knowledge of animal anatomy and his feel for the subject permeates all his work *right*.

MAURICE WILSON

The respected animal artist Maurice Wilson painted and drew as a child and always had a particular interest in natural history and nautical subjects, interests which he has carried into adult life. There was no obvious way of making a living from art when he left college so he took a job in the timber trade, first in a timber yard and then in a converting mill. An accident put him into the hospital for six months and Plaster of Paris for two years. After this inauspicious start he took a part-time teaching job. This was followed by a spell at a college of needlework, where he taught plant drawing and heraldry. He left after several years and made a good living producing work for reproduction, for cards, calendars and books.

He studied and taught anatomy, extending his knowledge by doing a few dissections at hospitals, but maintains that the best way to become familiar with human anatomy is by studying a good anatomy book, prodding and feeling our own muscles, looking for the muscle endings on a skeleton and studying the movements of our limbs. His extensive knowledge of anatomy got him work with a natural history museum making reconstructions of fossils — work which requires both knowledge of the subject and imagination. He was a founder member of the Society of Wildlife Artists but despite his reputation in that area he thinks of himself primarily as an artist rather than as an 'animal artist'. He is a good portrait painter with the ability to capture a likeness, and in his mind does not distinguish between his animal paintings and any others — his approach to painting an animal is just the same as when painting a portrait.

He has studied animals for years and has a large collection of drawings, sketches and photographs. When commissioned to paint a particular subject he will try to find a live subject to work from and refers to his references only to augment what he sees. He might use skins for details. The many natural history programs on television are a rich source of material, but Maurice bitterly resents the amount of time the film makers devote to pictures of naturalists looking significantly through fieldglasses and clutching at handfuls of air, time that could more profitably be devoted to the subject!

At the moment Maurice is working on a series of large mural paintings for a new museum. The largest panel, depicting a primeval lake scene, is 45ft×7ft. The panels are outdoor quality plywood painted with oils.

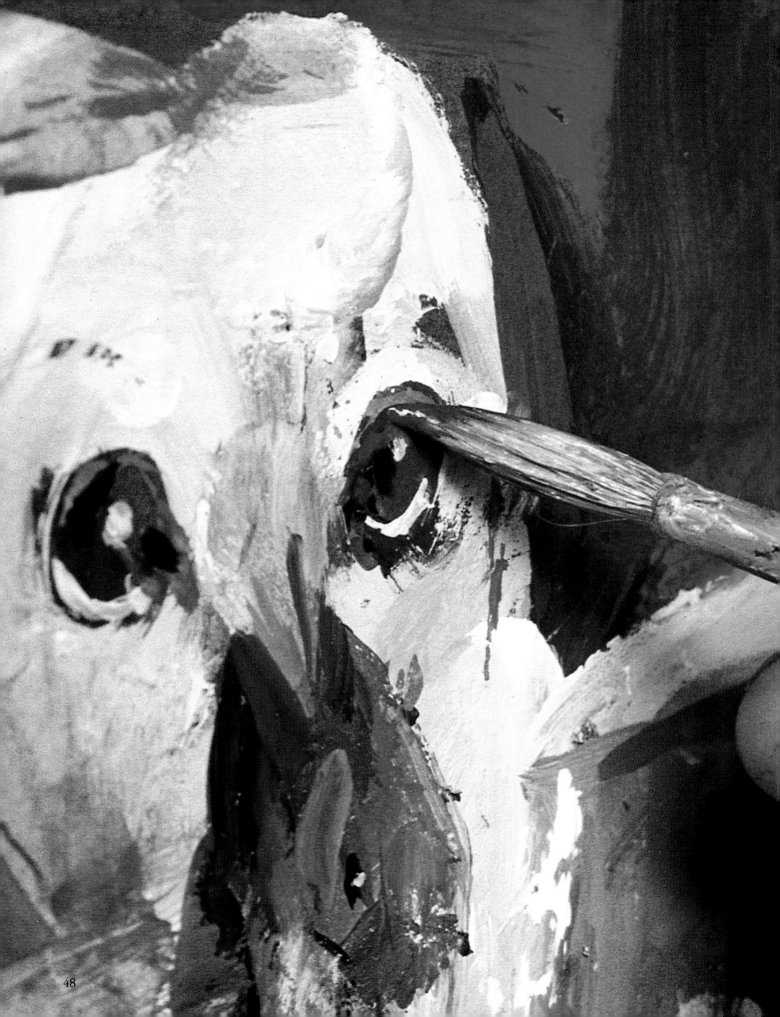

48

CHAPTER SEVEN

OIL

For the past five hundred years oil paint has been the favorite painting medium of most artists, and for very good reasons. It is a flexible medium capable of an incredible range of effects — the limitations lying in the artist rather than in the medium. With oil you can build up layer upon layer of thin, transparent glazes, creating subtle but richly suffused color which glows with an inner light. The paint can be diluted with a thinner such as turpentine and applied thinly but opaquely, each layer being allowed to dry before the next is scumbled on. Oil paint can also be used straight from the tube, its buttery consistency being exploited to build up thick, rich impastos in which the paint surface becomes a very important part of the finished image. The brush can then be used to create descriptive marks which build up texture and follow form. The artist can use a layered technique or work 'alla prima', laying on the paint directly and completing the painting in one session. One of the medium's few disadvantages is the time it takes to dry — many wildlife artists find this irksome and prefer acrylic paint.

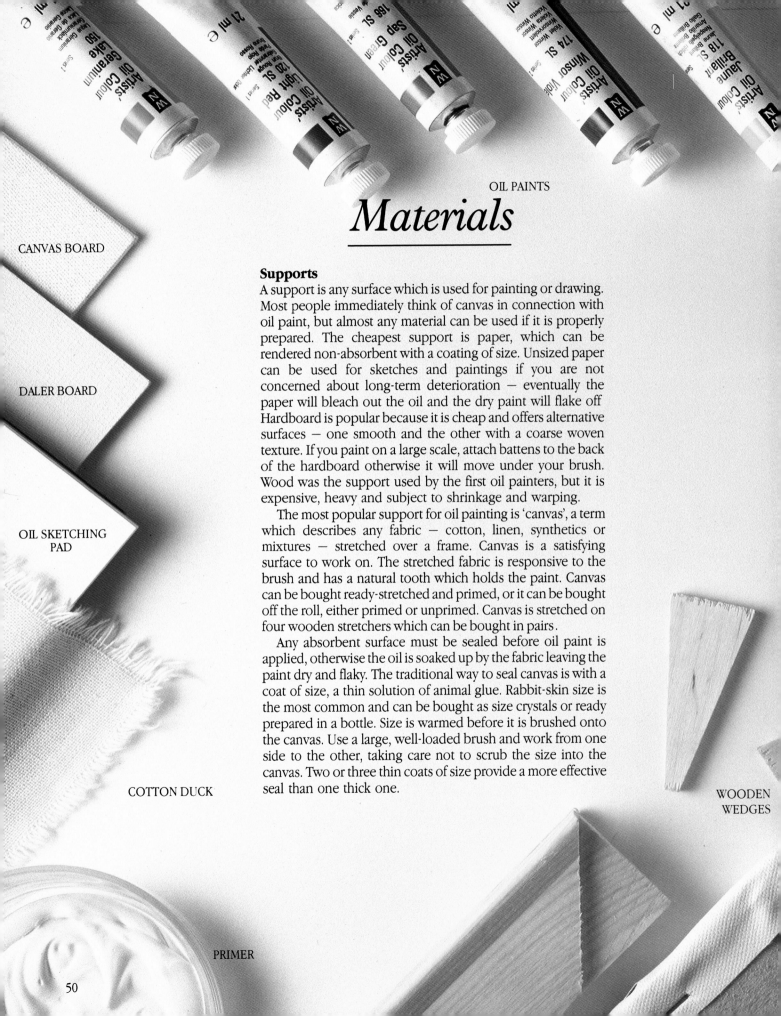

CANVAS BOARD

DALER BOARD

OIL SKETCHING
PAD

COTTON DUCK

PRIMER

Materials

Supports

A support is any surface which is used for painting or drawing. Most people immediately think of canvas in connection with oil paint, but almost any material can be used if it is properly prepared. The cheapest support is paper, which can be rendered non-absorbent with a coating of size. Unsized paper can be used for sketches and paintings if you are not concerned about long-term deterioration — eventually the paper will bleach out the oil and the dry paint will flake off. Hardboard is popular because it is cheap and offers alternative surfaces — one smooth and the other with a coarse woven texture. If you paint on a large scale, attach battens to the back of the hardboard otherwise it will move under your brush. Wood was the support used by the first oil painters, but it is expensive, heavy and subject to shrinkage and warping.

The most popular support for oil painting is 'canvas', a term which describes any fabric — cotton, linen, synthetics or mixtures — stretched over a frame. Canvas is a satisfying surface to work on. The stretched fabric is responsive to the brush and has a natural tooth which holds the paint. Canvas can be bought ready-stretched and primed, or it can be bought off the roll, either primed or unprimed. Canvas is stretched on four wooden stretchers which can be bought in pairs.

Any absorbent surface must be sealed before oil paint is applied, otherwise the oil is soaked up by the fabric leaving the paint dry and flaky. The traditional way to seal canvas is with a coat of size, a thin solution of animal glue. Rabbit-skin size is the most common and can be bought as size crystals or ready prepared in a bottle. Size is warmed before it is brushed onto the canvas. Use a large, well-loaded brush and work from one side to the other, taking care not to scrub the size into the canvas. Two or three thin coats of size provide a more effective seal than one thick one.

WOODEN
WEDGES

HARDBOARD
(SMOOTH SIDE)

HARDBOARD
(ROUGH SIDE)

PLYWOOD

TURPENTINE

A sized surface is smooth and shiny, and has no tooth. A white ground is usually applied over the size, forming a layer between the size and the paint, providing a pleasant surface to paint on and protecting the support. There are many different kinds of ground and most artists have their favorite. The cheapest is white undercoat paint available from decorator's stores. An even simpler method of preparing a support is to apply an acrylic primer directly onto the support without a preliminary application of size. Acrylic primer can be used as a ground for both acrylic and oil paintings.

You can also buy ready-made supports of various kinds. The cheapest is oil sketching paper, which is specially textured and primed for use with oil paint. Its advantages are that it is light, cheap and sold in pads which are convenient to carry.

A cheap but pleasant support can be produced by attaching scrim or muslin to a board such as hardboard. The muslin is cut to the required dimensions, allowing a 1¼in overlap all around. The fabric is laid over the board and warm size is brushed over it. This is allowed to dry and a second coat is applied if necessary. The size acts as both a glue and a seal.

Paints

Oil paint consists of pigment which is dispersed into a binder such as linseed oil or safflower oil. The oils dry by oxidation forming a plastic coat in which the pigments are held in suspension. Oil paint is sold in tubes and is available in two qualities. Artists' is the most expensive because it has the best quality pigments and the highest proportion of pigment to extender. Students' paints are cheaper because they contain lower-quality pigments but for most purposes they are quite adequate. You may occasionally have to buy artists' color, because certain colors are available in that range only.

Binders and mediums

Drying oils are fatty oils usually of vegetable origin which dry to form a solid transparent film when exposed to air. They dry by oxidation which changes their molecular structure. It is this characteristic which makes them suitable for binding pigments in oil paint. A binder is, as the name implies, a substance which

MINERAL
SPIRIT

LINSEED OIL

HT STRETCHED
AS

WOODEN
STRETCHER

SYNTHETIC RESIN MEDIUM
(WIN GEL)

51

PAINTING KNIFE NO. 4

PAINTING KNIFE NO. 11

PALETTE KNIFE NO. 1

PAINTING KNIFE NO. 6

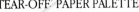

'TEAR-OFF' PAPER PALETTE

NO. 3 ROUND

DIPPERS

binds together. Drying oils are also used as paint mediums, that is, substances which are mixed with paint from the tube to change their character and consistency, and are used for glazing and varnishing. The traditional drying oils are linseed and poppy oil.

Linseed oil is the most widely used of the binders and mediums. The best linseed for painting is cold pressed linseed. Refined linseed oil is slow-drying but increases the gloss and transparency of the paint. Sun-bleached linseed oil is a paler, faster-drying oil, suitable for use with pale colors and whites. Poppy oil is slow-drying, but produces a pleasing buttery consistency which holds the marks of the brush and is especially suited for impasto and 'alla prima' work.

Diluents

Solvents are used to dilute tube color and to clean palettes and hands. Paint straight from the tube is mixed with a diluent to create a fluid mixture which can be applied freely and loosely to the picture surface. The diluent does not play any part in binding the pigments, but evaporates completely as the paint layer dries. Turpentine, the most popular solvent, is made from the resin of pine trees. There are many kinds, the best quality being distilled turpentine. Mineral spirit or turpentine substitute, a slightly weaker solvent than turpentine, does not deteriorate with age and dries more quickly than turpentine. It is also much cheaper.

Brushes

It is important to buy brushes of a reasonable quality — if you look after them they will give good service. The oil painter has a large range to choose from. The main fibers are bleached hog hair, red sable and synthetic. Hog hair is the most popular of these for painting in oil — the split ends of the fibers have particularly good paint-holding qualities. Red squirrel fibers are finer, hold less paint and are used for applying thinly diluted paint and for detailed work. Synthetic brushes have been on the market for some time now and while they are cheaper than natural fibers, some people find that their paint-holding capacity is not as good. The kind of brush you decide to use will really depend on the way you paint.

Brushes are available in a variety of shapes and sizes. You will need some rounds — the larger sizes can be used to apply

NO. 4 LONG FLAT

NO. 8 SHORT FLAT

NO. 6 SYNTHETIC FLAT

NO. 8 ROUND SABLE

thin paint to large areas, the small ones for drawing lines and putting in details. Flats are very versatile and can be used to create short dabs of color, and the side or the tip can be used to create thinner lines. Brights are like flats but have shorter bristles, while filberts taper at the end.

The size of a brush is indicated by the number on the handle and is specific to a particular type of brush. Thus a No. 6 sable will not be the same size as a No. 6 hog. Hog hair brushes are available in Nos. 1 to 12, sable brushes start from the extremely small No. 000 and go up to No. 14.

Good brushes are expensive and should be well looked after. Always clean your brushes at the end of each day's work. To clean them, rinse them in turpentine or mineral spirit and wipe dry with a cloth. Do not leave them to soak, or the liquid will work its way into the metal ferrule which holds the hairs, and loosen the ferrule until eventually the hairs fall out. When paint has been removed from the brushes they should be washed in warm water with strong household soap, rinsed carefully in running water, dried and the bristles molded back into shape. Store brushes bristle end up in a jar.

Other materials

Palettes for mixing paint are available in a range of shapes and sizes. Palette knives, made from smooth flexible steel, are used to clean the palette and mix paint, and can also be used to apply paint to the canvas. Painting knives have thin delicate blades with long cranked handles which insure that your fingers are kept clear of the paint surface. You will also need containers for diluents and mediums. Small metal containers called dippers can be clipped onto the side of a palette. You will also need a large jar of turpentine or white spirit for cleaning your brushes. A mahlstick is another useful tool. It is a cane with a chamois tip which supports your painting arm so that you can paint details without leaning on your surface.

This list of materials is by no means exhaustive, but all you need in order to start painting in oils is a support, a few paints, a brush and some mineral spirit or turpentine.

NO. 4 FAN

NO. 11 SYNTHETIC ROUND

WOODEN PALETTE

Teal Flying over Stodmarsh

Teal are small ducks which can be seen flying low and fast over both inland and coastal waters. The head of the male is striking, with its large areas of gingery red and bright green eye patch enclosed by a distinguishing cream line. The artist has chosen to show the birds in typical moorland surroundings, taking off amid rushes and small pools of water. Teal fly up almost vertically and can achieve great speeds very quickly.

'You cannot be an armchair naturalist', says artist Ken Wood and all his paintings have a 'mud on the boots' quality about them. This painting was based on a series of preliminary sketches in which he noted the broad forms of the birds and their relationship to the autumnal landscape. Birds set within a broad landscape present the artist with some difficulties. Collecting your materials is not easy, because birds are small and shy, and do not stay still for very long. At this time of the year the daylight hours are short and it is far too cold to spend long hours outdoors, making painting from the subject impractical. Sketches and photographs are the only way of getting information which can be worked up into paintings in the studio. Ken Wood uses photographs as reference — but only for the landscape. The birds are always sketched from life — either in the field, or from captive birds — or from dead specimens — he has quite an extensive collection of skins, feathers and stuffed birds.

A small sketch of the landscape, a large sketch of a group of teal and a sketch of the wing of a bird for greater detail and for color reference were the basis for this painting. He also used two stems of marsh grass.

The artist starts with a sketchy underdrawing which indicates the broad areas of the painting, the details evolving as the painting progresses. At first he uses a large bristle brush, applying the paint loosely to create textures which reflect the feel of the subject — smooth, unmodulated brushstrokes for the sky, and brisker, more textured marks for the vegetation in the middle ground. He continues to develop the background areas, heightening the degree of detail as he moves toward the foreground, using increasingly smaller brushstrokes. In this way he emphasizes the foreground areas, creating a sense of space which contrasts with the more impressionistically rendered background.

The painting successfully combines a landscape study with an accurately observed painting of birds in flight and the artist recreates his enjoyment of an actual experience, inviting the viewer to share it.

1 This small gouache sketch was made in the field. In it the artist records details of a typical teal habitat. The notes provide additional information.

DRY BRUSH

In these details the artist uses dry, undiluted paint to create the reeds in the middle distance. With the tip of a very fine brush he dashes in the flowering heads of the reeds, smearing the paint in some areas to suggest movement. Notice the way the paint is picked up by the tooth of the canvas to create an area of broken color.

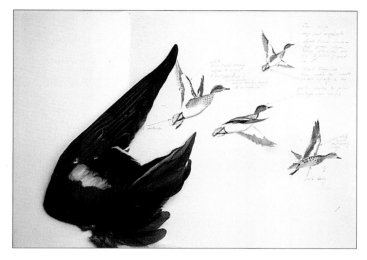

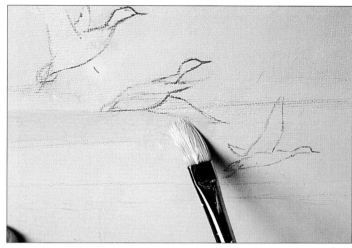

2 The painting was developed from a series of sketches and other reference material. Here the artist records a group of teal in flight. The wing was used for details of color and markings *above left*.

3 The artist starts with a pencil drawing based on his preliminary sketches. Using a mixture of ultramarine and white and a No. 9 bristle brush he blocks in the sky *above*.

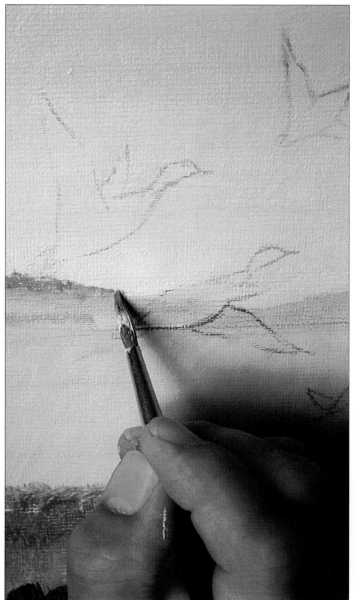

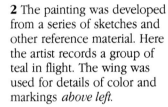

4 He continues to block in the background using a No. 9 bristle brush. The area near the water's edge is laid in with a mixture of raw sienna, burnt umber, oxide of chromium and black. Cadmium yellow mixed with a little white, or with the brown-green mixture is used for the area up to the horizon. Here he uses a No. 6 sable to define the horizon *left*.

5 The artist has used a single brush to achieve a variety of effects and textures *below*. The sky is laid in with thin paint and regular strokes of the brush. He uses coarser directional brushstrokes to describe the vegetation on the water's edge and the pale green middle ground.

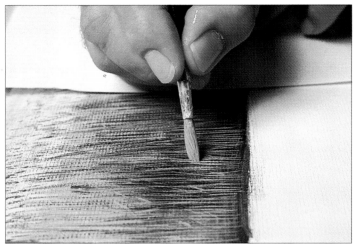

6 The artist mixes a lighter tone of the ocher-green, by adding a little white to the original mixture. With this he adds texture to the middle ground, using the same No. 9 bristle brush *above*.

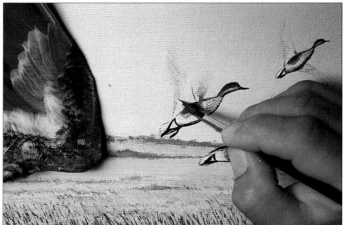

7 Fine details of the stems and the rush heads are put in with quick strokes of a No. 6 sable brush *above*. The lighter colored paint shows against the dark underpainting.

8 Using a No. 000 brush the artist develops the details of the duck's underwing, using the wing as reference *left*.

9 A mixture of black, chromium oxide and burnt umber was used to paint the reflections of the reeds in the water, blending them in with the base of the reeds. He used the point of a brush to create a soft, feathered edge. By using slightly varied tones of the paint he builds up the texture in the foreground *left*.

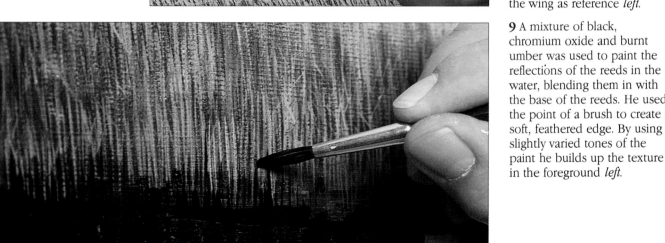

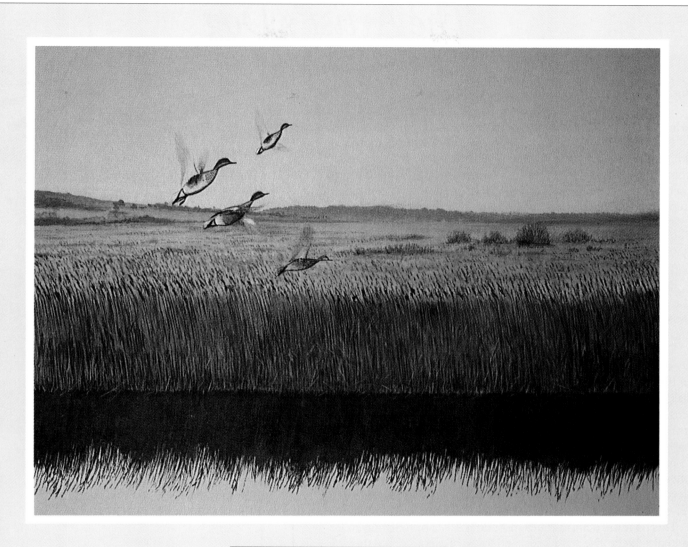

Teal Flying over Stodmarsh

What the artist used

His support was a 16×20in Daler board. The underdrawing was made with a B pencil and he used a No. 9 hog bristle brush and three sables — Nos. 00, 000 and 6. He worked on a flat surface — a Workmate table — and mixed his colors on a wooden palette. He used a limited range of colors — ultramarine, white, raw sienna, burnt umber, oxide of chromium, cadmium yellow and black.

The Artist's Dog

Subjects closest to home are in many ways the easiest to tackle — here the artist uses one of his own dogs as a model. Not only is he familiar with the subject, but he also has a large collection of sketches. The composition is based on a strong diagonal which sweeps into the picture area, with the dog's head centrally positioned. The head, and in particular the eyes with their alert but wary expression, is undoubtedly the most important element of the painting. The dog's decorative markings add a pleasing sense of drama to the composition.

The artist works with thin paint, allowing each stage to dry before progressing to the next. He paints into the background with a large brush and thin paint working up to and around the contours of the dog, the background color helping to define the form. He selects progressively smaller brushes, so that by the end of the painting he is laying in details such as the eyes and hairs with a No. 0 sable.

The artist works methodically over the entire painting, using short strokes to represent the hair of the animal. The direction of the brushmarks follows the direction of the growth of the hair, as can be seen in the area around the jowls and on the ears. The edges of the animal's markings have been softened, using thicker, sweeping strokes to describe the hair in rougher parts of the coat.

Faced with a fairly detailed painting such as this, beginners often lose heart, convinced that they could never achieve that degree of finish and realism. However, all that is required is observation and hard work.

This painting demonstrates just one way of approaching an animal subject. The artist knew and loved his subject, and this, together with his knowledge of anatomy, allowed him to work freely, thinking of the composition rather than the problems involved in depicting a living animal. The way the animal has been placed within the picture frame gives the painting an internal energy which suggests a living animal.

1 The artist used his own pet as a model *right* — the subjects closest to home are often the easiest to begin with.

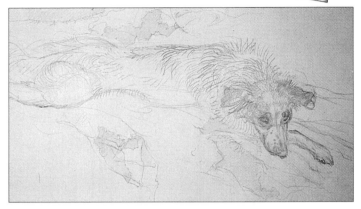

2 The sketches, *right*, were made at different times over a period of years. The artist referred to these as he developed this composition — as you can see the pose is based on the first of these sketches. The dog was in the studio so the artist was able to refer to the subject for details of color, texture and markings.

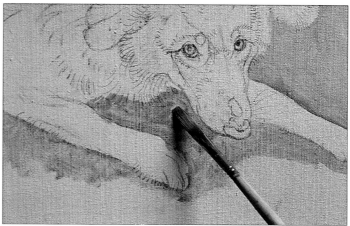

PENCIL UNDERDRAWING

There are many media which can be used for an underdrawing. Here the artist has used pencil — pencil is not restricted to use on paper. He chose a fairly hard pencil because he is going to use thin paint which might be discolored by a softer lead. Don't exert too much pressure when drawing with pencil, because canvas can be easily damaged.

3 The artist makes a fairly detailed drawing of the subject directly onto the canvas *above left*. He uses a hard 3H, pencil.

5 The head is laid in with a dilute mixture of cadmium yellow, cadmium red, white and black *below*. The nose is painted with black thinned with turpentine.

4 Using a mixture of viridian, cadmium yellow, cadmium red and flake white thinly diluted with turpentine, the artist applies color in the grassy area *above*. He applies the paint thinly so that he can paint over it, and keeps the edges soft at this stage. Thin paint dries quickly and it is easier to harden the edges later, if necessary, than to soften them.

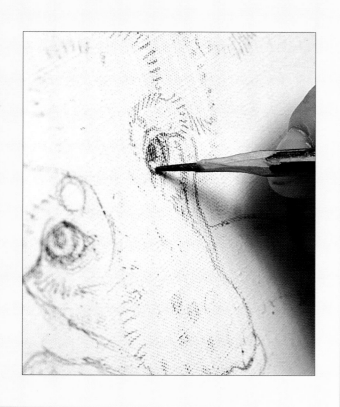

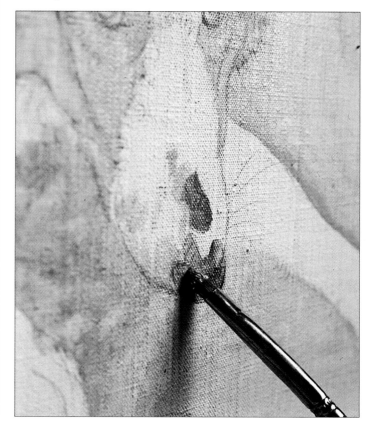

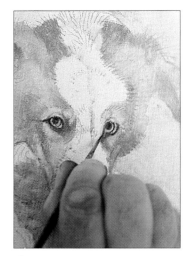

6 The artist allows the first paint layers to dry and then works over them using the same colors as before, building up depth and intensity. The paint is used thinly, partly from personal preference and also because it allows the artist to achieve a soft, realistic finish. He uses a fine, No. 0 sable brush to paint the eyes *above*.

7 Once the main areas of the face are worked up the artist goes over it with a fine brush putting in hairs to add texture and realism. Here he adds smudgy color to the lighter parts of the coat, using a pale tint of the main mixture *right*.

8 The artist's technique is slow and methodical. The painting develops as a series of thin layers of color. The initial blocking-in looks flat and uninteresting, but as the painting progresses the artist lays in highlights and details, usually working from the darkest tones to the lightest *right*.

9 In this detail, *far right*, the artist is putting in hairs with a No. 0 sable brush.

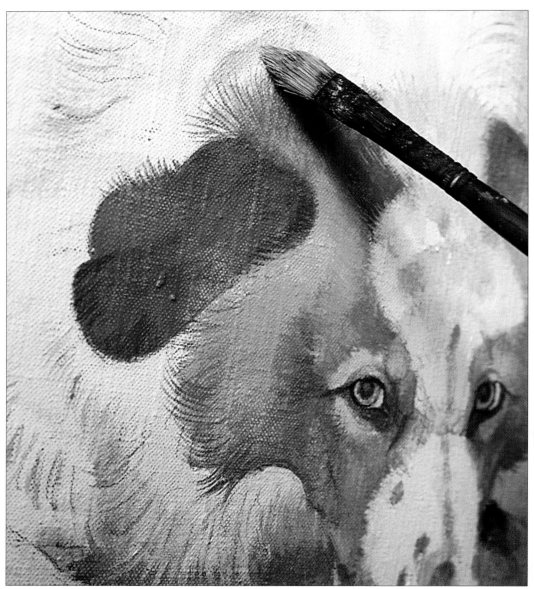

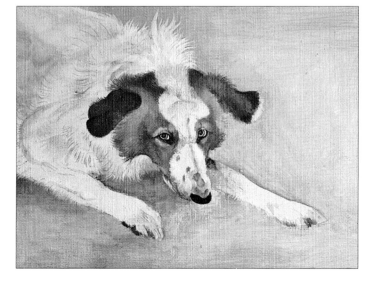

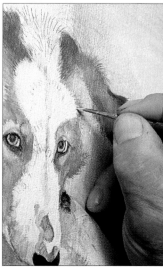

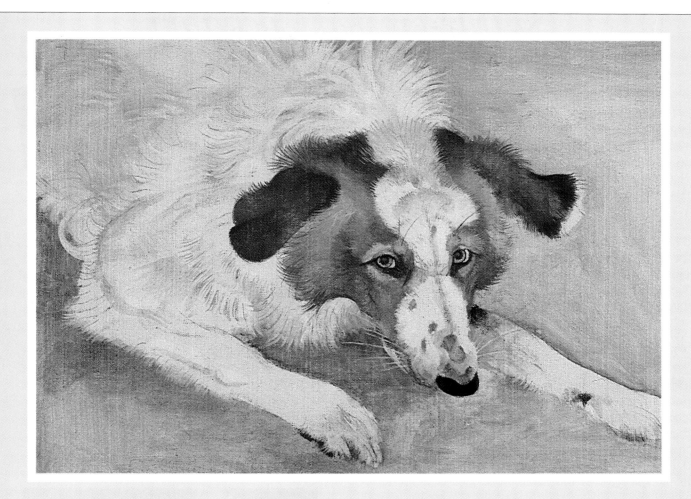

The Artist's Dog

What the artist used

The support was a 12×16in Daler Rowney Quality Kent stretched canvas, which has a fine grain with a slight tooth and is double oil primed. He used a 3H pencil for the underdrawing and his brushes were a No. 6 flat bristle brush, a worn No. 3 round, a No. 3 long filbert, with a No. 0 sable for the finest details. The paints were Rowney Artists' oil color in the following colors – viridian, cadmium yellow, cadmium red, flake white, black and alizarin crimson.

Sulfur-crested Cockatoo

This cockatoo is a striking bird which inhabits the forests of New Guinea. Noisy and gregarious, these birds are often found in large flocks, the bright yellow of their crests contrasting with the stark white of their plumage. They are fairly large, measuring 18 inches in length.

Here the artist has depicted a single captive specimen. The bird is shown on its perch and is placed in the very center of the canvas from which it looks out with one wary eye. Its body creates an oval diagonal which contradicts the strict vertical and horizontal lines of its perch and the repeated horizontals of the background. The dark green of the background acts as a foil for the brilliant yellow of the crest and the white plumage.

Where a painting focuses on a single subject, the space within the painting is relatively unimportant, but the artist nevertheless implies it with a number of devices. The bars of the perch cut the frame of the picture at top and bottom, simply and effectively establishing its position at the front of the picture space. Notice also the way in which the perch is rendered with meticulous attention to detail, so that the top and side surfaces are clearly defined, and the light which catches the edge of the metal bar is depicted by a thin line of lighter gray. Look also at the water can, which the artist has also represented very realistically, showing the tonal modulations and the mottled gray of the dull metal. These details contrast with the background blue of mottled greens — the effect achieved by a camera when it focuses sharply on a small subject and throws the background out of focus.

A white subject can be difficult. Here the artist uses various grays for the body, with a halo of pure white to show where the light catches the edges of the form. Pure white paint is also used for broad planes of light which describe the head — these bright highlights bring the bird to life, giving it form, adding sparkle and making the feathers stand out realistically.

The artist reworked the painting at various stages, first allowing the paint to dry. For example, he scrubbed thin, washy paint over the feathers on the breast because he felt these details were becoming too fussy. He wanted to create a stronger, simpler image without contrasts. By restricting detail to the face he sought to focus attention on that area. He also painted out the chain because it, too, detracted from the simplicity of the image. The final painting is simple and effective and captures the bright alertness of the subject.

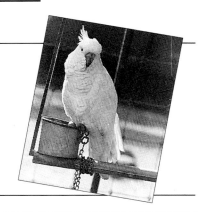

1 The artist used a series of photographs from a natural history book for reference *right*. Try, if possible, to use more than one reference.

PENCIL OVER OIL PAINT

In this detail the artist is using a soft B pencil to recreate the shading in the breast feathers. The feathers had been painted in at an earlier stage, but were lost during the painting. There are many approaches to painting, and mixing media in this way is quite acceptable. If you are pleased with the result, it doesn't matter what technique you use.

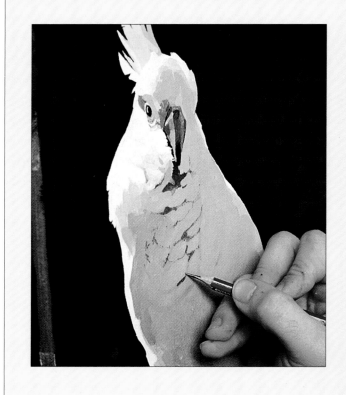

2 The artist draws onto the support with a B pencil. He then lays in the background with a mixture of Hooker's green, raw umber and ivory black *below*. Cadmium green toned down with the same mixture is used for the lower background. The brush is a No. 6 flat.

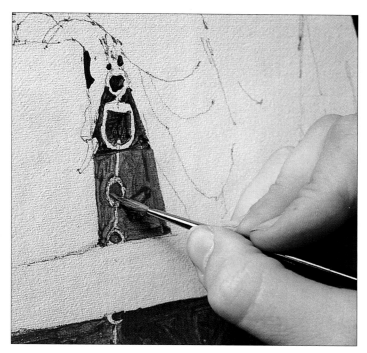

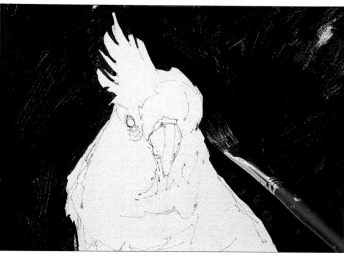

3 Using a No. 2 Kolinsky sable the artist paints in the fine details around the chain *above*. The paint is thinly diluted with turpentine.

4 The entire background is laid in to define the edges of the subject *left*. The dark surroundings make the white bird stand out clearly.

5 The shadows in the plumage are defined in Payne's gray, raw umber and titanium white. The artist uses a fine sable brush for these details *below*.

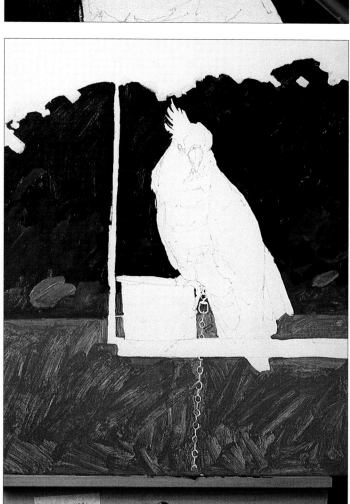

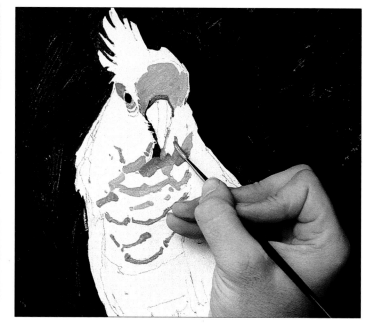

63

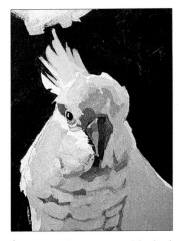

6 The middle tones are blocked in with the same mixture as before — Payne's gray, raw umber and titanium white — to which the artist adds cadmium yellow. The color is scrubbed in briskly but thinly using a No. 4 round. The crest is painted in cadmium yellow with a No. 2 Kolinsky *above*.

7 Using highly diluted paint the artist scrubs over the surface of the trees to create texture and to darken this area to provide more contrast with the bird *left*.

8 With a well-loaded brush the artist presses the brush into the vertical support, allowing the paint to run down the picture surface, creating vertical lines which indicate trees. He uses a rag to catch the dribbles at the bottom of the dark areas *below left*.

9 Diluted paint is splattered onto the tin on the bird's perch *below*, creating an interesting texture.

Sulfur-crested Cockatoo

What the artist used

The support was a Rowney canvas panel 24×18 inches, which is primed for both oil and acrylic paint. It has a medium-textured surface which holds the paint. The underdrawing was made with a B pencil and the artist used a selection of brushes — a No. 6 flat nylon, a No. 3 flat hog, a No. 2 Kolinsky sable and a No. 4 round, mixed hair. His paints were Artists' quality in the following colors — Payne's gray, raw umber, titanium white, cadmium yellow, Hooker's green, cadmium green, and ivory black.

Barn Owl in Flight

The barn owl, a native of most areas of western Europe, was once a familiar inhabitant of farmland which provided open areas for hunting, and hedgerows and outbuildings for roosting and breeding. Changes in farming practices have resulted in a decline in the population of barn owls, but if you are lucky, you may still catch a glimpse of its ghostly white form, swooping silently by at dusk. It has a characteristically large white head, medium length wings and a short, square tail.

The artist wanted to capture the spectral appearance of the bird returning to its roost, a fieldmouse clasped firmly in its strong feet. He was inspired by a series of photographs, which he used only as a point of departure. The painting gradually developed a life of its own, with each stage suggesting the next. The final image had only the loosest association with the original photographs. The artist was already familiar with the subject in this case, but if you are not, working from photographs may be the only course open to you. You can use them in two ways. You can copy from a photograph so as to learn in a detailed way about the bird and its appearance. This is only useful when combined with studies from life made in the field, in museums or in zoos. Or, if you are merely at a loss for something to paint, you can take a photograph such as this and use it to trigger inspiration, looking at the shapes, colors and forms as abstract elements, with which you can play around. Study this sequence of pictures and you will see that the picture continually changes as the artist experiments with different elements of the image.

1 The artist developed this image from several sources — personal experience, previous studies and images gleaned from natural history books, *right*, and television programs.

2 Working directly onto the dark ground the artist sketches in the broad outlines of the subject, using diluted white paint and a No. 9 flat bristle brush *left*.

3 A 1-inch decorator's brush is used to block in the dark tones under the wings and body *above*. The tip of the handle is used to draw the lower line of the wings and mark the center line of the face and the beak.

USING OIL ON PAPER

Paper is the cheapest support for oil painting. It is pleasant to use and artists from Rubens to Cézanne have painted in oil on paper. The heavier the paper the better. If it has not been sized, you should avoid adding more oil to your paint because it will be leached out, leaving the dry and flaky pigment on the surface. Here the artist wanted to develop an idea quickly and used the tinted paper to give him a good base color which more or less matched the color of the night sky.

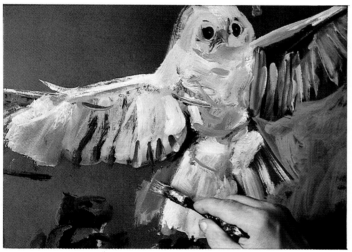

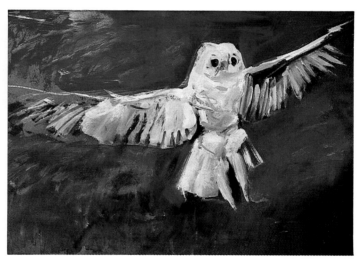

4 Using a ½-inch decorator's brush the artist strengthens the body by scrubbing it over with white paint mixed with black and contaminated with colors already on the palette. These accidental touches of color add interest to the painting. The breast is darkened with a mixture of gray and cadmium red. The artist then starts to block in the background, *above*, with cadmium red, ultramarine and Payne's gray, the colors being mixed on the palette.

5 A mixture of Venetian red, cadmium yellow and ivory black is scumbled over the original warm background tones, the underpainting shining through and modifying the final paint layer *above right*.

6 The artist uses Venetian red paint and a No. 6 mixed fiber round brush to indicate the small rodent which the bird carries in its beak. The paint is applied wet-into-wet, and the image emerges from the wet, smeary paint *right*.

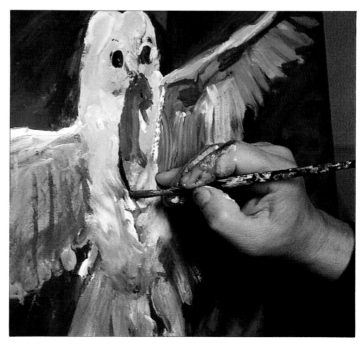

7 The artist continues to work over the entire painting, looking for the light and dark tones, continually adjusting the color and developing the texture. He uses all his brushes to vary the texture, and often resorts to hands and fingers to blend and slur the color *right*. The artist works quickly and freely, creating an exciting paint surface. He manages to convey to the viewer the pleasure he experienced in handling the paint — an important aspect of all painting.

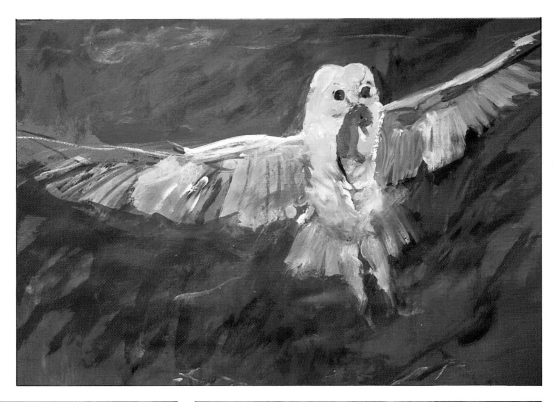

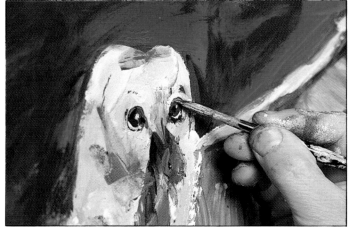

8 Using a No. 6 round brush the artist develops the details of the bird's eye. The paint is still wet, so he needs a deft touch to keep the color fresh *above*. The eyes and beak are important characteristics of a bird, giving it its personality, so it is important to get these features right. Avoid the temptation to fiddle — here the artist treats the face with the same free brushwork as he has used elsewhere.

9 With a large decorator's brush the artist darkens the background area beneath the bird, *above right*. This increases the suggestion of light reflected from below.

10 The detail, *right*, shows the free rendering of the details in the face. The vigorously applied paint, scrubbed and scumbled layer upon layer has a lively, shimmering quality.

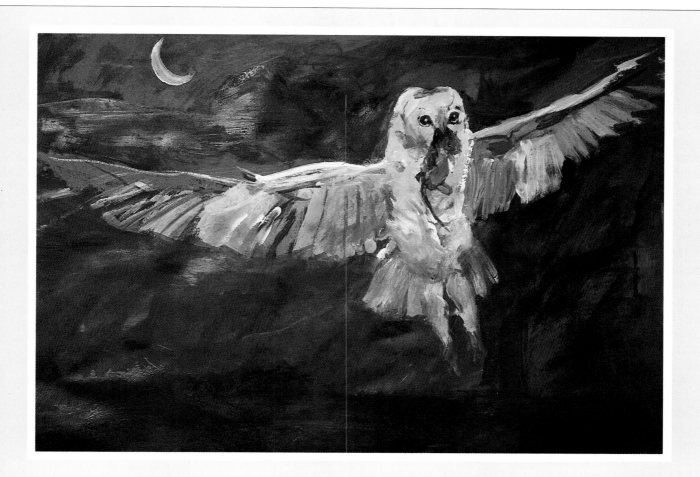

Barn Owl in Flight

What the artist used

For this oil sketch the artist used a sheet of $19\frac{1}{2} \times 27\frac{1}{2}$ inch French blue Ingres paper, a No. 9 flat hog-bristle brush, a No. 6 mixed fiber round brush, and $\frac{1}{2}$in and 1in decorator's brushes. He diluted his colors with distilled turpentine and mixed them on a large wooden palette. His colors were Rowney Artists' white, ivory black, ultramarine, Payne's gray, Venetian red, cadmium yellow and terre verte.

Polar Bear

The polar bear, an inhabitant of the arctic regions, hibernates in a hole in the ground during the winter months. It is a good swimmer and lives on a diet of seal and fish. To survive in these inhospitable conditions, the polar bear has developed powerful muscles for swimming, and a heavy coat to provide insulation against the cold. The artist wanted to capture the emptiness of the landscape which the animal inhabits, and the bulk and power of the bear itself. This white-on-white subject was a challenge, and the pictures demonstrate some of the ways in which the artist has overcome the problems.

He worked from a fairly loose initial drawing developed from a variety of photographs of bears in their natural environment. By using several sources, he avoided some of the problems inherent in working from reference material. He is not tempted simply to copy and is not tied to a given composition, but can develop his own while at the same time creating an image which accurately and convincingly shows the animals in their natural habitat.

Bears are big, solid animals, and their bone structure is hidden deep within layers of flesh, fat and fur. It would be easy to end up with a white, amorphous shape. The artist has avoided this by looking for the masses and the planes of the form — he has seen the animal as a sculptor would when chiseling a likeness in stone.

The composition is simple yet effective, based on sloping lines which criss-cross the painting. The horizon slopes to the left, dropping down to create a shape which surrounds and draws attention to the bear in the foreground. The animal itself is set upon a line which drops across the painting, this line being expressed by the tracks of the animal on the right and by its shadow on the left. Look for the other straight lines which form part of this complex geometry.

The artist works with loose, washy paint, thinly diluted with turpentine. The underpainting acts primarily as a guide for the successive, increasingly detailed layers, until in the final layers the paint is fairly thick.

In the areas where the contour of the animal is seen against the white background, the fur is sometimes darker than the snow and sometimes lighter. For example, where the fur is brightly highlighted, a cool blue is introduced into the white of the snow so that the fur can be seen against it.

1 The artist used several sources for this painting — pictures from natural history books and magazines, and studies made at the zoo *right*.

2 The broad outlines of the composition are sketched in with a soft B pencil. The composition is simple with the focal point, the bear, placed in a commanding position in the lower left of the picture area. The strong diagonals of the snowline, shadows and footprints constantly draw the viewer's eye back to this point. Using a diluted mixture of titanium white, Payne's gray, cobalt blue, yellow ocher and ivory black the artist blocks in the darker tones on the animal's coat *right*.

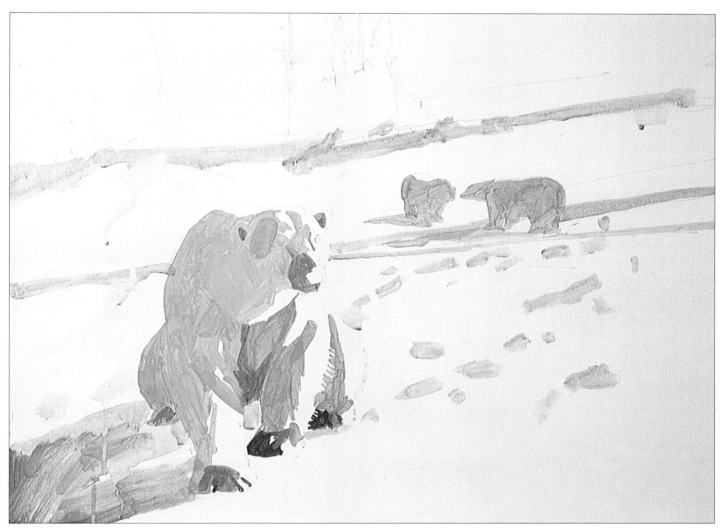

3 Using the same mixture the artist develops the main elements of the picture *above*. At this stage the paint is applied very loosely, because it is intended primarily as a guide for the subsequent paint layers. At this stage the painting is left to dry completely.

4 With a mixture of sap green and ivory black diluted with turpentine, the artist scrubs in the trees on the horizon *right*. The paint is applied thinly and left to dry. The artist will add more of the same mixture at a later stage.

CREATING TEXTURE WITH HESSIAN

In order to create the loose, fluffy texture of the snow beneath the tree line, the artist cut a strip of hessian about 2 to 3 inches wide. He taped this with masking tape along the tree line and then, using thick unmixed paint contaminated with colors picked up from the brush (Payne's gray and yellow ocher), he dabbed and pressed the well-loaded brush onto the hessian, forcing the paint through the pores in the fabric. He lifted the hessian to reveal solid areas of paint in which the texture of the hessian was transferred to the canvas, the broken white paint breaking up the hard edge between snow and trees.

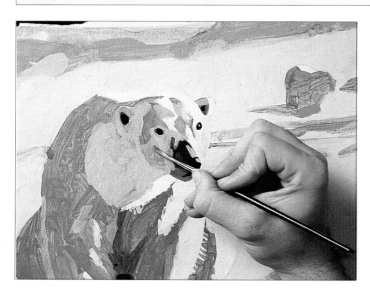

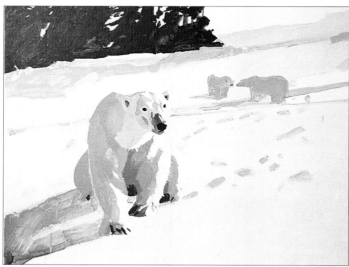

5 Once the main area of the painting has been blocked in, the artist starts to develop the bear in the foreground. Starting with the darkest tones on the underside of the bear he works outward to the highlights at the edges *above*.

6 The white-on-white subject is quite a challenge. As you can see the artist has started by establishing the dark and mid-tones, looking in particular for the transitions. In general, darks are seen against lights and vice versa *above*.

7 A mixture of monestial blue and Payne's gray is used for the sky. The artist starts by picking out the details of the sky seen through the trees with a No. 2 sable brush, using the negative spaces to define the outlines *right*.

8 With a No. 2 sable brush the artist develops the furry texture of the bear's coat. On the right leg he has used a lighter mixture of the same color. On the left leg the white fur on the margins is seen against the darker tones of the back leg *below*.

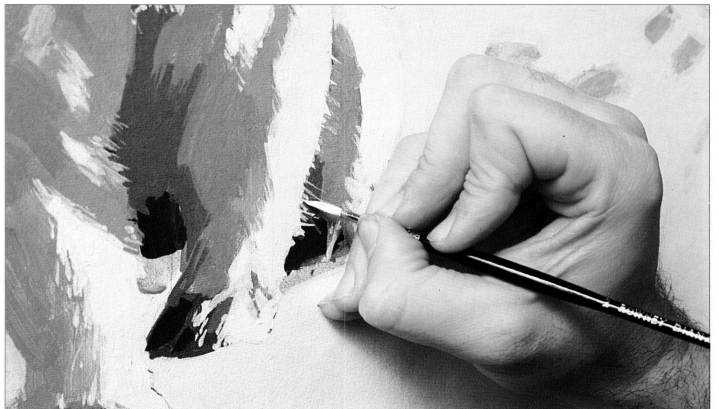

9 He blocks in the broad areas of the sky with a No. 6 brush. Before painting the horizon line the artist lays down torn masking tape allowing him to work freely without creating a hard edge *above*. When he removes the tape it picks up some of the underlying paint, revealing the white support beneath, creating highlights in the snow — an example of the 'happy accident'.

10 The artist softened the tree line using hessian as described in the box on page 72. In some areas too much paint gets through the hessian and the artist lifts and smudges it with a rag *above right*.

11 The artist splatters and flicks a mixture of white and blue over the painting, using a 1-inch decorator's brush *below*. This suggests the fluffiness of snow.

12 In order to maintain the sense of space and recession in the painting the artist uses the same brush to blur the splattered areas on the trees, suggesting distant snow flurries *right*.

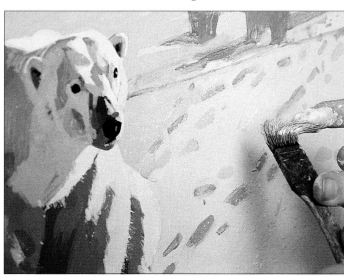

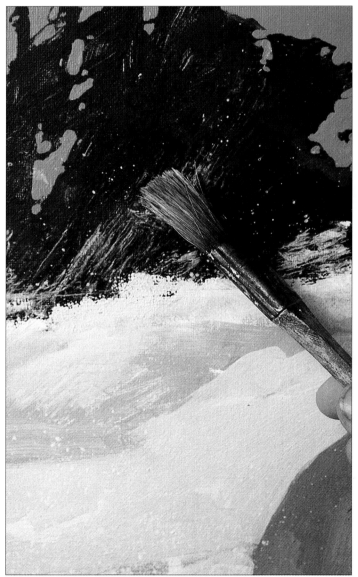

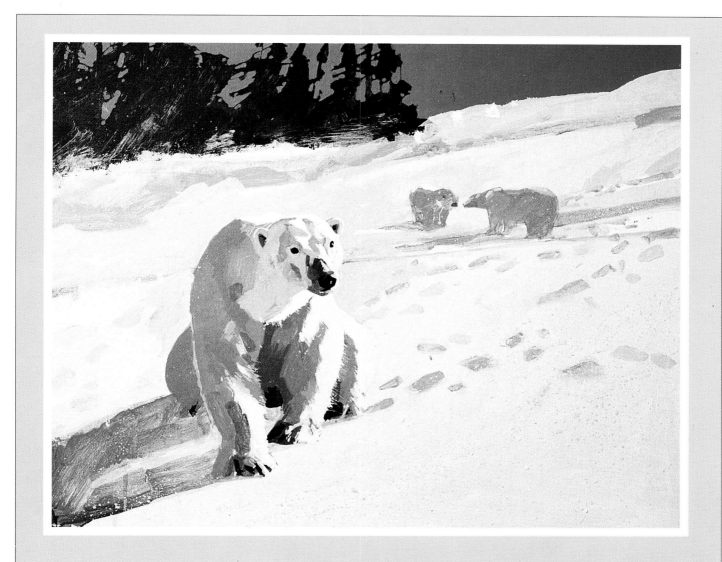

Polar Bear

What the artist used

The support was a Rowney Georgian painting board 20×24in which is suitable for both oil and acrylic. The underdrawing was made with a B pencil, and the brushes were a No. 2 sable, a No. 6 round nylon, a No. 7 flat nylon and a 1-inch decorator's brush. He also used masking tape and coarse hessian. His paints were Rowney Artists' quality in the following colors — cobalt blue, titanium white, Payne's gray, monestial blue, ivory black, sap green, and yellow ocher.

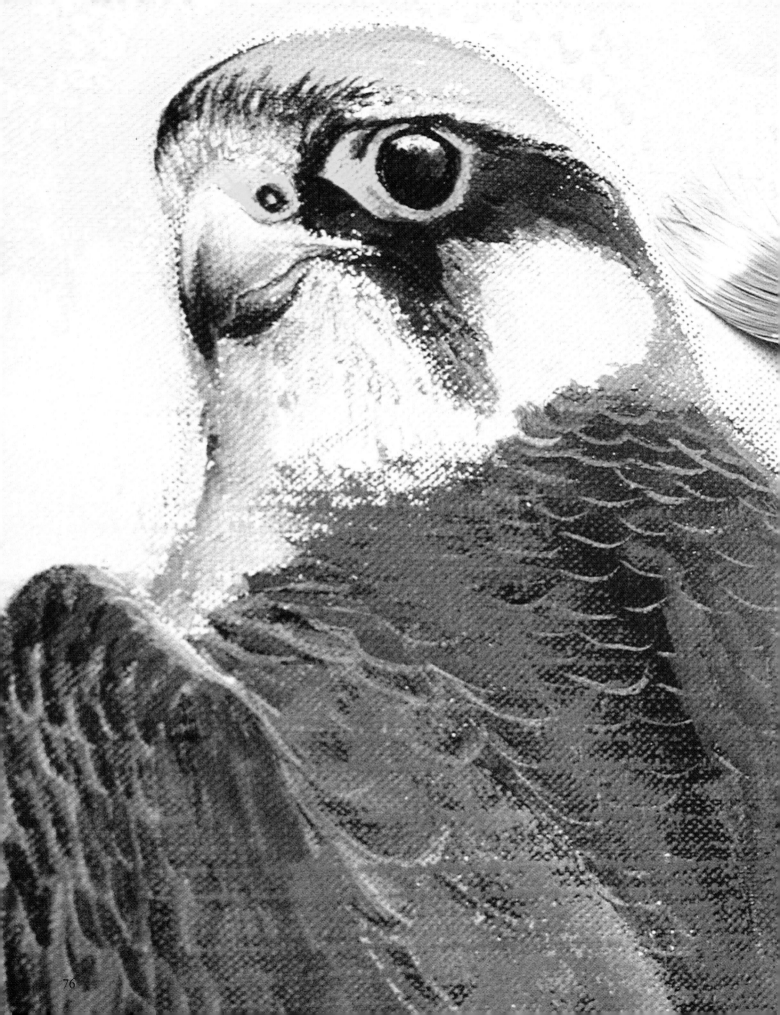

CHAPTER EIGHT

ACRYLIC

Acrylic is a relatively new medium which was first used by a small group of artists in the early part of this century and has only gradually begun to achieve more widespread acceptance. The pigments are generally the same as those used in other painting media, and it is the polymer resins used to bind these pigments which are different. The most outstanding qualities of acrylic paint are the speed with which it dries and the fact that it is water-soluble, making it a particularly flexible and clean medium to use. Acrylics are exceptionally tough, permanent and stable. They do not seem to suffer the yellowing sometimes experienced with oils. As acrylics have only been in use for about seventy years, however, and oils have been around for nearly six hundred, we are not yet in a position to make a final judgement. Acrylic paint is popular with animal artists. The rapid drying time means that artists do not have to struggle home with a wet canvas after a day's work in the field. It is a particularly useful medium for work requiring a tight technique, for rendering feathers and fur for example. Artists who produce illustrations for reproduction find that work in acrylic is permanent and can withstand heavy handling.

MAT VARNISH

GLOSS VARNISH

HARDBOARD:
SMOOTH SIDE

HARDBOARD:
ROUGH SIDE

PLYWOOD

ACRYLIC PRIMER

CRYLA TEXTURE PASTE

ROBESON'S
BRUSHMARK

Materials

Supports

Acrylic paint can be applied to almost any surface with very little preparation. It was first developed as a permanent weatherproof medium for outdoor murals. Acrylic can be used on either primed or unprimed surfaces. Once it is dry, acrylic is completely inert so, unlike with oil paint, it is not necessary to isolate the paint from the support. This means that it can be used for staining techniques — if oil paint is used in this way it will eventually destroy the fabric of the support. If you need a white ground, use an acrylic primer. Remember that while acrylic primer can be used for oil paint, an oil ground cannot be used for acrylic paint. If you want to work on a non-absorbent surface, you can seal it with acrylic medium which makes an excellent transparent primer. Whether you use a primed or unprimed support will depend on the effect you wish to achieve — you would obviously use an unprimed canvas for stained canvas techniques. Acrylic applied to an unprimed surface will dry with a dull mat finish although this can be modified by the addition of one of the many mediums which are available. Acrylic paint can be used on paper, but if you are going to dilute it with a lot of water the paper should be stretched as for watercolor painting.

Paints

There are a great many ranges of acrylic paint on the market. You will discover which brand suits only you by experiment. There are two types of acrylic paint — 'flow' formula, which is useful for covering large areas, and 'standard' formula, which has a buttery consistency more appropriate for stiff, textured impastos. The colors available in the acrylic range are much the same as in the oil range, although you may find they do not look quite the same. Some new colors are available in the acrylic ranges only.

Acrylic paint can be purchased in tubes, small jars or large half-gallon containers. Generally the jars contain flow formula paint, but check the label before you buy them. You must be particularly vigilant about replacing lids on acrylic paint, because it dries within hours and becomes unusable. You could waste a lot of money this way.

Acrylic mediums

There are several mediums which can be mixed with acrylic paint to change the way it behaves. The effects of gloss and mat mediums are self-explanatory. Glaze medium makes acrylic paint more transparent and gel retarder slows the drying process at the same time increasing the transparency. Texture paste is a very flexible medium used for creating texture and building up heavy impastos. The paste can be mixed with color or it can be applied to the surface and paint can then be applied over it. Texture paste has very good adhesive powers and is therefore useful for collage.

QUITEX MODELLING PASTE

MAT MEDIUM

CANVAS BOARDS

LASCAUX THICKENER

LIQUITEX PAINT

PALETTE KNIVES

Brushes and knives

The brushes used for painting in acrylic are the same as those used for oil or watercolor. Hog hair and the stiffer synthetic brushes are used for applying undiluted paint and for building up impastos. Ox and sable brushes and the softer synthetic brushes are used for handling dilute paint, for glazing techniques and for laying in washes. Brushes used for acrylic painting cannot be left lying around — they become dry, hard and completely unusable within hours. If this happens, you can resort to paint stripper, but it will shorten the useful life of the brush. Rinse your brushes in water as you go along, and wash them with soap and water at the end of the day. Don't leave them standing bristle end down in water because the fibers will splay out, destroying the shape of the brush. Leave brushes to dry in a jar, bristle end up.

Palette knives have straight, flexible steel blades. They are used for mixing paint on the palette, scraping paint from the support, cleaning the palette and also for applying paint to the support. Painting knives have cranked handles designed to keep your hand away from the paint surface. They are available in many shapes and sizes, and each can be used to create a different set of marks, ranging from large areas of smeared paint to a variety of linear marks which can be built up into patterns. Painting knives can be used to build up thick

SYNTHETIC FAN-SHAPED
BLENDER NO.4

HOG HAIR FLAT NO.8

HOG HAIR ROUND NO.3

impastos, to create exciting textural effects and to scratch back into the paint. Acrylic paint responds particularly well to the knife, the color retains its crisp edges and the paint can be applied very thickly without risk of cracking.

Other equipment

You will need a palette on which to mix your paint. A palette with a glossy, non-absorbent surface — such as glass, plastic or melamine — is most suitable because it is easy to clean. Disposable paper palettes sold in pads are a good alternative. Acrylic paint may start to dry on the palette before you have finished work, so keep the paint moist by sprinkling water onto the palette. A small water spray is a useful addition to the acrylic painter's armory. If you have to leave a painting for more than an hour, sprinkle the palette with water and cover it with plastic wrap or foil. 'Stay wet' palettes have recently come on the market to counteract this problem. They consist of a plastic tray lined with an absorbent material. A little water is poured into the tray and the absorbent material is then covered with special membrane paper on which you lay out paint and mix colors. These trays will keep acrylic paint moist for weeks and, with luck, for months.

SYNTHETIC BRIGHT NO.6

SYNTHETIC ROUND NO.11

FLOW FORMULA ACRYLIC PAINT

SABLE ROUND NO.8

Chimpanzee

Apes resemble humans in many ways, although their proportions are slightly different — they have longer arms and shorter legs, a characteristic which reflects their arboreal way of life. Humans are rather species-centric and recognizing the similarities between ourselves and the apes, we feel a great deal of affection for them. We find chimpanzees particularly endearing because with their bright, curious eyes and their heavily lined faces they remind us of careworn old men.

This painting was developed from sketches made at the zoo, supplemented by photographic reference in natural history books. If you look at the drawing in the artist's sketchbook, you will see that he had originally intended to include two animals in the composition, but decided that the painting would have more impact if it was simplified.

The chimpanzee is portrayed in a three-quarters view. The artist has used a landscape format, rather than a portrait shape which might seem more obvious given the shape of the subject. The way the subject is placed within the rectangle of the support creates a series of simple spaces and shapes which are an important feature of the composition.

The artist approaches the subject in a carefully controlled way. Starting with a pencil drawing, he outlines the main tonal areas. Using thin, fluid paint he then blocks in the body of the chimpanzee and the sky. Having established these areas, he has something against which to judge subsequent color. All color is modified by the color which surrounds it, and if you work on canvas in which large areas are still white, you will find that you have to adjust much of the initial work at a later stage. Some painters overcome this problem by tinting the canvas with an appropriate middle tone. The face is the most important part of the picture and here the artist works particularly carefully, identifying first the darkest tones, then the middle tones and finally the lightest areas. Using thin paint and a small brush he paints each of these areas in turn, allowing the paint to dry between stages. He uses no magic formulas, but by close observation and by rigorously putting down what he sees, creates an image which is accurate and at the same time lively.

This ability to separate local color from tones, from the color changes caused by the effect of light striking the objects, is essential for any artist. It is these changes — subtle in poor light and accentuated in bright light — which give paintings bulk and form. The best way to identify the tonal areas is by studying the subject through half-closed eyes.

1 This composition evolved from studies made at the zoo, *right*, with photographic reference for color and detail.

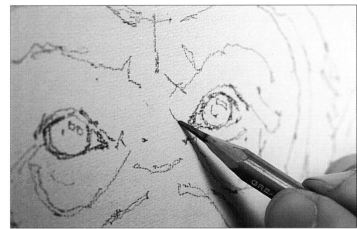

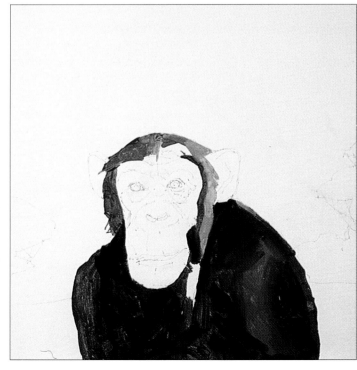

2 The artist starts by making an underdrawing on the canvas panel with a B pencil, *center left*. This drawing has two functions — it indicates the general arrangement of the elements within the picture area, and it records details such as the eyes and the tonal areas on the face.

3 The artist mixes raw umber, burnt sienna, ivory black and Payne's gray and uses this to block in the body of the chimpanzee *bottom left*.

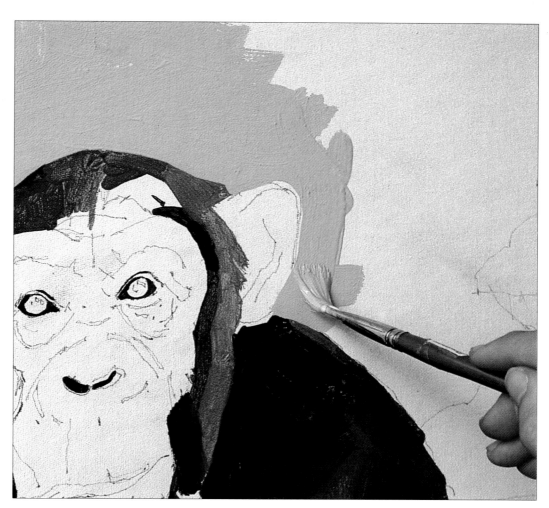

4 The sky is blocked in with a mixture of cerulean blue and titanium white applied with a No. 6 bristle flat *right*.

5 Having established the background and the broad areas of the body, the artist moves on to the face of the animal. He starts by laying in the darkest tones using a mixture of yellow ocher, raw umber, ivory black and cadmium red. The color is thinly diluted with turpentine and applied with a No. 7 Dalon brush, and a No. 2 sable for the finer lines *right*.

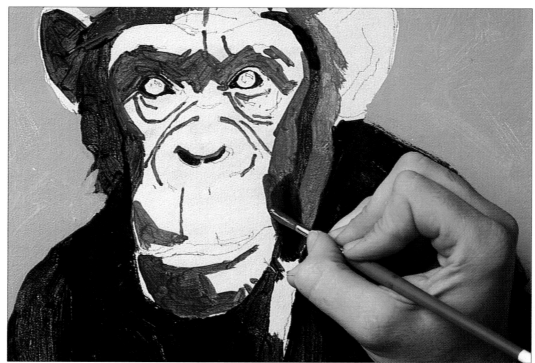

6 The artist lightens the mixture used for the face by adding more white and yellow ocher and starts to lay in the middle tones *right*. The paint is very thin, and where two colors overlap a third is created.

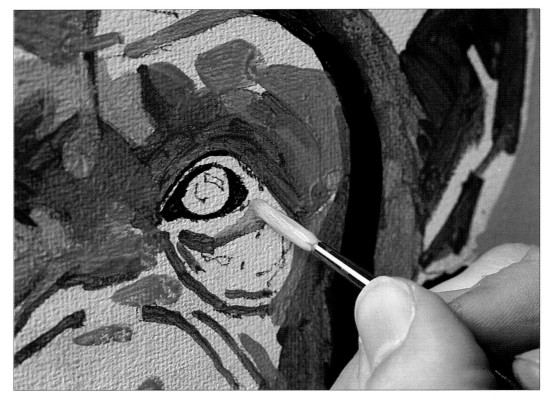

7 Because the artist has started by blocking in broad areas the painting builds up very quickly. This is useful because the blue expanse of the sky is an important element of this painting and will affect any other colors, *below*.

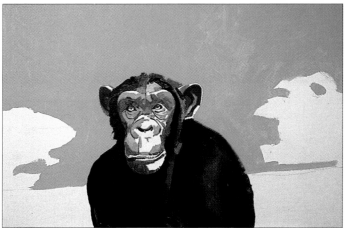

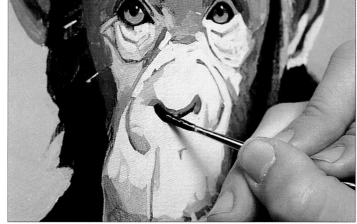

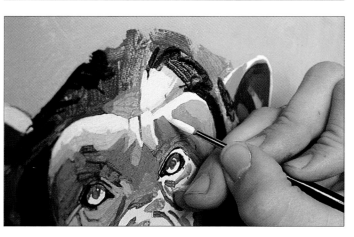

8 The artist allows the dark and middle tones of the face to dry and then mixes the lightest tones by adding cadmium yellow and more white to the original mixture *left*. He lays in the color carefully with a No. 2 sable, keeping the edges clean and letting the colors overlap slightly in only a few places.

9 He continues to work over the face in this way, adding small patches of color, gradually building up the final image *above*. The eyes are an important part of any animal painting and here the artist has handled them very simply but has managed to capture the animal's intelligent wariness.

USING MASKING TAPE

Masking tape is a low-tack tape used by designers and graphic artists because it can be applied to most surfaces without damaging them. The artist wants a clean, sharp line between the trees and the concrete wall and a definite line which is not quite so sharp between the wall and the chimpanzee. In the first picture the artist lays in gray paint, working up to and over the masking tape. In the second picture he lifts the tape around the chimpanzee, before the paint is dry, because he wants an uneven line to describe the animal's fur. The tape along the top of the wall is not removed until the paint is quite dry because here he wants a clean sharp line.

10 Using a diluted mixture of sap green and ivory black the artist puts in the trees in the background. The paint is applied freely, the varying densities of color capturing the quality of foliage. When the first paint layer is dry the artist works over it with a slightly lighter shade of the same mixture, created by adding white and yellow ocher *right*.

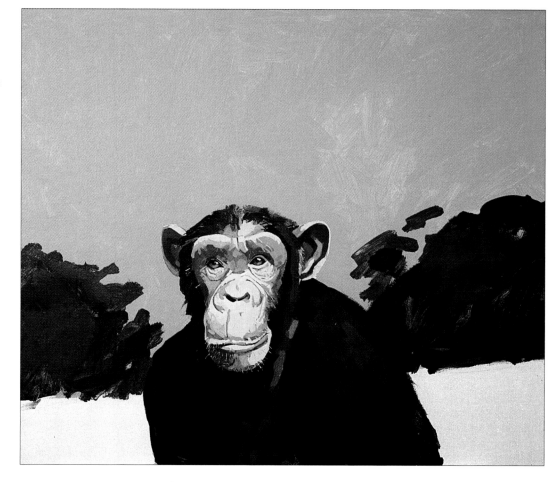

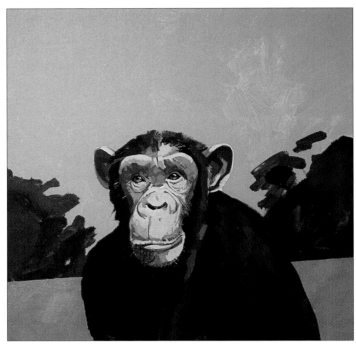

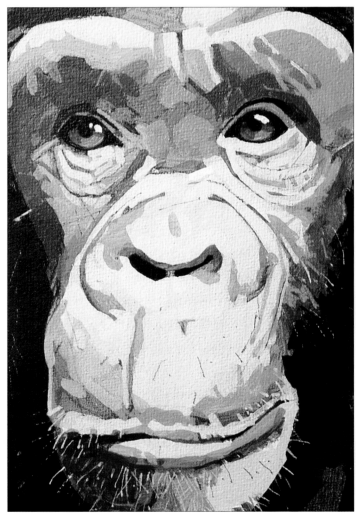

11 With a craft knife the artist scratches back into the paint layer, making fine marks which give the illusion of fur *top*. The whiskers on the chimp's chin are created in the same way.

12 Using masking tape to protect the surrounding areas the artist blocks in the gray background in the lower part of the painting *top right*. The gray is mixed from Payne's gray, yellow ocher and titanium white.

13 When the paint is thoroughly dry the artist uses pencil to put in details such as the branches of the trees in the background and the wrinkles on the chimp's face *above*.

14 The detail, *right*, shows some of the techniques used by the artist. By combining careful brushwork, sgraffito and pencil drawing he has created a convincing and charming portrait.

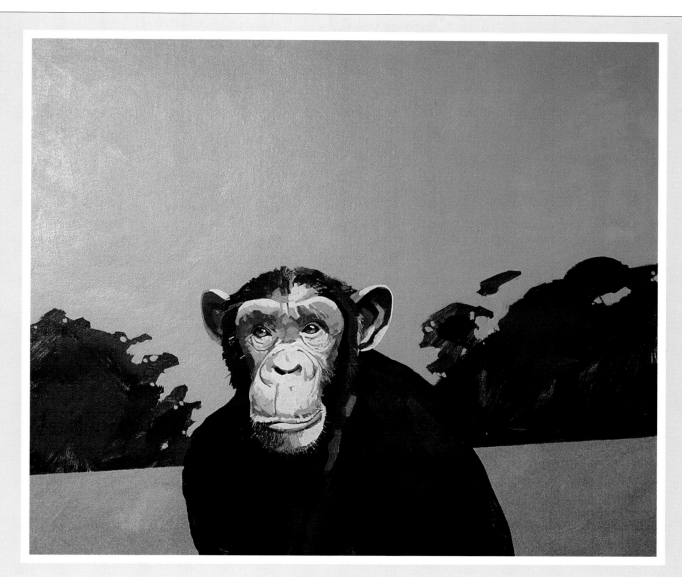

Chimpanzee

What the artist used

The picture was painted on a Rowney canvas panel 20×24in, which is cotton canvas stretched over a thick board and is primed for both oil and acrylic painting. He used a B pencil for the underdrawing and for working into the face of the animal. The brushes were a Rowney No. 2 sable, a No. 7 Daler Dalon synthetic and a No. 6 Bristlewhite. His paints were Rowney Artists' oil in the following colors — raw umber, burnt sienna, Payne's gray, ivory black, cerulean blue, titanium white, yellow ocher, cadmium yellow, sap green, and cadmium red. He used a piece of chipboard for a palette.

Lanner Falcon

A falcon streaking from the sky to take its prey in mid-air is a breathtaking sight. Superbly designed for speed and power, falcons are characterized by long pointed wings and slender, streamlined bodies. The Lanner falcon is a native of the Mediterranean and North Africa. It resembles the peregrine falcon but is paler and smaller and is distinguished by its buff crown and by its whitish, lightly spotted underparts.

The subject of this painting is the artist's own bird, perched on an Arab-style perch. Hawks are his special love and he knows the subject well enough to be able to paint the details of feathers and overall pattern.

The artist worked from life. He started by making a pencil drawing on paper, but because the bird was hooded to discourage it from moving around, the artist drew only the body at this stage, rendering it in great detail. He transferred this to the canvas by covering the back of the drawing with pencil. He then removed the bird's hood and drew the head, moving around the bird as it moved. This drawing was again transferred to the canvas using the graphite powder method.

In human portraiture the head is the most important part of the painting. The eyes are particularly crucial if you are to capture the personality of the subject. This is also true of animal painting, and the artist concentrates on the bird's head. If a head does not work, he discards the painting and starts again. In this case he was quite pleased with the way it worked and moved on to the body.

He approaches the body in quite a different way, blocking in the broad areas with a color which will provide a good key for subsequent color and will form the basis of the plumage. The artist has problems with the canvas because of its rather greasy surface which does not respond well to the acrylic paint. He applies the paint with a brush and then uses his fingers to work it well into the grain of the canvas to insure a good surface for the detail work. He then starts to develop the feathers, drawing the scalelike shapes with a small brush and developing the tones within each feather with tiny hatched brushstrokes. In the final stages the artist works with a very dry brush, outlining and highlighting each feather, occasionally softening the color by smudging it gently with his finger. In this way he keeps the paint translucent and alive and avoids a mechanical appearance.

The artist completes the painting by laying in a loosely worked, impressionistic background which frames the bird and makes it stand out from its surroundings.

1 The subject of this painting was the artist's own bird *right*. Birds of prey are his special love and he is interested in falconry.

'FLOW' FORMULA OR 'STANDARD' FORMULA?

On the right of the picture we see flow formula paint in its unmixed state. It is a soft free-flowing paint which is very useful for covering the large flat areas required in hard edge and abstract painting and is ideal for watercolor techniques and for working wet-into-wet. Standard formula acrylic paint, on the left of the picture, has the same buttery consistency as oil paint and can be applied thickly with a brush or knife.

2 The artist starts by making a drawing on paper. He transfers this to the canvas by covering the back of the drawing with charcoal powder and tracing over the lines of the drawing. He strengthens the drawing with a 4B pencil *below.*

3 The artist starts with the head because the eye and the beak are crucial and if he gets those right, the painting will succeed *below.*

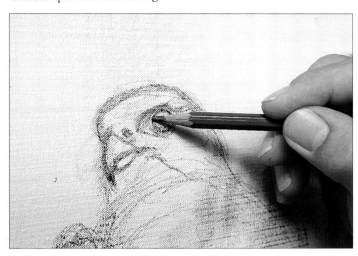

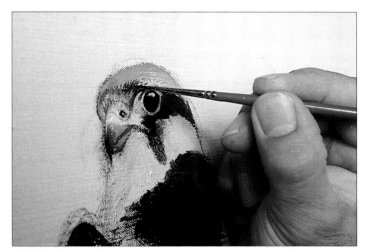

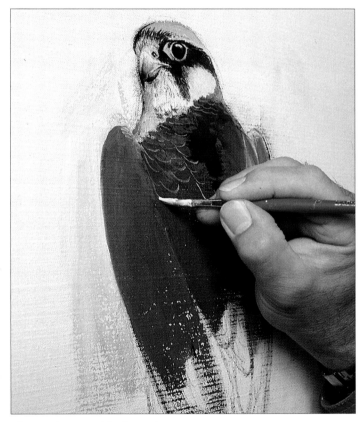

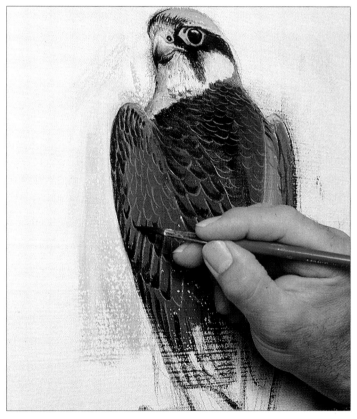

4 Next the artist blocks in the body of the bird, using a mixture of Payne's gray and raw umber as the base color. He draws the outlines of the feathers, using a mixture of white and black *above.*

5 He then applies a mixture of raw umber and black around the edges of the feathers using a No. 2 brush, building up the color with tiny hatched strokes *above.*

6 He starts to block in the background using white and yellow ocher. This helps to define the edge of the head. Using white paint and a No. 2 Dalon the artist develops the details on the neck of the bird, smudging the paint with his finger to keep it translucent *below.*

7 The artist continues working over the plumage, adding further details and developing details already there *right.*

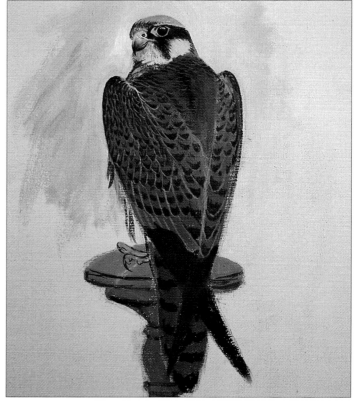

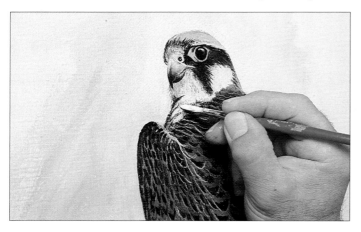

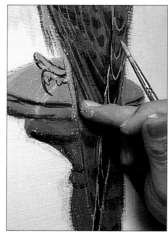

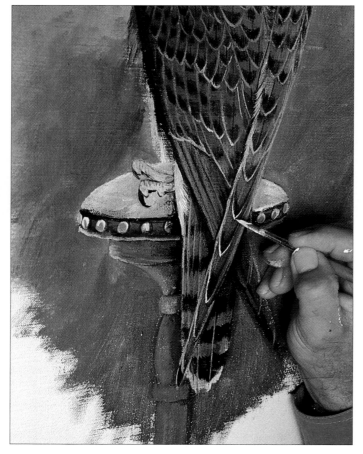

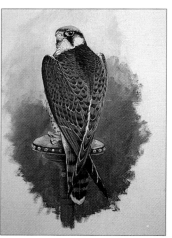

8 The artist uses a mixture of black and white to highlight the tips of the wings. He smudges the paint with his finger or the side of his hand to keep the paint translucent and fresh *above.*

9 With white paint and a No. 2 sable he outlines the tail feathers *right.*

10 The artist lays in the background with a mixture of burnt sienna and yellow ocher, applying the color loosely with a No. 5 bristle brush *above.* He was not happy with this, however, and felt that it detracted from the image. In the final painting he has laid in a pale neutral background.

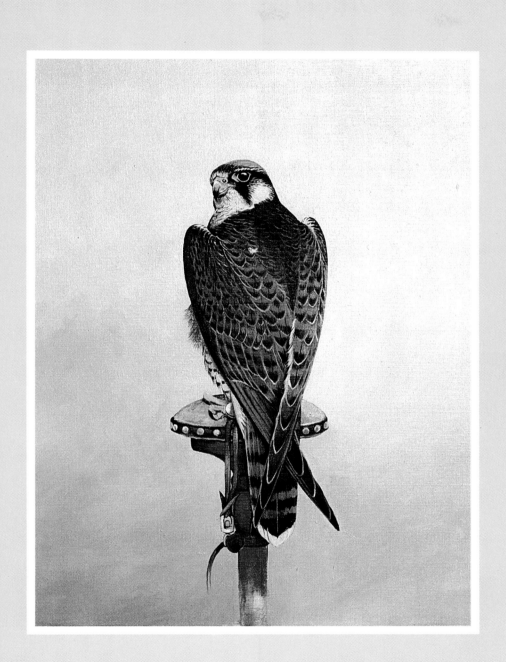

Lanner Falcon

What the artist used

The support was a Daler pre-stretched Herston flax canvas 24×18in, which is primed for both acrylic and oil painting. It has a fine-grained surface which suited the artist's tight brushwork. The drawing was made with a soft 4B pencil and his brushes were a No. 5 Bristlewhite hog bristle long flat, a No. 2 Daler Dalon and a No. 3 flat hog bristle. The artist used Cryla artists' quality flow formula paint in the following colors — black, Payne's gray, cadmium yellow, yellow ocher, raw umber, white, and burnt sienna. He mixed his colors in small round ceramic dishes.

Polecat

The foul-smelling polecat is a member of the *Mustelidae* family which includes such rapacious killers as the stoat and the weasel. It is sometimes known as the foulmarten. The ferret is a domesticated variety of polecat and the two frequently interbreed. The polecat has a long, lean body which hugs the ground and curves sinuously from a small head to a large round rump. The head has distinctive black markings which give the animal a rather sinister appearance, as though it were wearing a highwayman's mask.

The artist developed this painting from a series of drawings and sketches made several years ago. He starts by drawing onto the drawing paper with a hard pencil, creating barely any outline, building up the forms with a series of short pencil strokes which reproduce the texture of the animal's fur. Using a large brush he wets the paper, then with a small brush loaded with dilute black paint he floats the color on. Because the paper has been wetted first, he merely touches the surface with the tip of the brush and color bleeds from the brush onto the paper. Working in this way he builds up a series of graduated gray tones. In some places the base of the fur is dark and the top layers are fair, in others the hairs are fair at the base and black at the tips. The artist lays down the base colors so that the top colors can be stroked on at a later stage. He continues to work wet-into-wet, flooding in strong solutions of color where necessary. He works in this way because he wants to keep the edges of the colors soft, blending into each other.

At this stage the broad modeling of the animal has been achieved but the details of fur and markings have yet to be added. He leaves the painting to dry, speeding up the process by using a hair dryer. The artist now begins to use a dry brush technique, putting in the details of the hair with the tip of a very

fine brush. Again the painting is allowed to dry completely and with a mixture of red, yellow and white the creamy color of the animal's body is washed in. The hairs picked out with the fine brush show through this paint layer. Once this stage has dried, the top layer of dark hair can be stroked in. The painting is finished with a green wash to represent the background.

The artist has used thinly diluted acrylic in a way which resembles pure watercolor. The image has developed from a series of carefully controlled washes and he has worked wet-into-wet and used a dry brush technique. Once acrylic paint is dry it is permanent and cannot be lifted as watercolor can. The washes have less transparency than pure watercolor, but the paint's opacity gives the artist great flexibility.

1 The artist prefers to work from live subjects whenever possible. In this case he used sketches *right* with photographs to check the color.

2 The artist makes a careful pencil drawing of the subject. He does not start with an outline, but allows the form to emerge from the short pencil strokes used to describe the texture of the animal's fur. Once the drawing is complete the artist starts to lay on the first wash, wetting the paper with a large brush, and then floating in diluted black paint to describe the light gray areas *left*. With the point of a fine brush and black paint he draws in some of the animal's fine hairs.

USING A HAIR DRYER

Watercolor — whether transparent watercolor, gouache or acrylic paint — used with a lot of water is often considered to be a useful technique for dashing off quick color sketches. Many watercolor techniques, however, rely for their success on each layer being quite dry before the next one is applied. To speed up the drying process, and thus the completion of the painting, many artists use artificial heat. Here the artist uses a hair dryer so that he can work over the first gray wash. Hair dryers can also be used to control wet paint by blowing it around the paper surface or by causing pools of very wet paint to dry rapidly, creating an area of staining with a dark and very clearly defined edge.

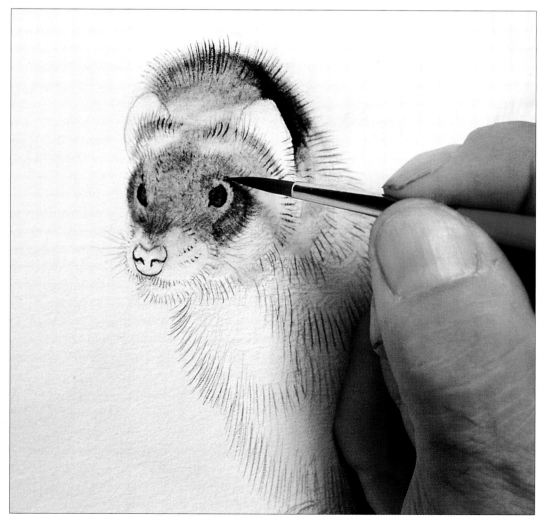

3 The artist continues to work on the head, introducing stronger solutions of color *left*. He applies the color while the paper is still wet in order to keep the edges soft. When using watercolor it is important to remember that quite different effects can be achieved by working wet-into-wet or wet-on-dry. When paint is added to wet paper the edges blur, and it is possible to achieve gently graduated tones. If you allow previous paint layers to dry the new paint will not run and you can make precise marks.

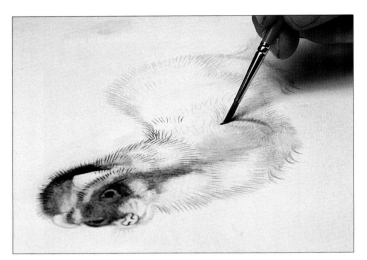

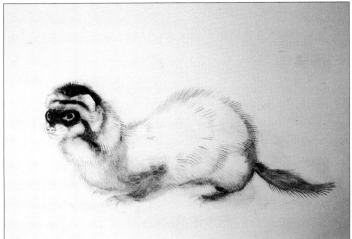

4 The artist now develops the darker tones in the animal's body, wetting the paper and flooding in the color as before *above*.

5 At this stage the painting is allowed to dry *above right*. To speed up the process he uses a hair drier — a fan heater would be just as effective.

6 The painting is now dry so the artist can apply a wash of a lighter color without the black paint affecting it *below*. The body color is mixed from cadmium yellow, cadmium red and white. He applies a thin wash so that the hairs show through. Shadows are built up by adding a small amount of black and washing it in. The edges between washes are softened with a large brush loaded with water.

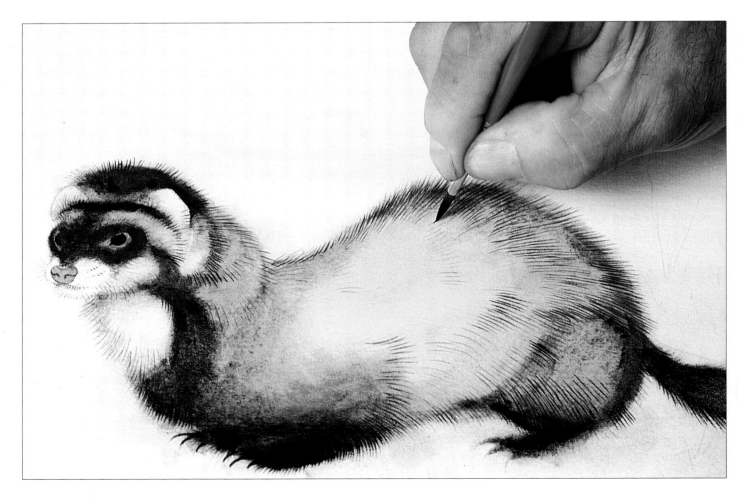

What the artist used

The support was a sheet of Rowney drawing paper 15×22in taped to a drawing board which the artist used on his knees. The drawing was made with a hard 3H pencil and his brushes were a $\frac{5}{8}$-inch flat and Daler Dalon No. 11 round and No. 4 round. His paints were Rowney Cryla flow formula in the following colors — black, white, cadmium red, olive green, cadmium yellow and yellow ocher.

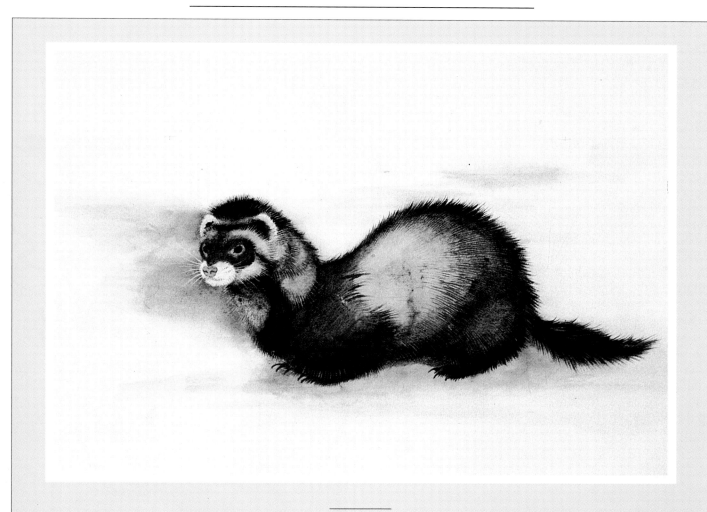

Polecat

Tiger

Some subjects have an obvious attraction for the wildlife artist and are painted repeatedly, sometimes by good artists, more often by mediocre ones, and in the process they become visually overworked and trivialized. The artist was anxious to avoid cliché in this treatment of a tiger and approached the subject directly, seeking to portray the animal's strength, intelligence and frightening beauty.

He worked from photographic reference, but did not copy. He used the photographs as a starting point for the study. He made several preparatory drawings to investigate the facial markings, the structure of the head and the eye.

He also thought carefully about the composition and finally opted for this upright format which emphasizes the lean power of the ruthlessly foreshortened body. He deliberately crops into the subject — by confining it so tightly within the picture's boundaries he suggests that the animal is about to burst from the painting. The tiger dominates the viewer with the fierce intensity of a real encounter.

The underdrawing was laid in with willow charcoal, a soft and responsive medium, which allows the artist to work quickly and freely. With a small decorator's brush the artist starts to lay in broad expressive swathes of vibrant color. He works with acrylic paint which dries quickly, allowing him to work fast and keep the paint surface fresh and immediate. He applies the paint to the canvas with quick scrubbing strokes, using the side of the brush, the tips of the bristles and, on occasions, smearing paint with his fingertips. As the painting progresses the image begins to emerge from the masses of broken color. At this stage the artist starts to work up details, such as the small stripes on the face and body.

The artist steps back from the canvas to view the painting — this is particularly important when you are working with loosely applied broken color, for it is only when the image is seen from a distance that the individual marks dissolve, the painting comes into focus and the various elements that make up the picture can be clearly seen.

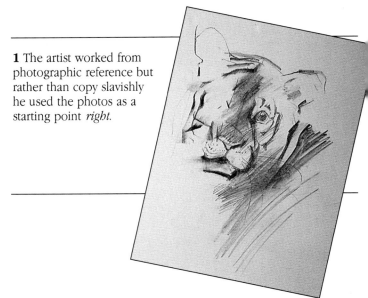

1 The artist worked from photographic reference but rather than copy slavishly he used the photos as a starting point *right*.

2 In this free charcoal study the artist explores the possibilities of the subject. He uses the end of a thin piece of willow charcoal to achieve crisp lines, and smudges and smears the charcoal to create tones and half-tones *right*.

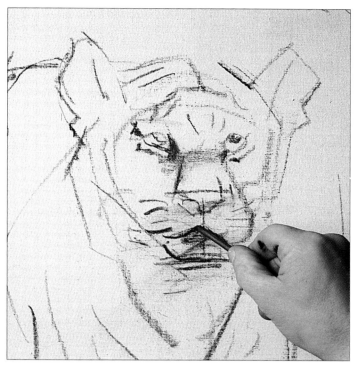

3 The artist opts for a narrow, upright format which emphasizes the leanness of the animal's powerful body. He makes a simple charcoal drawing on the canvas, *left*, in which he fixes the position of the subject and the main features within the picture area.

4 Charcoal is a soft crumbly medium, and the fine dust will contaminate subsequent paint layers. The artist avoids this by flicking off the loose dust particles with a duster *below left*.

5 The artist starts to lay in broad areas of color using a 1-inch decorator's brush *below*. The paint, raw sienna and cadmium yellow deep, is applied with quick scrubbing strokes, sometimes using the side of the brush and sometimes the tips of the bristles. The colors blocked in at this stage will give the artist a key to work against, and will suggest the way the painting can progress.

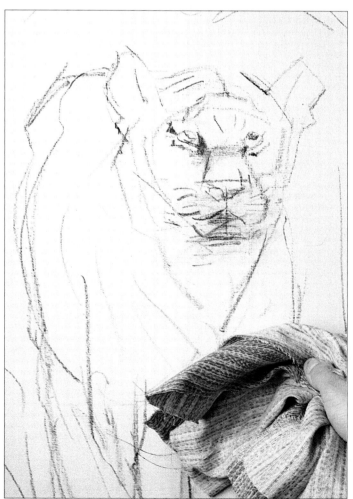

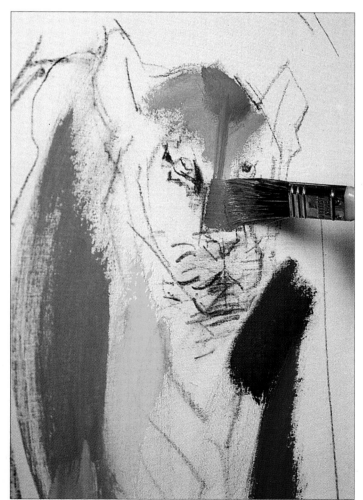

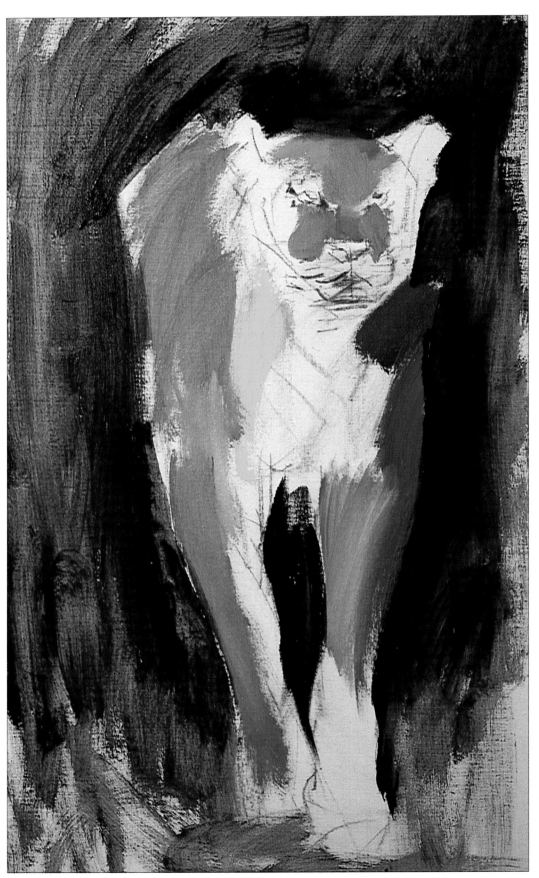

6 The artist blocks in the background with vigorous brushstrokes using the same decorator's brush *left*. He uses sap green, a particularly translucent color, with black added in the area immediately surrounding the tiger.

7 The artist uses a No. 12 ox hair to paint details on the tiger's face *top right*: the pink of the nose with a mixture of cadmium red and white and the stripes on the face with black.

8 He defines the eyes with a smaller brush a No. 8 sable round *center right*. The pale green of the pupils is mixed from sap green, cadmium yellow and white.

9 The artist continues to apply color all over the painting, often stepping back from the picture to assess its progress, sometimes half-closing his eyes to judge the overall effect. He adds broad splashes of yellow, white and black working with all his brushes and sometimes, as here *right*, with fingers and thumbs.

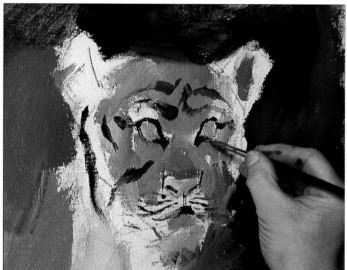

SGRAFFITO

This technique involves the artist scratching through paint to reveal either the paint layer beneath or the support. You can use sgraffito lines to create texture or to draw into wet paint. This is particularly useful if, for example, your original drawing has become lost under layers of paint. Here the artist has used the tip of the brush handle to create texture suggestive of vegetation. Painting knives or any pointed tool can be used in this way

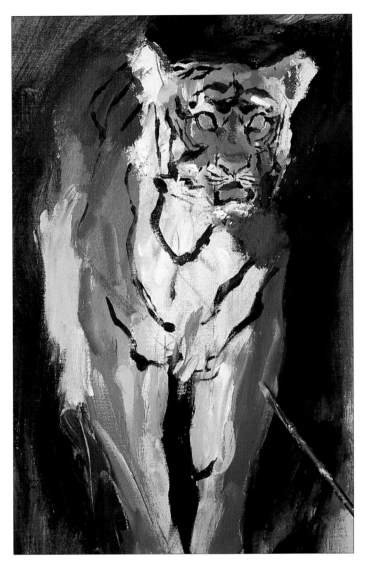

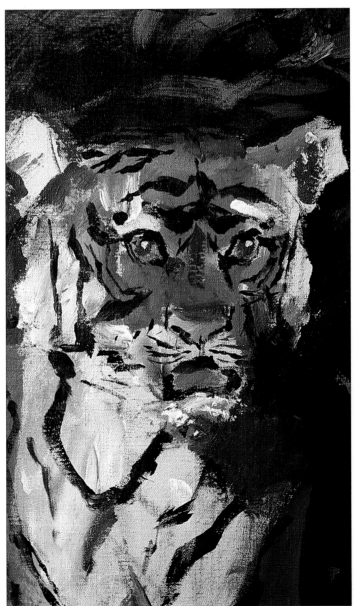

10 The image of the tiger emerges convincingly from the vigorous brushwork, the separate areas of bright, fresh colors merging in the viewer's eyes. The artist begins to develop details such as small stripes in the face and body, using a small bristle brush, a No. 4 Bristlewhite *above*. The advantage of acrylic paint is that it dries quickly, allowing the artist to work over the first paint layers without the paint becoming overworked.

11 In the detail, *above right,* the artist is working over the underpainting, applying broad loose marks to enliven this area of the composition. As the marks build up, the foliage emerges from the background.

12 In the detail, *right,* we see just how exciting the paint surface is. The painting succeeds both as an abstract arrangement of pattern and color, and as a realistic but expressive representation of a wild animal.

What the artist used

The support for this painting was a Daler Herston flax canvas 30×20in. These canvases are sold ready-stretched and double-primed. They are suitable for both oil and acrylic painting. The underdrawing was executed in charcoal and the artist used several brushes: a 1-inch housepainting brush, a No. 12 round ox hair, a No. 8 sable round and a Daler No. 4 Bristlewhite round. He used Rowney Cryla colors, a mixture of flow and standard formula, in the following colors — raw sienna, cadmium red, cadmium yellow, cadmium yellow deep, black, white and sap green.

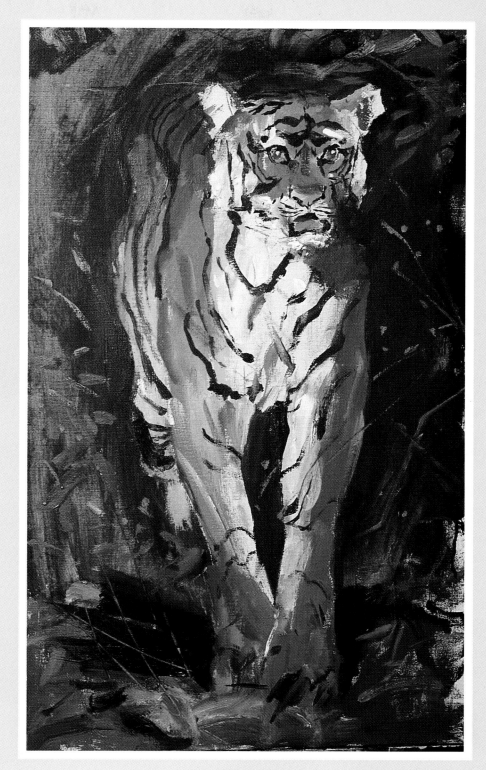

Tiger

Peregrine Falcon and Grouse

The peregrine is a blocky, rather heavily built falcon, but no other bird can match the mastery with which it catches and kills its prey, plummeting from the sky at breathtaking speeds and leveling out just before it deals a lethal blow with its hind toe. Here the artist has shown the peregrine swooping on a group of grouse which rise with a whirring of wings from a characteristic moorland setting. The subject is, as with all his work, taken from personal experience, and the composition is developed from memory and from sketchbooks. Sometimes he uses photographic reference for the background but in this case it is drawn from memory.

He starts with the slightest of drawings, merely mapping out the position of the sky, the land and the birds, but showing no detail. The painting develops as a series of thin paint layers, each one more detailed than the last. This method of working demands patience and considerable knowledge of both subject and materials. The artist sees the finished picture in his mind's eye and works toward that, judging each application of color carefully, assessing how it will modify previous layers and be modified by subsequent layers. Painters have different approaches and some start with less carefully refined ideas, letting the details of the composition evolve as the work progresses and even allowing the materials to dictate to some extent. In general, wildlife artists have to produce literal descriptions of their subjects, for the client or viewer usually wants an accurate description of a creature with which they are already familiar or about which they would like to learn more. In this painting the artist has described an attractive and colorful landscape but the point of the painting is his desire to record for himself, and share with others, an experience from which he derived great enjoyment.

1 Birds do not stay still for very long, so sketching and photography are the only practical ways of getting information for a painting *right*.

USING GLOSS MEDIUM

There are a great many mediums which can be used with acrylic paint to change the way it behaves. Ken Wood usually uses an even smoother suppport than this fine-grained canvas and found that the paint did not move as easily as he would like, *below left*. He was also painting in a slightly drier atmosphere than usual, and found that the paint was drying too quickly. By adding Cryla Gloss Medium No. 1 to his paint, *below right*, he increased the flow of the paint which suited his painting style and also extended the drying time very slightly.

2 The artist starts with a simple pencil drawing in which he outlines the birds and their relationship to the background. He then lays in a thin layer of dilute blue mixed from ultramarine and white, for the sky. The ground is laid in with diluted burnt umber *above*.

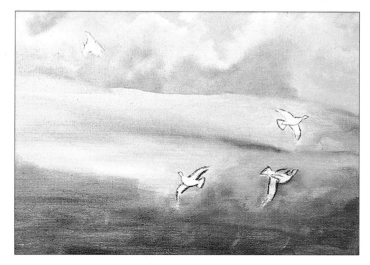

3 The clouds in the sky are laid in with gray mixed from white and black. The mixture is varied, with the darkest grays being kept for the underside of the clouds, and pure white for the tops *left*. Acrylic paint dries quickly, allowing the artist to proceed almost immediately to the next layer.

4 The artist scrubs a mixture of permanent violet and white into the middle distance, using a No. 4 bristle brush and dryish paint *below*. The direction of the brushstrokes and the texture of the paint are used to capture the appearance of heather. The mark of the brush is a very important element in any painting.

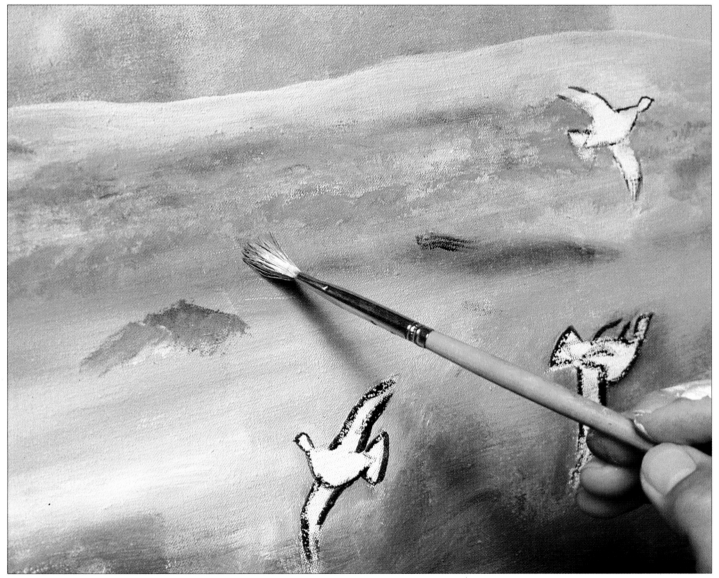

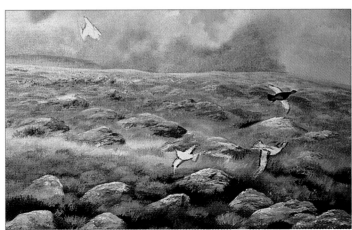

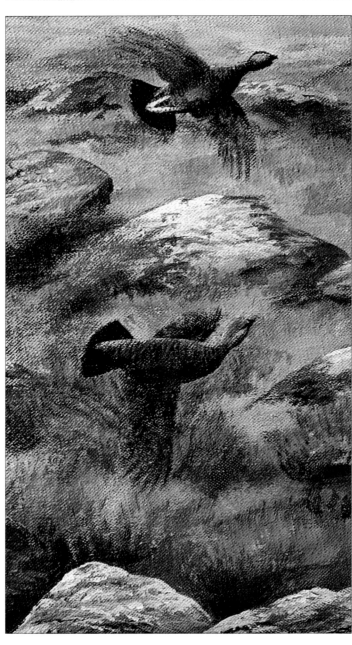

5 The artist continues to apply more color — a broad swathe of cadmium yellow in the middle distance and vertical strokes of permanent violet and a mixture of violet and yellow in the foreground. The rocks are painted in grays mixed from black and white. Notice the broken, stippled texture of the rocks *top*.

6 Using the same colors the artist continues to work over the entire painting. In this way he maintains its unity, as small touches of color are inadvertently carried from one area to another, giving the color arrangements coherence *top right*.

7 The artist leaves the painting of the birds to the very end. Working from sketches and memory he paints the peregrine using a small sable brush *above*.

8 The grouse are painted in the same way with a small sable brush. Notice the way the artist has blurred the wings to create an impression of movement *right*.

What the artist used

His support was a Herston flax canvas 20×24in which was bought on stretchers with a primer suitable for oil on canvas. The brushes were Nos. 4 and 8 bristle flats, and Nos 3 and 6 sables. He used Rowney Cryla gloss medium and Cryla flow formula paints in the following colors — ultramarine, white, black, cadmium yellow, burnt sienna, burnt umber, permanent violet and crimson.

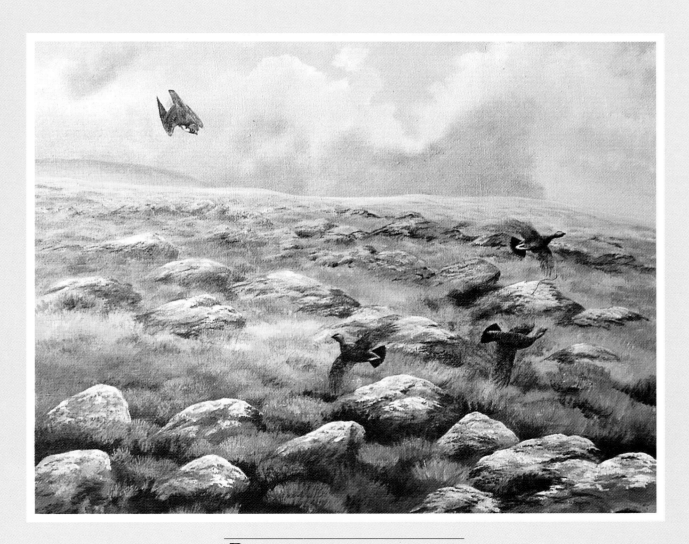

Peregrine Falcon and Grouse

Small Tortoiseshell

The artist has studied, collected and drawn butterflies since he was a child. His butterfly paintings are drawn from personal experience and so he is never guilty of errors which are sometimes found in the work of artists who have relied on photographic reference only. Butterfly species can be identified by their color and markings, but shape, pose and the vegetation upon which they are found also provide clues. The brimstone butterfly, for example, hibernates in holly bushes and never sits with wings spread, so any painting which shows the brimstone with wings outstretched has probably been cobbled together from several sources.

The artist draws from life constantly, using pencil in a small sketchbook. He has developed a rapid sketching technique which allows him to record particular shapes and positions, supplying details such as markings later. His extensive knowledge of the subject is invaluable, for he does not have to puzzle over details and can easily interpret what he sees. Less experienced butterfly watchers and artists have to look with a more questioning eye, cross-checking what they see against previous experience and constantly referring to books.

The artist develops the composition in a preliminary pencil drawing on paper. He does not transfer this drawing to the support but works directly onto the dry ground with paint and brush. He lays in the broad forms of the thistle using a very fine bristle brush and mixing olive green and white to get the pale bluish green of the stem, leaves and flower bases. The artist was able to reach this stage very quickly because the acrylic underpainting dried fast and, as the pictures show, subsequent layers cover very effectively even though the paint is fairly thin.

The artist continues in this way, laying in broad areas of thin color, mapping out the composition and constantly referring to his drawing. He then begins to paint details such as the dark tones on the underside of the thistle leaves, the mid-tones on the upper surfaces and the highlights along the edges. He carefully reproduces the colors and textures, working meticulously with a fine sable brush and varying the way the paint is applied. The shading on the thistle leaves is laid in with thin, washy paint, but the hairy texture of the base of the flower heads is built up with many small, fine strokes using light and dark tones to create a three-dimensional effect.

When the painting is nearly complete, the artist assesses it as a whole to check that all the elements are harmoniously balanced and then makes any final adjustments. In this case he decided that the thistles were a little dull and rectified this by adding a very thin, pale wash to the highlight areas on the upper surface of the leaves.

1 The artist has studied butterflies since childhood and can paint their markings from memory. In this case, however, a Small Tortoiseshell had invited itself into the studio *right*.

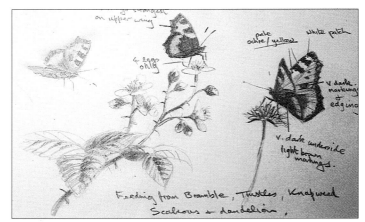

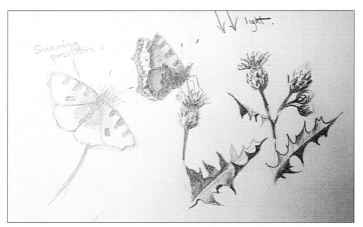

2 The artist draws from life whenever possible. He knows his subject well and can capture their shape and position, supplying markings later. He refers to these sketchbook drawings for ideas for paintings *above center*.

3 The butterflies in this painting were taken from two sketches, the one on the right in the middle sketch and the one sunning itself on the left of the sketch *above*.

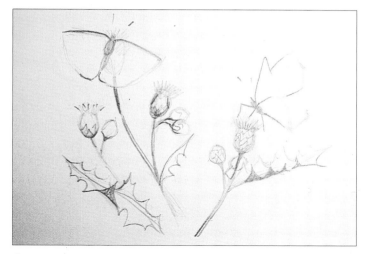

4 In the detailed sketch *above* the artist works out the composition, organizing the butterflies and the thistle in a pleasing arrangement.

6 The artist lays down the broad shapes of the butterflies *below*, using a mixture of cadmium orange and burnt umber. A little of the same mixture added to white is used for the highlights on the base of the thistle flowers.

5 The artist prepares a colored ground as described in the box on page 109. As he is using acrylic paint it can be completed very quickly. In the detail, *right*, he is putting down the basic color of the thistles — a mixture of olive green and white — using a fine sable brush.

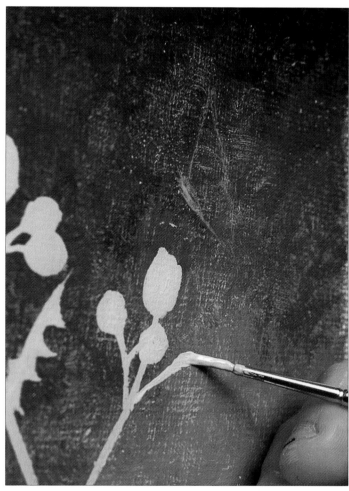

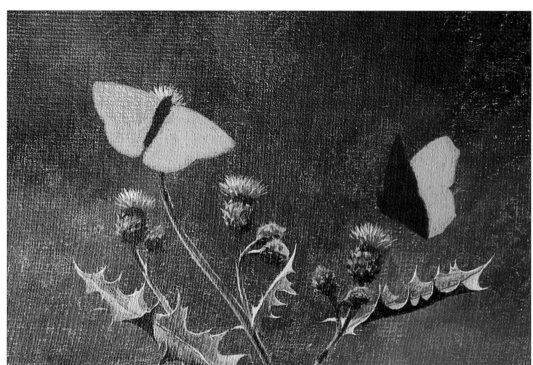

7 The thistle flowers are underpainted with a mixture of dioxazine deep purple and red iron oxide. Olive green is used for the deep shadow areas on the stems and flowers *above*.

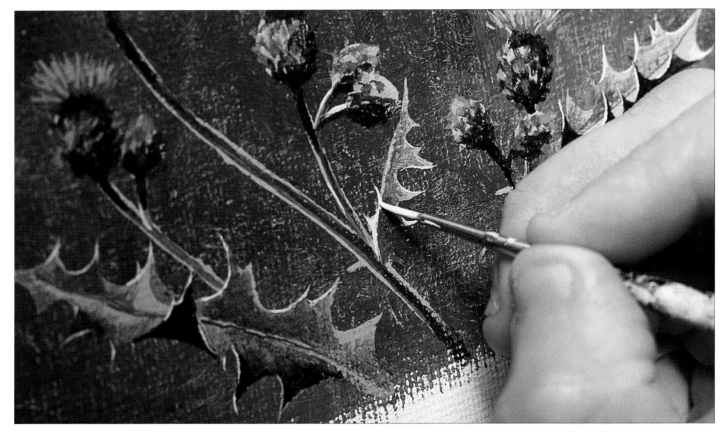

8 The highlights on the bristly bases of the thistle flowers are painted with a mixture of cadmium yellow and olive green, using small, fine strokes which reproduce the 'hairy' texture. A wash of olive green is used to create the middle and dark-tones on the leaves. The artist uses a No. 00 sable brush and a mixture of cadmium yellow and white to pick out the highlights on the stems and leaf points *above*.

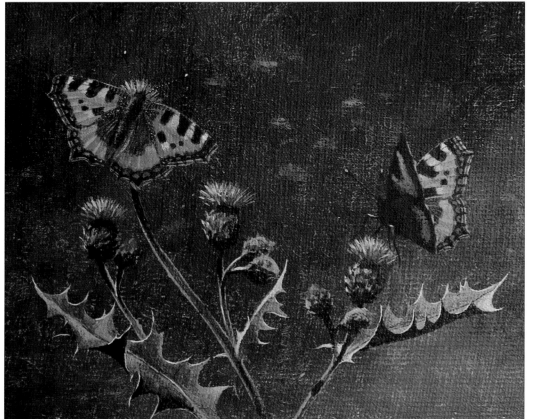

9 At this stage the thistle is nearly complete but the butterflies are almost untouched *left*. The artist now turns his attention to these.

PREPARING A COLORED GROUND

The artist wants a colored ground against which to set the bright, jewellike colors of the butterflies and thistle flowers. In order to achieve the required richness he lays down two layers of color. In the first picture he uses a small bristle brush to work Payne's gray and white over the top part of the support, mixing the color on the support to achieve a marbled effect. On the lower part of the support he applies the paint in the same way but with a warmer mixture of yellow ocher and white. He works over this first layer with cadmium yellow, cadmium orange and Payne's gray, mixing the color on the support with a brisk circular movement, and introducing more cadmium orange to the mixture as he works down the support. The resulting dark, rich background provides the artist with a pleasant texture to work on and helps to push the butterfly forward, giving depth to the painting.

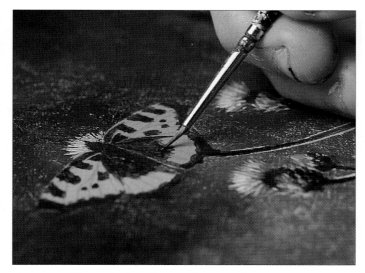
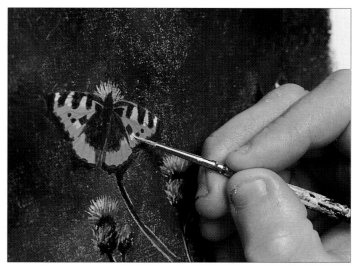

10 Using a dilute solution of burnt umber and a No. 00 sable brush the artist draws in the vein structure of the wings. This helps him to place the markings accurately. Using a more concentrated solution of burnt umber in order to achieve a more intense color, the artist then starts to paint in the dark markings, using the vein structure to define the edges of the markings *above*.

11 Once the darkest markings have been established the artist then starts to paint in the lightest markings using various mixtures of yellows and whites *above*.

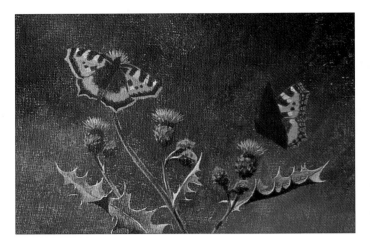

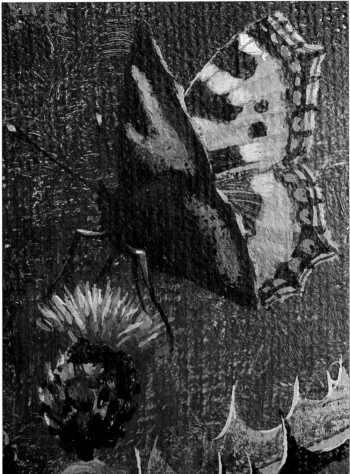

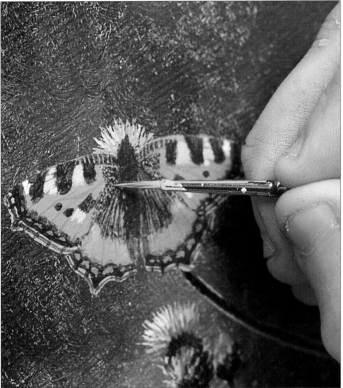

12 The same mixture of yellow and white is used for the light area on the margins of the wings above. This will provide a good base for the final detailed markings *top left*.

13 The blue markings on the wing edges are painted in Payne's gray rather than blue. Blue is a complementary of orange and would appear too bright, but the orange draws out the blue in Payne's gray, creating a more subtle effect. A mixture of cadmium yellow and cadmium orange is spotted onto the dark areas near the body of the butterfly, softening the color and adding texture *center left*.

14 The dark underside of the wing is lightened with a thin layer of yellow ocher and white *above*. The veins are highlighted with pure cadmium orange.

15 The artist stipples the body of the butterfly, blurring the paint with his finger *bottom left*. He stands back from the painting to see if any area is too bright or too dull. In this case he decided to add more highlights to the thistle flowers.

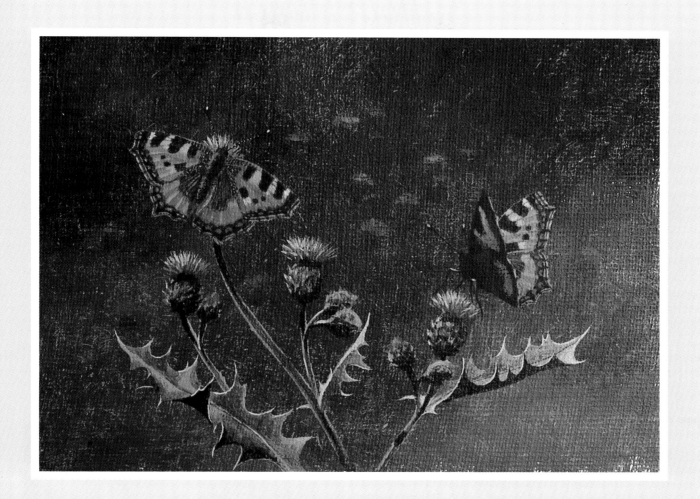

Small Tortoiseshell

What the artist used

This picture was painted on a small Daler board 6×8in with a No. 4 flat bristle, and Nos. 2 and 00 sables. He used Winsor and Newton acrylic paint which has a consistency between Rowney's Cryla flow formula and standard formula. The colors were Payne's gray, white, yellow ocher, cadmium orange, cadmium yellow, olive green, burnt umber, red iron oxide and dioxazine deep purple.

Suffolk Punch

This artist has been painting animals all his life and has an extensive and thorough knowledge of their appearance, anatomy and habits. He also has a very large collection of drawings made from life which are the basis of much of his work. This composition developed from two drawings made quite independently of the horse and the dog. The background came from his imagination.

Using a 3H pencil the artist makes a detailed drawing of the subject. He then applies a very dilute wash of brown over all the parts of the horse which will be brown, using a large brush for the main areas and a small sable to work color around the edges. The artist uses very thin acrylic paint, building up the color as a series of washes. Thicker paint is used to achieve texture and opacity in certain areas. In many ways the technique resembles transparent watercolor and body color but acrylic paint tends to granulate more than watercolor. It is ideal for illustration work because it is more permanent and the bright and opaque colors reproduce well. But when acrylic is used thinly as it is here, it is difficult to tell whether it is watercolor or acrylic.

The background and foreground are washed on with very pale tints of blue and green. The painting is then left to dry. When these areas are completely dry the artist is free to work over these washes of color in any way he likes. If you look carefully at the painting you will see some of the ways in which the artist has handled the paint. Thick white paint was used to lay in the clouds, a very thin brush and opaque paint was used for the small pine trees in the background, the large elms were stippled with the tip of a fine brush and the hedge along the field boundary was created by brushing on water and allowing green paint to blend onto the damp paper. The details of the horse's harness were drawn with pencil and completed with undiluted paint.

Drawing paper is not an ideal support for a technique which uses a lot of water unless the paper is stretched first. Here the artist overcame the tendency to cockle by using thicker, more opaque paint in the later stages. This combination of thin washes and opaque color creates a variety of textures which the artist has exploited sympathetically so that they reflect the quality of the surfaces they describe.

1 The artist is very familiar with his subject. The composition is based on two sketches of the horse *right* and the dog, made quite independently.

BLENDING EDGES

In the detail below we see the artist applying dilute acrylic paint onto the body of the horse. He uses fluid paint and is careful to keep the edges wet so that he achieves a subtle fusion of colors with no hard edges.

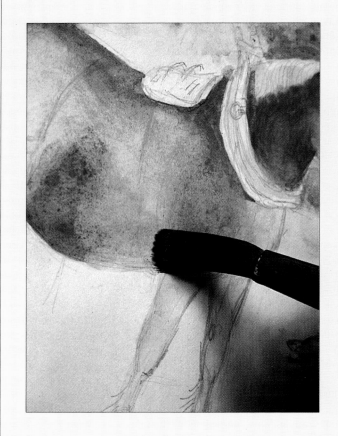

2 The artist starts by making a detailed pencil drawing of the subject. He then mixes a solution of burnt sienna and washes this over all the areas which will be brown *left*.

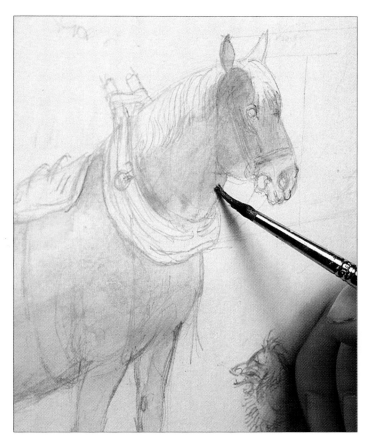

3 In the early stages the painting is built up from a series of transparent washes *above*. Later the artist may use thicker paint to achieve texture and opacity in certain areas.

4 In order to create the softly blended tones of this hedge the artist first wets the paper with a brush loaded with water, taking care to keep the water to the area where he wants color and making sure that he does not flood the paper. Using a small sable brush loaded with a dilute mixture of raw umber and bright green he introduces the color *above*.

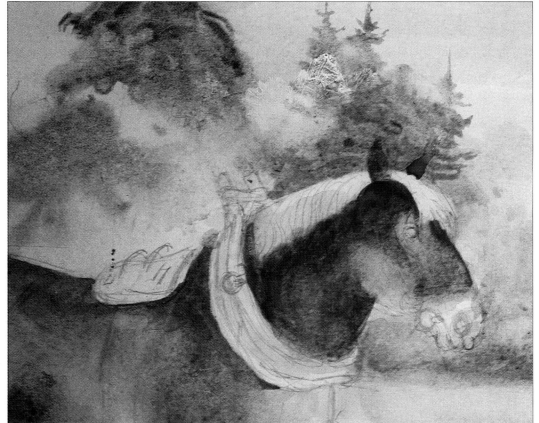

5 The trees in this detail *left* are treated in the same way, but the tips of the pine trees are painted wet-on-dry with a small sable brush. The initial washes are allowed to dry and then the artist introduces more color onto the body of the horse, using the same color mixes.

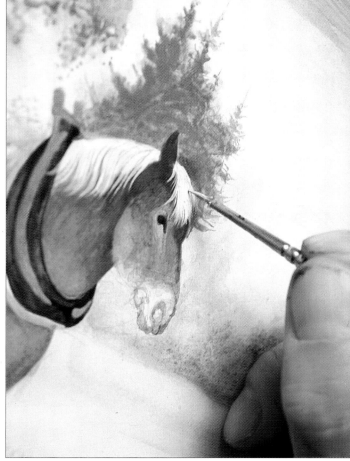

6 In the detail, *above left*, we see the artist working over the initial wash which is now dry, stippling on the color with a fine sable brush.

7 The details of the harness and traces are painted with a fine sable brush and lamp black. This proves to be too intense and is subsequently softened with a little water. The artist uses white to paint the horse's mane *above*.

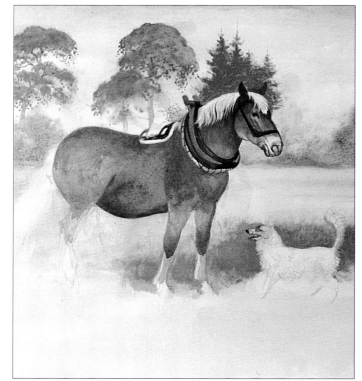

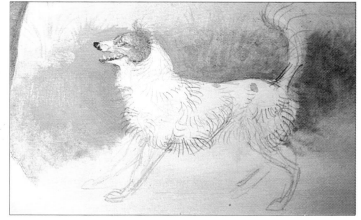

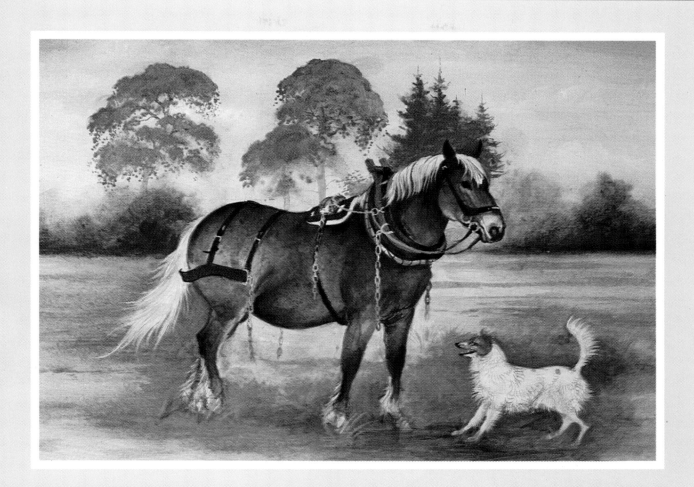

Suffolk Punch

8 For the grass the artist uses bright green and a No. 6 sable, adding white and raw umber in the darker areas *far left*.

9 The white dog stands out from the dark background *left*. In the final picture its form has been strengthened by darkening the surrounding color and rendering its hair with white paint applied with fine brushstrokes. The painting is completed by adding the harness in a mixture of black, yellow, red and white. The chains are drawn in pencil and painted in gray. The tail and the characteristic plumes of hair on the legs are added using pure white paint.

What the artist used

The support was a sheet of drawing paper 11×15in. He used a 3H pencil for the underdrawing and for drawing details into the painted areas. His brushes were a No. 00 sable and a No. 6 sable. The paint was Rowney Cryla flow formula in the following colors — raw umber, burnt sienna, bright green, cadmium yellow, cadmium red, black, white and cobalt blue.

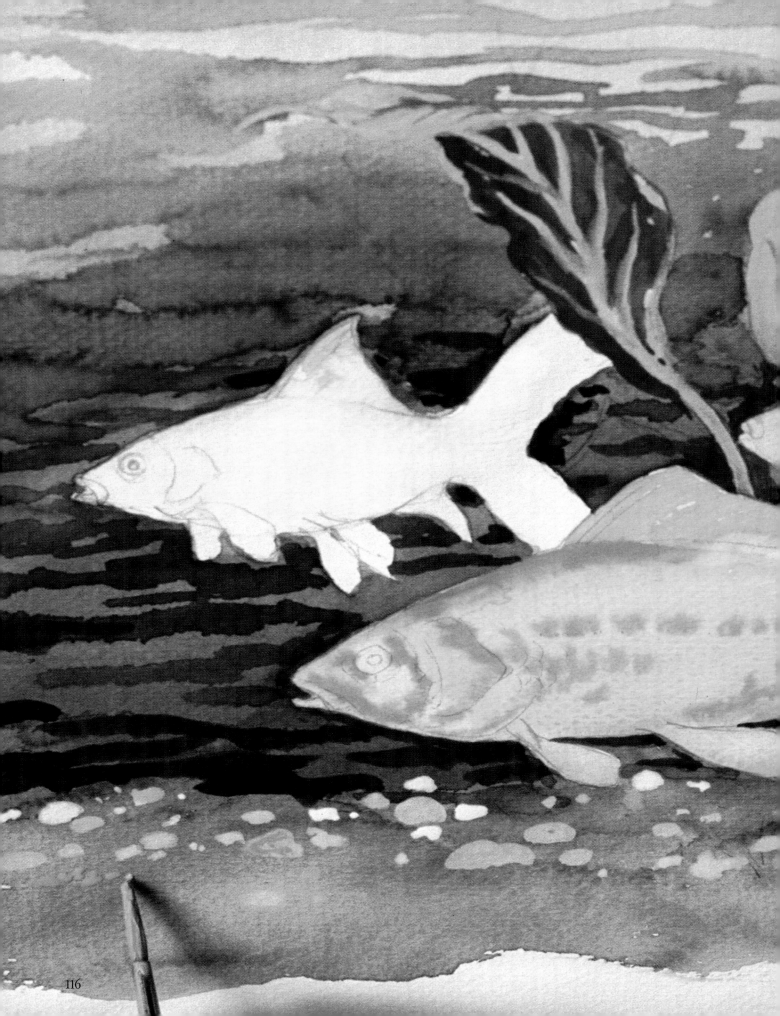

CHAPTER NINE

WATERCOLOR
AND
GOUACHE

Watercolor is one of the most attractive, technically difficult and satisfying of the painting media. Its reputation unfortunately dissuades many inexperienced artists from trying it. While it is undoubtedly frustrating, watercolor is not impossible to master, and the results are well worth the effort. There are two kinds of watercolor — pure watercolor which is transparent, and gouache, or body color, which is opaque. Different techniques are employed with each. With pure watercolor the painting is built up from a series of transparent washes. As the paint dries, it stains the paper which shines through the color to give the characteristic brilliance and sparkle. Gouache is much easier to handle — it is opaque, so the color can be laid on either in washes or as flat creamy color. It can be used on tinted papers and has good covering powers so that mistakes can be overpainted. Both watercolor and gouache are valued by wildlife artists for their clear, subtle colors and because the equipment is simple and light and therefore convenient for working in the field.

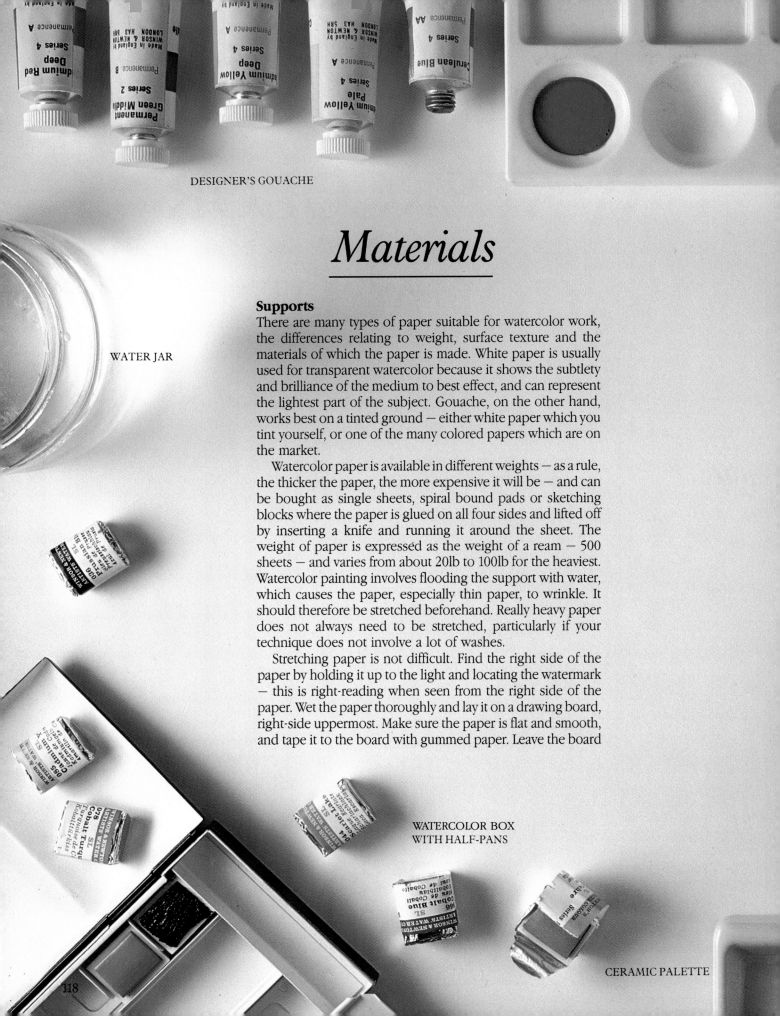

DESIGNER'S GOUACHE

WATER JAR

Materials

Supports

There are many types of paper suitable for watercolor work, the differences relating to weight, surface texture and the materials of which the paper is made. White paper is usually used for transparent watercolor because it shows the subtlety and brilliance of the medium to best effect, and can represent the lightest part of the subject. Gouache, on the other hand, works best on a tinted ground — either white paper which you tint yourself, or one of the many colored papers which are on the market.

Watercolor paper is available in different weights — as a rule, the thicker the paper, the more expensive it will be — and can be bought as single sheets, spiral bound pads or sketching blocks where the paper is glued on all four sides and lifted off by inserting a knife and running it around the sheet. The weight of paper is expressed as the weight of a ream — 500 sheets — and varies from about 20lb to 100lb for the heaviest. Watercolor painting involves flooding the support with water, which causes the paper, especially thin paper, to wrinkle. It should therefore be stretched beforehand. Really heavy paper does not always need to be stretched, particularly if your technique does not involve a lot of washes.

Stretching paper is not difficult. Find the right side of the paper by holding it up to the light and locating the watermark — this is right-reading when seen from the right side of the paper. Wet the paper thoroughly and lay it on a drawing board, right-side uppermost. Make sure the paper is flat and smooth, and tape it to the board with gummed paper. Leave the board

WATERCOLOR BOX
WITH HALF-PANS

CERAMIC PALETTE

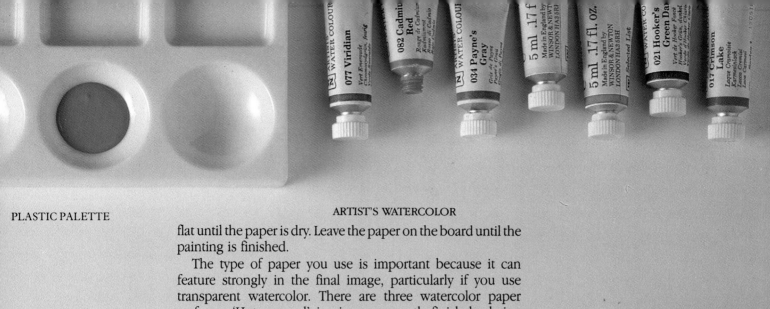

PLASTIC PALETTE

WATERCOLOR
CONCENTRATES

flat until the paper is dry. Leave the paper on the board until the painting is finished.

The type of paper you use is important because it can feature strongly in the final image, particularly if you use transparent watercolor. There are three watercolor paper surfaces. 'Hot pressed' is given a smooth finish by being passed through a series of hot rollers at the paper mill. It has a hard, untextured surface which is suitable for drawing and for line and wash techniques. 'Cold pressed' or 'Not paper', so-called because it is not passed through hot rollers, has a fine grained texture and is very popular among watercolor artists. Rough paper has a distinctive textured surface, often exploited by artists who like the way paint takes to the raised areas leaving the recessed parts as white areas.

The materials from which paper is made vary considerably, from the most expensive handmade papers made from 100 per cent rag to ordinary machine-made papers made from mixtures of rag and wood pulp. Your choice of paper will depend on the effects you are seeking to achieve and on the techniques you favor. Many beginners make the mistake of starting with cheap materials, intending to progress to better ones when they have mastered the technique. This only results in disappointment. Good paper responds sympathetically to the paint and improves your chance of succeeding with this difficult medium.

Paints

The artist choosing watercolors has a great many decisions to make. Designer's gouache, an alternative to pure watercolor, is sold in tubes. The colors are in artists' and students' qualities, and these in turn can be bought as tube color or in semi-moist pans or half-pans. Artists' colors provide the painter with the very best quality and the greatest choice of colors. If you are buying pure watercolor, it is probably worth investing in the

DROPPER

WATERCOLOR PAPERS, SMOOTH TO
ROUGH (LEFT TO RIGHT)

BROWN TAPE

MASKING FLUID

GUM ARABIC

GUM WATER

CERAMIC MIXING DISH

WATERCOLOR
MEDIUM

best quality pigments from the very beginning. They are expensive and you have to pay more for some colors than others. The brilliance and saturation of artists' colors make them easier to handle than students' color, and they go a long way. Tubes of paint are useful for mixing large quantities of color for extensive washes. Pans are convenient for most other purposes and are economical to use because you lift the color as required.

Watercolors can be bought as individual tubes or pans, or as boxed sets. Boxes are also available separately, so that you can fill them with your personal selection of colors. Watercolor boxes range from the very small to large, quite elaborate wooden boxes with a drawer which contains the palette. There are miniature boxes which contain 12 quarter pans and slip easily into any pocket and the Daler Rowney combination box which contains 18 quarter pans, a sable brush and a water bottle. The top of the water bottle can be removed and clipped to the side of the box to form a dipper, so that, apart from the support, all your painting materials are contained in a single unit which measures only $7 \times 2\frac{1}{4}$ inches.

A box of pan color is ideal for sketching and working in the field. The lid of the box can be used as a palette and the paint in pans is easily accessible.

Brushes

The very best brushes for watercolor are sable. Other materials include ox-sable mixtures, ox hair, squirrel, mixed fiber and various synthetic brushes. The size of brush ranges from No. 000 to about No. 14, but not all sizes are available in all series, a No. 6 in one series will not necessarily bear any resemblance to a No. 6 in another, and of course different manufacturers will have different numbering systems. Note the series and size numbers of a favorite brush so that you can replace it easily.

To give you some idea of the complexity of the subject, consider Daler Rowney's Kolinsky sable brushes. These are made from the tail hair of wild sables, a species of weasel found

in Siberia and North Korea. There are seven series, each one with slightly different characteristics. For example, Diana is a round brush available in sizes 000, 00, 0, 1, 2, 3, 4, 5, 6, 7, 8, 10, 11, 12, 14. Series 40 is similar to Diana but the hairs are slightly shorter, making the brush more springy. Because this brush can be brought to and retain a fine point, it is useful for detailed work. Series 101 brushes have long handles and are used for oil or acrylic painting. Series 102 also have long handles. When they are wet the hairs go to a point, but when they are loaded with color they form a chisel end. Series 103 are described as designer's riggers. They have very long hairs and are available in a limited range of sizes. Series 43 are similar but have slightly shorter hairs. Series 46 have very short fine points and are used for controlled fine work. If you were to buy every one of these brushes, you would have 76 brushes to choose from!

Watercolor brushes can be expensive and it makes sense to look after them carefully. Wash brushes in clean water after use, making sure that all the color is removed, especially round the ferrule. Dry your brushes by stroking them with a rag or paper towel, then shape the head with your fingers and store them upright in a jar.

Other equipment

You will need a good palette with recesses for mixing color. Palettes for watercolor are usually made from white plastic or china so that you can judge the color. White plastic or china dishes can also be used for mixing watercolor. Some are divided into three or four separate mixing sections. Well and slant palettes are particularly useful for tube color — the color is squeezed onto the slant areas and the washes are mixed in the hollows.

Many watercolor techniques involve moving the support to control the flow of the paint, so you will need to work on a drawing board. A board is also necessary for stretching paper. If you intend to use watercolor a lot, consider buying an easel which can be adjusted to give a horizontal surface.

NO. 18 SYNTHETIC ROUND

NO. ¾ SYNTHETIC FLAT

NO. 6 GOAT HAIR BLENDER

NO. 4 STENCIL BRUSH

SKETCHBOOKS

NO. 40 WASH BRUSH

Tropical Fish

Watercolor is at its most beautiful when the paint is laid down as thin films of color called washes. The secret of applying a wash is to wet the paper carefully first and to lay in the color with a loaded brush, working quickly so that the color lies flat with no edges or ripples. Practice laying flat washes and you will soon be able to get it right about 80 percent of the time — one of the delights of watercolor is the unexpected effects that result from 'getting it wrong'. Watercolor is unpredictable and one of the skills the watercolorist must master is being able to recognize the 'happy accident' and make quick decisions about whether and how it can be incorporated. By introducing other colors into a wash which is still wet you can create a variegated wash. Adding more water to the color as you work down the sheet creates a graded wash. Practice these techniques using good paper and good paints.

This delightful watercolor is based on a series of drawings made several years ago. The artist started by making a careful drawing in HB pencil. This is soft enough to give a range of thicks and thins on the soft watercolor paper without destroying the paper surface. She then laid in the first of a series of washes. Sometimes washes are allowed to dry before more color is applied, a technique described as working wet-into-dry. This effect can be seen in the background where a series of overlapping washes with clearly defined edges create the illusion of ripples in moving water. The washes are the same color mix applied in different strengths. In other areas the artist has worked wet-into-wet, so that the colors blend and bleed. Creamy undiluted paint is used for the aquatic plants and for the fish scales and the ribs of the fins.

1 The artist has made many studies of tropical fish over the years and it was to these that she referred for this watercolor *right*.

WORKING WET-INTO-WET

The blush of darker color on the gills, fins, scales and upper contours of the fish was created by painting these details with a fine sable brush before the basic wash was quite dry. Working wet paint into wet paint in this way causes the color to bleed, creating these subtle blended effects.

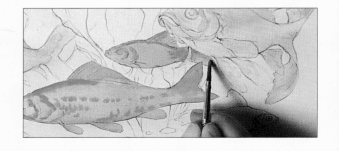

2 The artist starts by stretching a sheet of watercolor paper. When it is dry she makes a careful pencil drawing directly onto the support *right*. She draws with a sharp pencil in order to achieve a clean line. In the drawing she sorts out the details of the composition — from now on she can concentrate on manipulating the paint.

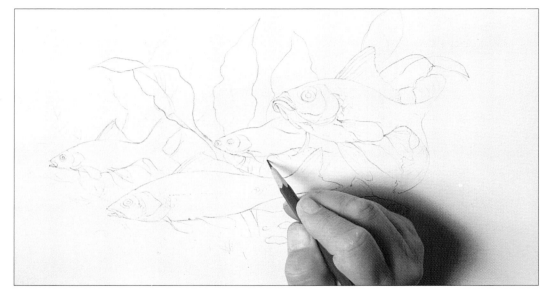

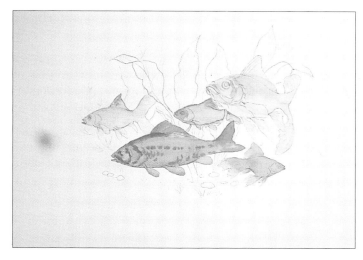

3 The artist starts by mixing cadmium red and cadmium yellow pale and uses this to wash in the broad forms of the fish. She varies the proportions of the colors to create the different colors of the individual fish. By adjusting the strengths of the color she is able to indicate the lights and darks over their bodies. The details are drawn into the basic wash before it is quite dry, softening the lines *left*.

4 The background is washed in with a mixture of lemon yellow and black *below.* The wash is deliberately applied unevenly in order to create a ripple effect. The same mixture is applied in different strengths and in different ways. In some places the paint is applied wet-into-wet, in others it is applied wet-on-dry to achieve hard edges.

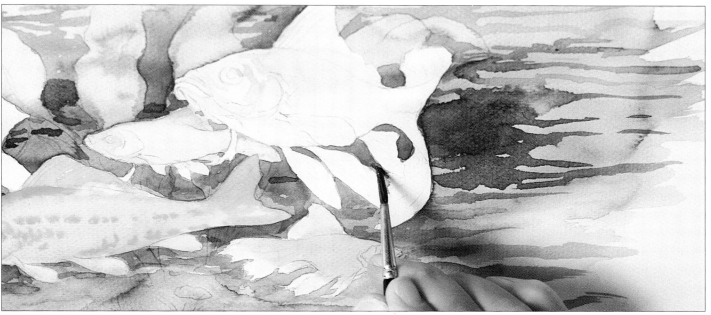

5 The painting is allowed to dry and the artist applies more layers of color so that the water becomes stronger and stronger. She varies the color by increasing the proportion of yellow in the top layers *right.* The density of the color around the fish helps to define their shapes.

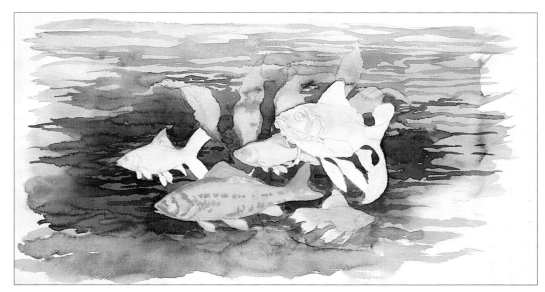

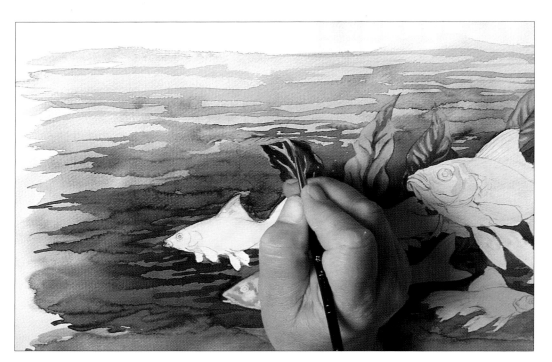

6 The leaves of the waterweed are painted with a light yellow which is almost pure lemon yellow *left*. The paint is diluted as little as possible in order to create an intense color and to cover the original wash. For the darker tones she uses the color mixed for the water, and a black and cadmium yellow mixture for the darkest tones.

7 The scales of the fish are picked out with a No. 00 sable brush and a mixture of cadmium orange and cadmium red *below*. The artist also uses touches of white.

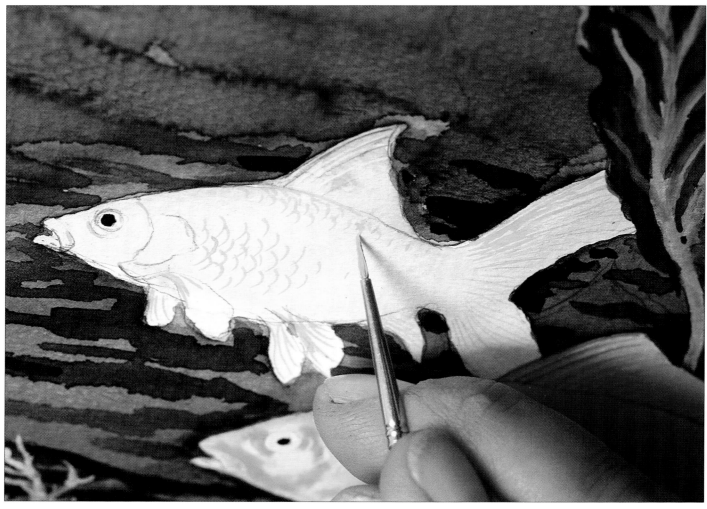

8 The cadmium red and orange mixture is used to enrich the color in the fins, the tails and around the gills. The pebbles are picked out with a mixture of white, grays and ochers *right*. Watercolor mixed with white paint loses its translucency but increases its covering power — used in this way it is called body color. The final painting is an excellent example of the brilliant colors and varied effects that can be achieved by carefully controlled use of this tantalizing medium.

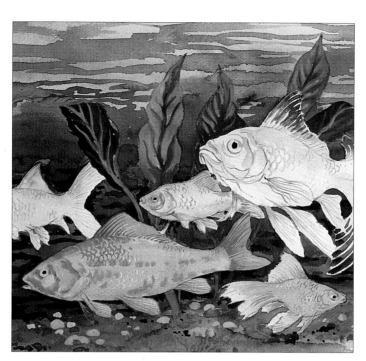

What the artist used

The artist used a good quality watercolor paper 14×20in, and a selection of sable brushes — Nos. 00, 3, 5 and 7. She used Rowney Artists' quality watercolors, both pan and tube, in the following colors — cadmium red, cadmium yellow pale, black, lemon yellow, yellow ocher, white, gray, cadmium orange and sap green.

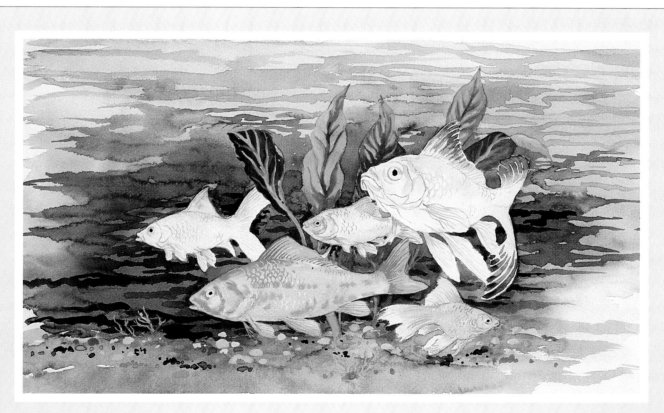

Tropical Fish

Bullfinch

Bright areas of flat, saturated color can be achieved with gouache, a waterbased paint favoured by designers and illustrators who produce work for reproduction. In many ways it is easier to use then pure watercolor, but you cannot achieve the translucent films of color which are the hallmark of watercolor. If you have never used watercolor and would like to try, consider starting with gouache. It is a soft, creamy paint and is sold in tubes. Pure watercolor in pans or tubes can also be made to behave like gouache if it is mixed with white pigment. Gouache is mainly exploited for its opacity, although it can also be used for thin washes. Paler tints of a color are achieved by mixing white with the color, whereas with pure watercolor you lighten the tone by adding more water to the mixture. With gouache it is possible to paint over and obliterate other colors – impossible with pure watercolor – and very fine details can be painted with a small brush. Watercolor and gouache are sometimes used together in a mixed technique, the opaque color being used to highlight or to scumble clouds over a blue washed sky, for example. Gouache can also be used as an underpainting for oils, the singing color shining through subsequent layers.

The artist Ken Wood uses acrylic for his larger, more impressionistic bird paintings in which the bird is usually set against its natural habitat. He prefers gouache for illustrations and bird portraits. The medium is particularly effective with his tightly controlled technique in which thin washes of color are overlaid by opaque color, carefully applied stroke by stroke with a tiny brush. This hatching technique describes very effectively the fine mesh of feathers, the soft undefined downy feathers and the more definite scalelike top feathers.

This painting was developed from several sources, from the skin of a bird, his observations in the field, memory and from a sprig of hawthorn. He washed in a pale tint for the background and then concentrated on the head. He always applies himself to the head early on for if he gets the head and the eye right the painting is almost certain to succeed – if he is not satisfied with the head, the painting is abandoned. The artist works carefully, using a very dry brush to record the color and pattern of the plumage accurately, at the same time looking for the tonal changes which help to describe the form and add life and sparkle to the image.

1 Ken Wood works from sketches made in the field, *right*, from skins and from his knowledge of his subject and an excellent memory for detail.

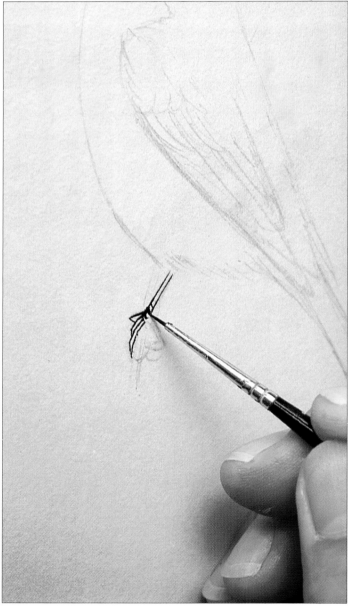

2 The broad outlines of the subject are set down in a simple pencil drawing. Over this the artist lays a light yellow wash for the background. He draws in the leg with a tiny sable brush and black paint *right*.

3 Using a No. 0 sable and black paint the artist develops the head of the bullfinch, laying down tiny strokes of color *right*. This meticulous hatching is particularly appropriate for the subject, capturing the fine, silky texture of the feathers of the bird's head. The artist considers that the eye and the beak are the most important features of any bird painting and always applies himself to these first — if he gets these right he continues, if not the painting is rejected at this early stage.

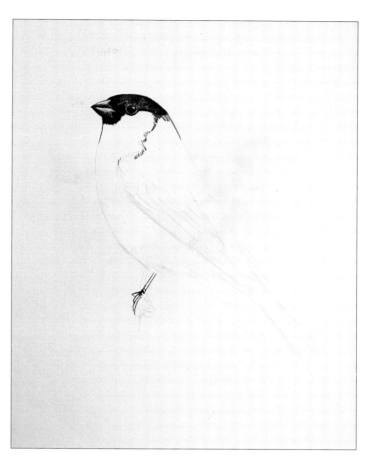

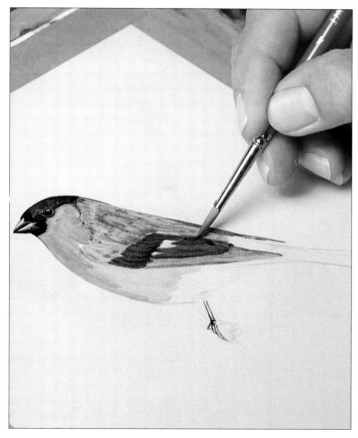

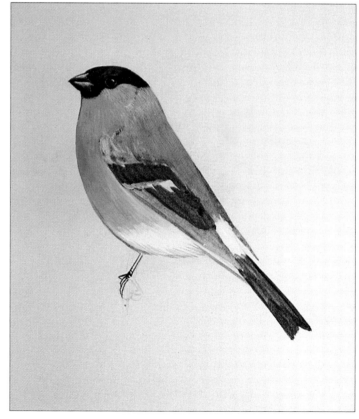

4 The basic areas of color in the body and head are blocked in with a heavy wash using a No. 7 Dalon round. Once the washes are dry the artist begins to add details, building up tone, texture and detail generally with a dry brush, but sometimes adding touches with more fluid paint *above*.

5 Using a fine sable brush he begins to build up the texture of the feathers, laying down tiny strokes of gray for the back, and crimson and cadmium red for the chest feathers *right*.

6 In the detail, *right*, the artist continues to develop the plumage, gradually building up the dense web of delicate feathers, laying down the color stroke by stroke with a No. 0 sable. Here he is using white paint to create highlights on the gray back feathers. He has already created fine highlights in the red around the eyes. He rests his hand on a sheet of paper, to protect the painting from grime and grease marks.

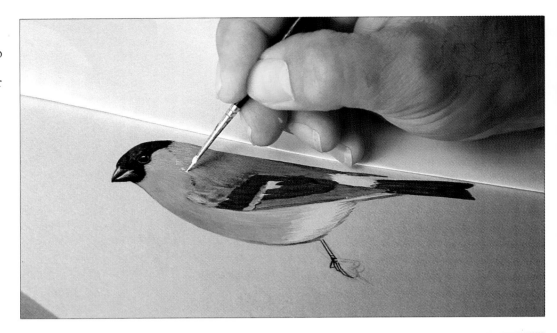

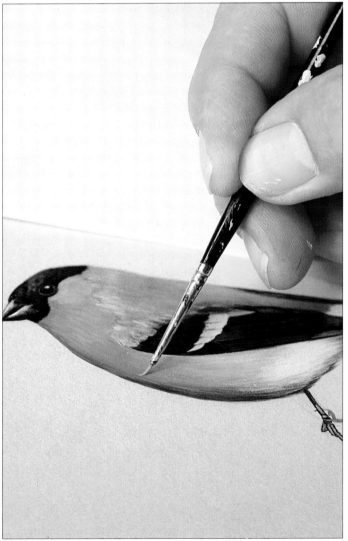

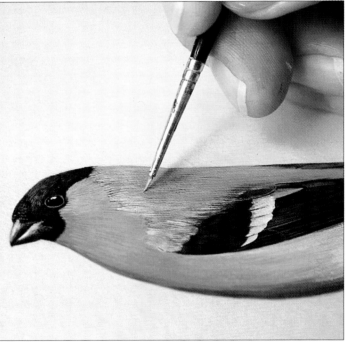

7 The black and white wing feathers have been elaborated using the same meticulous dry brush technique, a limited palette and color which is often used straight from the tube. He has developed the dark tones under the body and now adds more red to the chest *left*.

8 In the detail, *above*, the artist adds dark tones to the gray plumage on the back. The combination of lights, darks and middle tones gives a sense of depth to the plumage.

HATCHING

This is a technique in which areas of tone are created by laying down fine, parallel strokes which follow a single direction. In this detail you can see the way the artist has used a hatching technique to lay on color which reproduces the appearance of the plumage and suggests its texture. The paint is applied carefully with a small sable brush and dry, undiluted paint, the brushstrokes becoming finer in the upper layers as the painting nears completion.

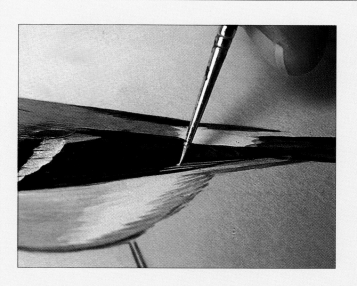

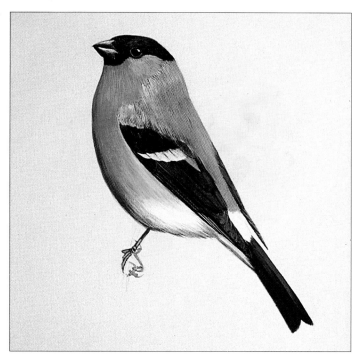

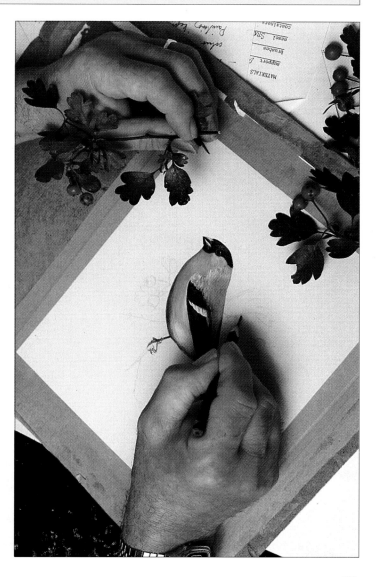

9 The painting of the bird is more or less complete *above*. The artist has achieved a remarkable likeness which is accurate and at the same time lively. Despite the high degree of finish and the attention to detail the entire painting was finished in a single day.

10 The artist now turns his attention to the background. Working from a sprig of hawthorn he makes a detailed drawing of the parts he wishes to include in the painting *right*.

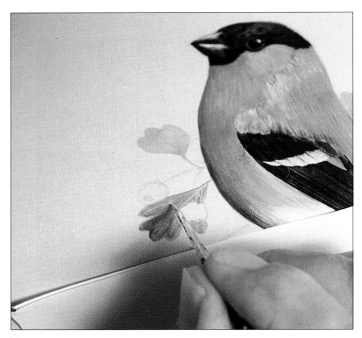

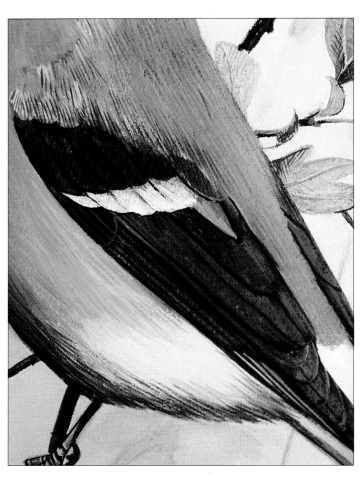

11 The areas of basic color on the hawthorn twig are washed in using a No. 4 Dalon and a solution of chromium oxide. When the wash is dry the artist works over the basic wash with a tiny sable brush, applying pale yellow paint to strengthen the color and suggest the veining, leaving the underwash showing through in parts *above*. The base color of the berries is washed in in crimson and cadmium red.

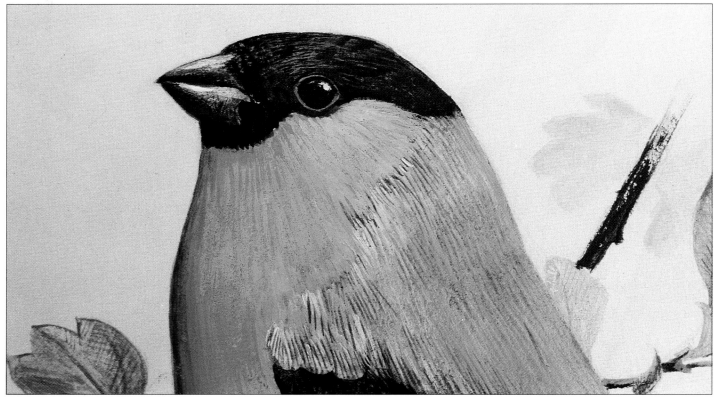

12 The detail, *left*, is larger than the original painting and shows the careful way the color has been applied.

13 In this detail, *below left*, we see the elaborate mesh of tiny strokes of which the image is composed. Even the leaves are built up by careful hatching and cross-hatching. Compare this with details from some of the other paintings in this chapter. Watercolor is a particularly exciting medium which can be used in a great many ways.

What the artist used

The artist used a sheet of gray drawing paper 10×8in which he stretched on a piece of hardboard. He used an F pencil and a ½-inch Daler Dalon synthetic fiber brush, a No. 7 Dalon round, a No. 4 Dalon round, with a No. 0 sable for the details. The paints were Rowney designer's gouache in the following colors — cadmium yellow deep, cadmium yellow pale, lemon yellow, black, white, ultramarine, crimson, cadmium red and opaque oxide of chromium.

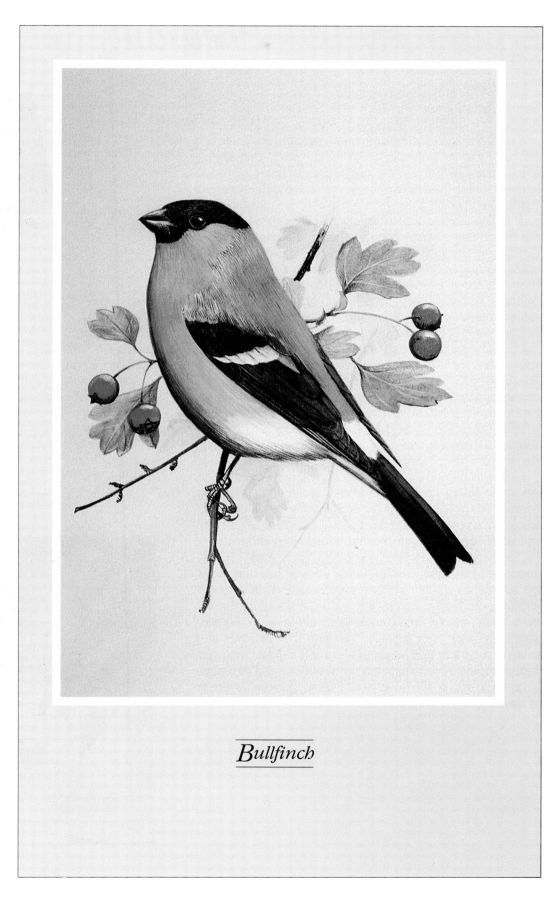

Bullfinch

Pheasant

This stuffed pheasant was borrowed from an antique store. Painting from stuffed animals is an excellent way of starting if you are a newcomer to natural history painting and have not yet had time to gather material in the field. The stuffed specimen will give you ample opportunity to study the broad forms as well as the details of beak, eye, legs and plumage. Do check your specimen against photographs in books. Not all taxidermists have the skill to achieve a lifelike appearance, and the animal may be presented in an uncharacteristic attitude. Experts can immediately spot the tell-tale signs which show that a painting has been done from a skin or a stuffed animal. However, these animals make wonderful subjects for the painter — who could wish for a more colorful and stimulating subject than this bird with its long, elegant tail feathers and brilliant, iridescent plumage?

There are many other rich sources of material for the wildlife artist, including the fish store and the game butcher. Do investigate your local suppliers. The brilliant, shot colors of a mackerel or the dappled patterns of a trout are an ideal subject for the watercolorist. Lay fish on a bed of ice to keep them cool. Shellfish such as lobsters, crabs and mussels are also spendid subjects to paint, because they are subtly colored and varied in shape and texture.

In this painting the artist has worked simply, directly and quickly, building up the form from a series of overlapping washes. The washy paint is handled loosely and confidently with obvious enjoyment of the medium. The paint is very wet, and while some colors are worked wet-into-wet, the artist lets the painting dry completely between each stage. This is important particularly when using such a free technique because floods of water and lots of color can result in a wet and muddy mess. Notice the way the colors have been developed from light to dark in the classic watercolor way. In the later stages the artist uses paint to describe the markings and develop the more precise shapes, but still handles the paint freely, keeping the brushmarks fairly loose to avoid the image looking too stilted. The final painting shows yet another aspect of this infinitely challenging and exciting medium.

1 The brilliant colors of this pheasant, *right*, glimpsed in an antique store, fired the artist's imagination. He borrowed it and produced this lovely watercolor.

WET-OVER-DRY

In this detail you can see the way the artist has created a rich variety of shapes, patterns and tones by allowing one paint layer to dry and then applying more wet paint in a series of dabs and dashes that together suggest the texture of the bird's plumage. When you work wet-over-dry the later paint layers dry with clearly defined edges, the underlying marks showing through to create a complex surface which has depth and varying densities of color.

2 The artist starts by making a very simple outline drawing of the bird. He uses an F pencil and a light touch — the drawing barely shows. He mixes chrome orange and raw umber and lays a pale underwash *below*.

3 The artist applies another wash of chrome orange and raw umber in the tail area. Burnt sienna, alizarin crimson and black are used for the dark underparts, ultramarine and viridian for the head and a splash of alizarin crimson for the eyepatch *below*.

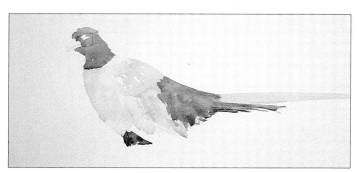

4 A wash of alizarin crimson is laid over the breast — again the paint is applied loosely because the artist wants the color to dry unevenly to suggest the texture of feathers. He continues to apply wash over wash, gradually intensifying the color and building up texture and detail. He uses a No. 2 sable and a mixture of ultramarine, viridian and black, *right*, to describe the gleaming feathers on head and neck.

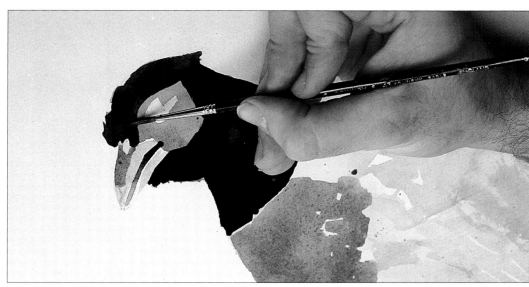

5 Using a No. 2 sable and a solution of raw umber with a little chrome orange the artist builds up the complex pattern of feathers *right*. The artist works more carefully and accurately at this stage, recording the markings precisely, but nevertheless keeping the brushmarks fairly loose to prevent the image from looking too stilted.

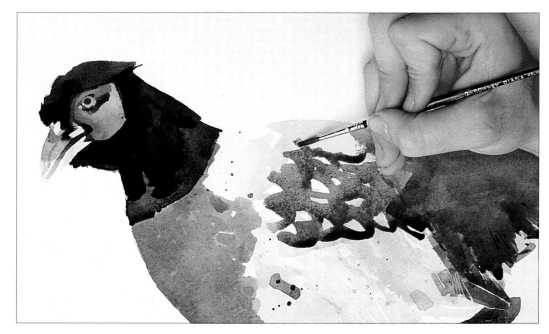

6 In the detail, *right*, we see the richness and variety of pure watercolor. In some places the artist has put down details using the very tip of a No. 2 sable brush, in others the paint has been applied more freely. Edges are important — some colors are allowed to bleed together, others dry with a clearly defined margin. These overlapping edges create a feathery effect which softens the perimeter of the crimson chest feathers, for example.

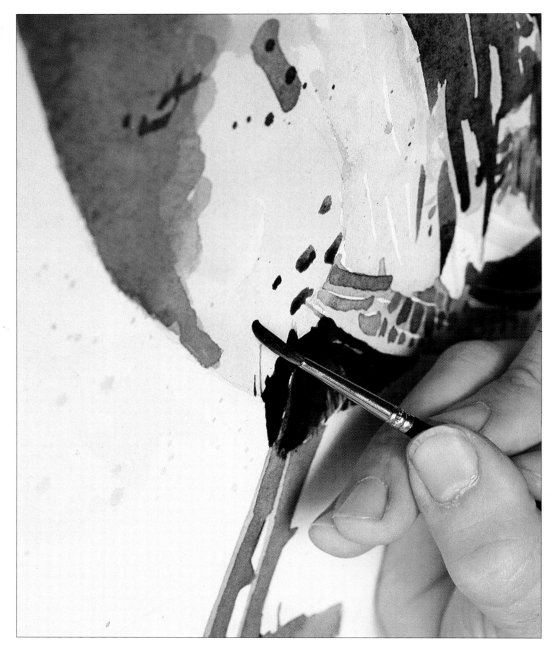

7 The artist continues working in this way, allowing the paint to dry between each application of color. Watercolor demands forethought, for once the color is laid down it is difficult to change it and impossible to overpaint it if it is dark. Yet it is possible to achieve dense, saturated colors *below*.

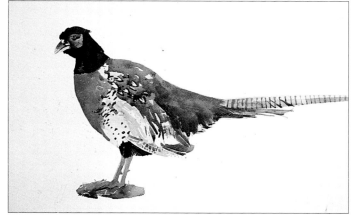

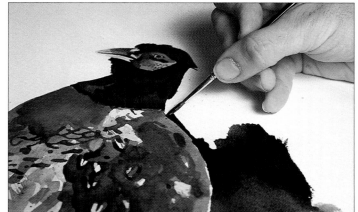

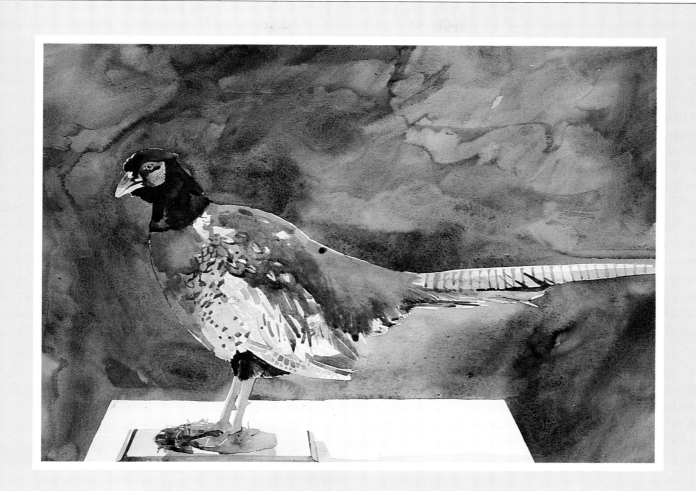

Pheasant

8 The base on which the bird is mounted is painted in with a few simple strokes. Finally the background is washed in — a mixture of Payne's gray and black applied with a No. 12 sable. The color is applied freely, varying intensity to achieve a variegated effect *left.*

What the artist used

The support was a sheet of Bockingford watercolor paper 22×30in which he stretched on a drawing board. He used an F pencil and a No. 7 Daler Dalon round, a No. 2 sable and a No. 12 sable for the background. The paints were half pans of Rowney Artists' watercolors in the following colors — chrome orange, raw umber, burnt sienna, alizarin crimson, black, ultramarine, viridian and Payne's gray.

Black and White Cat

Domestic cats can only really be painted successfully when they are relaxed in their own homes. The artist has a collection of sketches and finished drawings of her own pet and these formed the basis of this charming and unusual painting. The pose was rather difficult and there were several problems to be resolved so she did not draw directly onto the support but worked out her ideas on a piece of cartridge paper using her sketches as reference. When she was satisfied with the composition she made a detailed drawing on tracing paper and then chalked the back of the paper so that she could transfer the outline to the support. She then strengthened the image with a black conté pastel. This is a very useful technique if you do not want to make changes to the drawing once it is transferred to the support. This might be the case if you were using a particularly expensive support or if you were working to a very specific brief for a commission.

She used watercolor for the background which she laid in as a loose wash, wetting the paper first and then running the color into the wetted areas. By increasing the strength of the color in certain areas, she created a variegated and interesting setting which does not detract from the subject. At this stage she allowed the painting to dry.

The handling of the cat is simple and carefully controlled, the artist considering each mark carefully because she wanted to keep the pastel as fresh as possible. Only three colors were used — blue-gray for the underpainting, poppy red for the nose, tongue, pads and ears, and black conté for the fur. She started by indentifying the lightest areas of the cat's coat, difficult to see with such a dark, velvety subject. However, her knowledge of cats and of this one in particular helped her to feel the forms beneath the fur. Gray pastel was rubbed on loosely in these areas, using the side of the stick so that it barely skimmed the surface of the paper, leaving a layer of broken color. The black conté pastel was laid over this, creating a dense but lively surface. The final image illustrates just how effective a simple technique and a limited range of colors can be when handled with confidence, skill and imagination.

1 This delightful painting was based on a series of studies made from life. It is the artist's own pet, so she was familiar with the subject and the animal was relaxed *right*.

2 Using sketches as reference , the artist makes a drawing on tracing paper. She chalks the back of the drawing, lays it over the support and traces over the image. A pale chalk image appears on the support and this is strengthened with black conté pastel *left*.

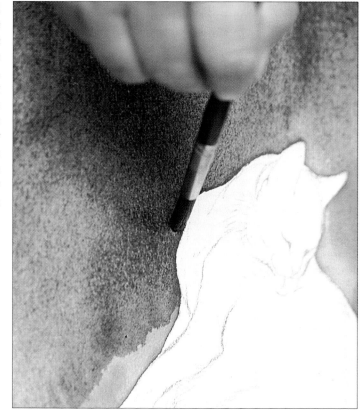

3 In this painting the artist uses watercolor for the background because it is simpler to apply over large areas than pastel. The background color is a mixture of Winsor yellow, cerulean blue, cadmium yellow, burnt sienna and lamp black. The artist wets the paper and then runs the wash over the wetted areas. She darkens the upper background by increasing the strength of the initial wash *right*.

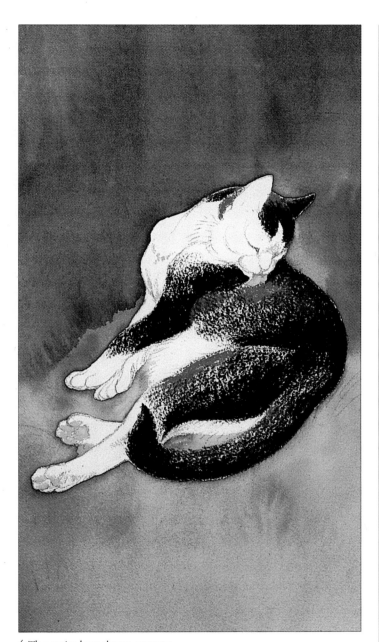

USING THE SIDE
OF THE STICK

In this detail we see the artist laying on colour with the side of the pastel stick. This allows her to cover large areas quickly. Colour applied in this way is more grainy than colour applied with the tip of the stick, because the pressure you apply is distributed across a broad surface, rather than being concentrated at a single point. Here the grainy texture is emphasized by the texture of the support, and is exploited by the artist to create soft but dense colour which accurately captures the quality of the animal's furry coat.

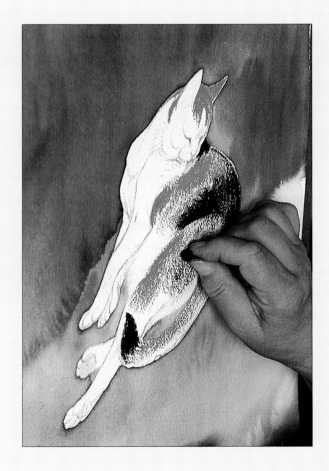

4 The artist lays down grey to highlight the black fur using a Rowney blue grey pastel. Black is applied broadly over the grey, building up the depth and body of the colour. The pads and tongue were put in using poppy red tint No. 1 *above.*

5 With her finger she blends the black into the gray, working the pastel into the grain of the paper to produce a single solid color *right*.

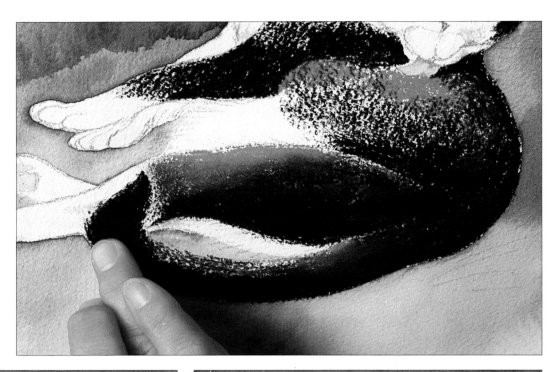

6 She continues to work in this way, applying pastel and working it into the paper, building up the rich dark color of the cat's fur. Poppy red is worked into the inside of the ear, and this is then overlaid with black. She then breaks the black pastel to make a sharp drawing edge and flicks in individual hairs *below*.

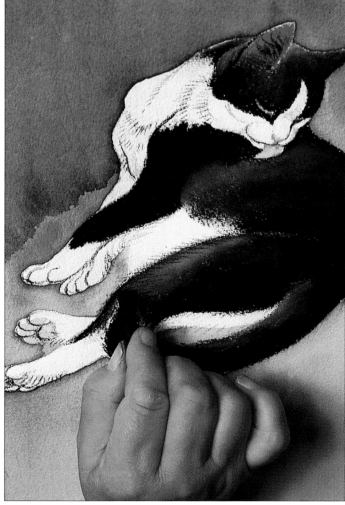

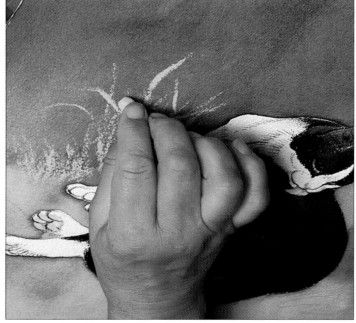

7 With a stick of grass green, tint No. 4, the artist draws the blades of grass, the watercolor wash providing the base color *above*. Black is used to add form to the tufts of grass.

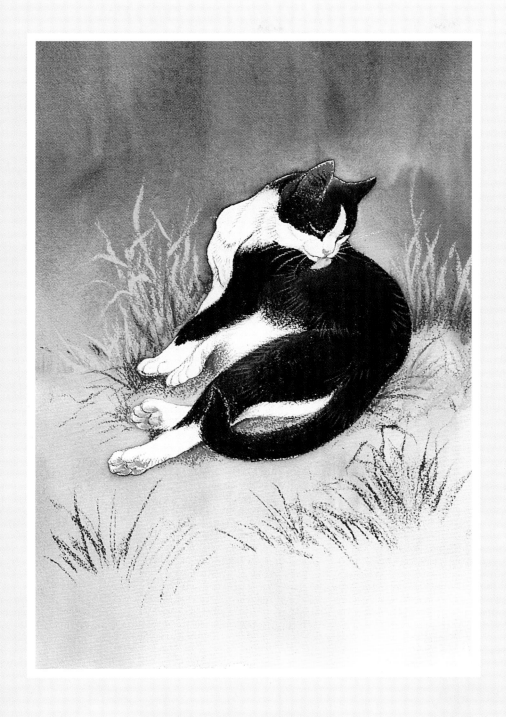

What the artist used

The support was Daler Whatman 140lb watercolor paper 14×10in. The drawing was made with an HB pencil, and the watercolor was applied with a No. 6 sable. The watercolors were half pans of Artists' color — Winsor yellow, cerulean blue, cadmium yellow, burnt sienna and lamp black. For the cat she used a black conté pastel, Rowney blue gray (tint 4), poppy red (tint 1) and grass green (tint 4).

Black and White Cat

Sketching with Watercolor

In this very brief sketch the artist has recorded information which could be incorporated into a larger painting in another medium. The sketch records notes on color, tone and form. The paper is ordinary drawing paper which is not stretched and therefore wrinkles slightly. This does not affect the usefulness of the sketch and, if necessary, the paper can be stretched later. This requires a jar of clean water, a large brush, a drawing board or other flat surface and four strips of gummed paper cut to the required length. Place the dry painting face-down on a flat surface — a wooden drawing board or a sheet of glass or melamine — the smoother the surface the better. With a large, soft fibered brush apply water to the back of the paper, making sure that it is thoroughly damp and that you have not missed any parts. Then turn the damp sheet of paper over and tape it to the surface, making sure that the paper is completely flat, but do not apply any pressure or the paper may tear. Leave it to dry naturally.

Try using your watercolors in this free and direct way, dashing in color with fluid movements of the hand. Lift the color directly from the pans rather than mixing elaborate washes, and in this way you will learn more about the medium and will also improve your drawing and ability to summarize a scene or subject.

1 Birds are difficult subjects to work from for they are shy and rarely stay still for very long. However, the ducks in your local park or zoo will be tamer and therefore easier to sketch *right*.

USING A WATERCOLOR BOX

A watercolor box containing dry pans and a brush provides you with all you need for painting outdoors. As you can see in this picture the open lid provides a mixing surface. Some boxes are so small that they will slip into a pocket, others have an integral water container with a lid which turns into a dipper.

2 The shellduck's shape is recorded with a few pencil marks *above center*, scribbled lines describing the patterns of its plumage.

3 With a No. 8 sable brush loaded with water the artist lifts color from a pan of raw sienna and, working quickly, dashes in the band of color across the breast. The other colors are also applied unmixed *above*.

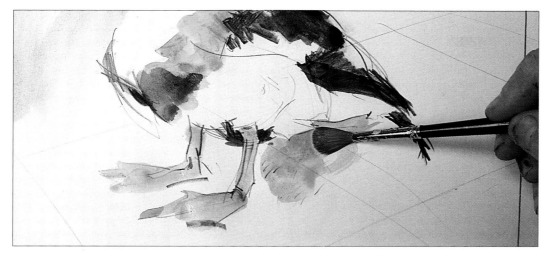

4 The paint is applied quickly, a splash of color here, another there, colors mixing inadvertently on the brush. The background is dashed in — cobalt for the sky and a mixture of cadmium yellow and black for the grass *left*. The sketch is simple but provides the artist with a useful record of what he saw. A set of watercolors is a very useful piece of equipment especially if you are working outdoors.

What the artist used

For this rapid sketch the artist used a sheet of unstretched drawing paper 8½×11in. The drawing was made with a very soft 6B pencil and the color was applied with a Rowney No. 8 Kolinsky sable brush. His paints were a set of Artists' quality watercolors from which he used the following colors — black, raw sienna, cadmium yellow and cobalt.

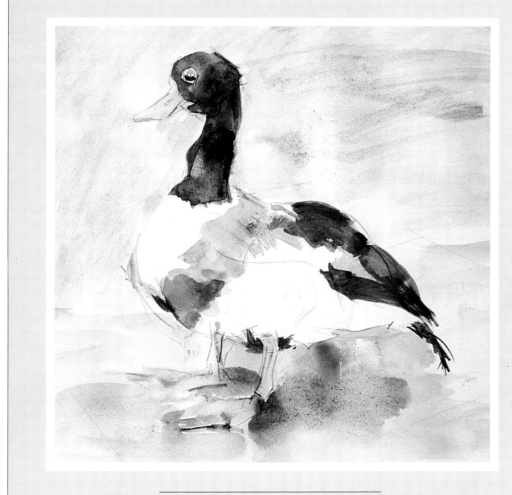

Sketching with Watercolor

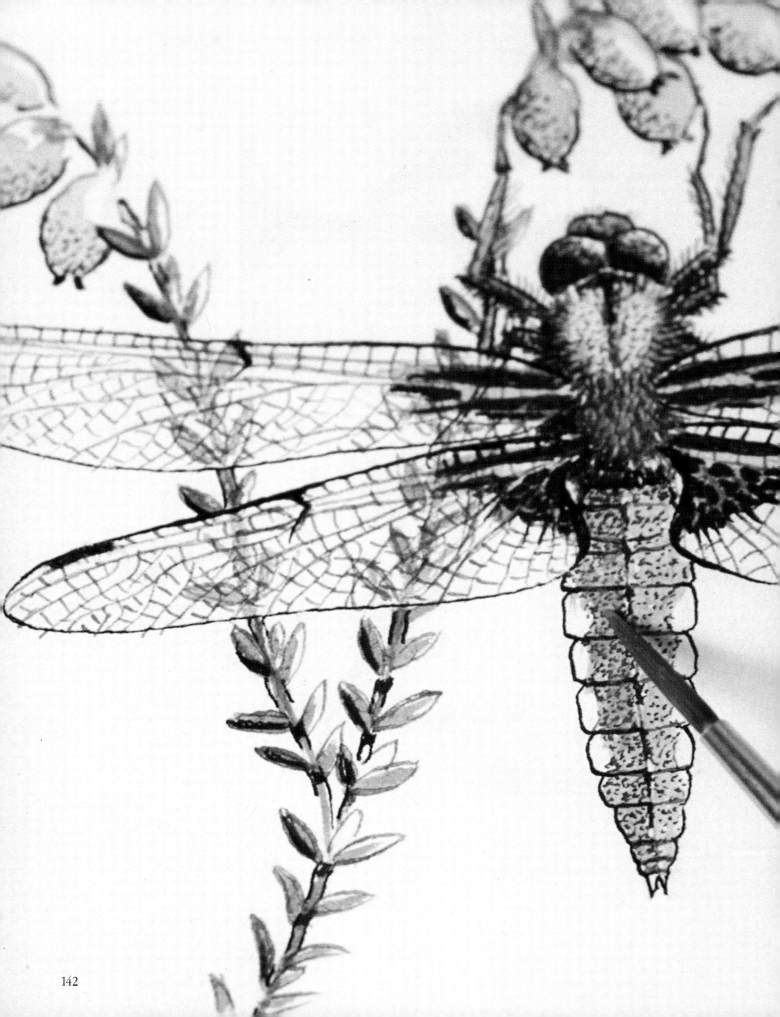

CHAPTER TEN

DRAWING MEDIA

Drawing is an immediate, simple and useful skill. It is a challenging way of representing the visual world and is the best way of recording information quickly. Because the artist approaches a subject very directly with drawing materials, it is a stark technique and you will find that all your faults and weaknesses are exposed. Try to get into the habit of drawing a little every day, experimenting with media and techniques. Some people think drawing is synonymous with pencil drawing, but there is a wide variety of materials to choose from and many new ones have come on the market in the past decade. In this chapter we look at just a few — at pen and wash, pastel, watercolor and fiber pen.

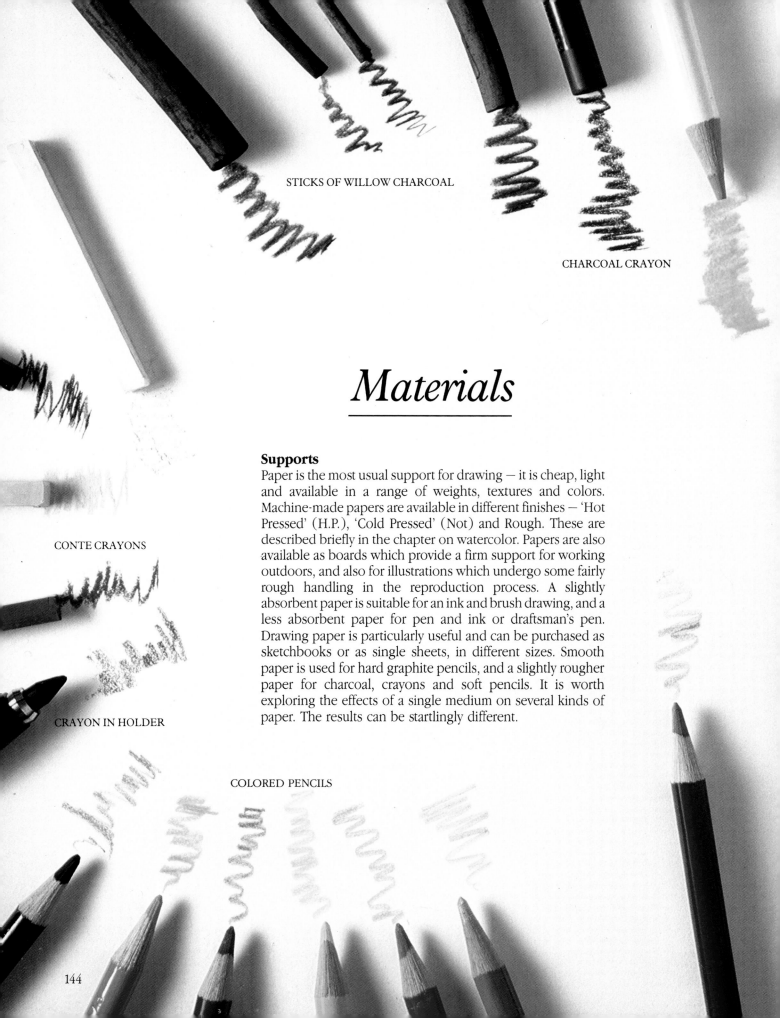

STICKS OF WILLOW CHARCOAL

CHARCOAL CRAYON

Materials

Supports

Paper is the most usual support for drawing — it is cheap, light and available in a range of weights, textures and colors. Machine-made papers are available in different finishes — 'Hot Pressed' (H.P.), 'Cold Pressed' (Not) and Rough. These are described briefly in the chapter on watercolor. Papers are also available as boards which provide a firm support for working outdoors, and also for illustrations which undergo some fairly rough handling in the reproduction process. A slightly absorbent paper is suitable for an ink and brush drawing, and a less absorbent paper for pen and ink or draftsman's pen. Drawing paper is particularly useful and can be purchased as sketchbooks or as single sheets, in different sizes. Smooth paper is used for hard graphite pencils, and a slightly rougher paper for charcoal, crayons and soft pencils. It is worth exploring the effects of a single medium on several kinds of paper. The results can be startlingly different.

CONTE CRAYONS

CRAYON IN HOLDER

COLORED PENCILS

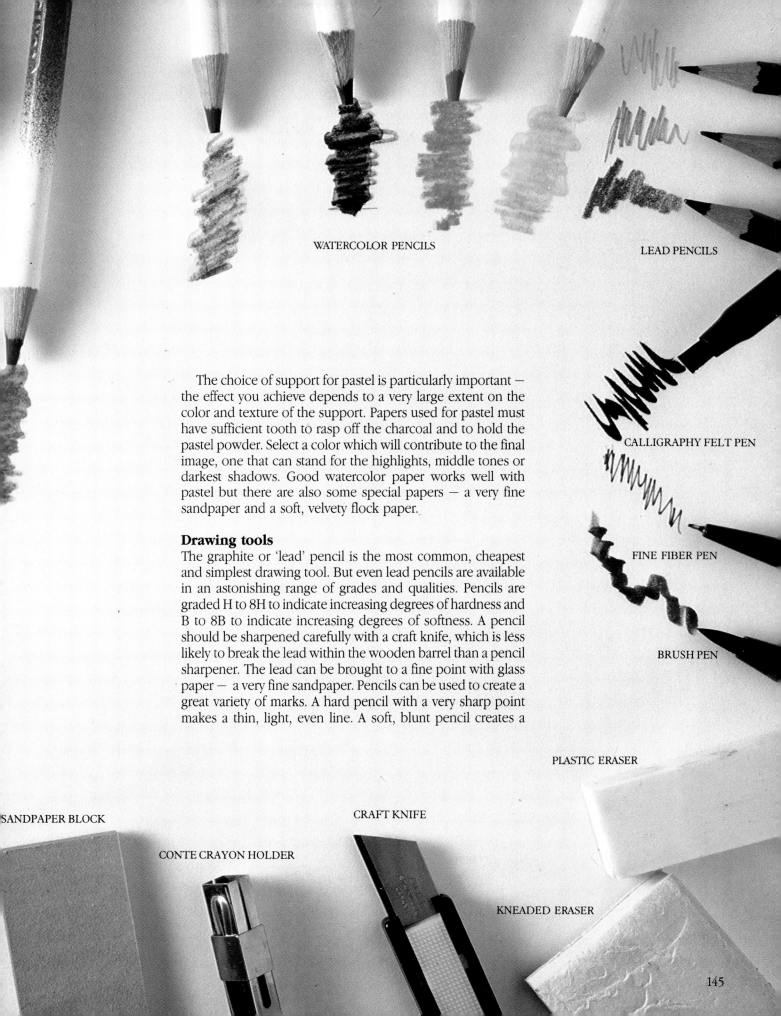

WATERCOLOR PENCILS

LEAD PENCILS

CALLIGRAPHY FELT PEN

FINE FIBER PEN

BRUSH PEN

The choice of support for pastel is particularly important — the effect you achieve depends to a very large extent on the color and texture of the support. Papers used for pastel must have sufficient tooth to rasp off the charcoal and to hold the pastel powder. Select a color which will contribute to the final image, one that can stand for the highlights, middle tones or darkest shadows. Good watercolor paper works well with pastel but there are also some special papers — a very fine sandpaper and a soft, velvety flock paper.

Drawing tools

The graphite or 'lead' pencil is the most common, cheapest and simplest drawing tool. But even lead pencils are available in an astonishing range of grades and qualities. Pencils are graded H to 8H to indicate increasing degrees of hardness and B to 8B to indicate increasing degrees of softness. A pencil should be sharpened carefully with a craft knife, which is less likely to break the lead within the wooden barrel than a pencil sharpener. The lead can be brought to a fine point with glass paper — a very fine sandpaper. Pencils can be used to create a great variety of marks. A hard pencil with a very sharp point makes a thin, light, even line. A soft, blunt pencil creates a

PLASTIC ERASER

SANDPAPER BLOCK

CRAFT KNIFE

CONTE CRAYON HOLDER

KNEADED ERASER

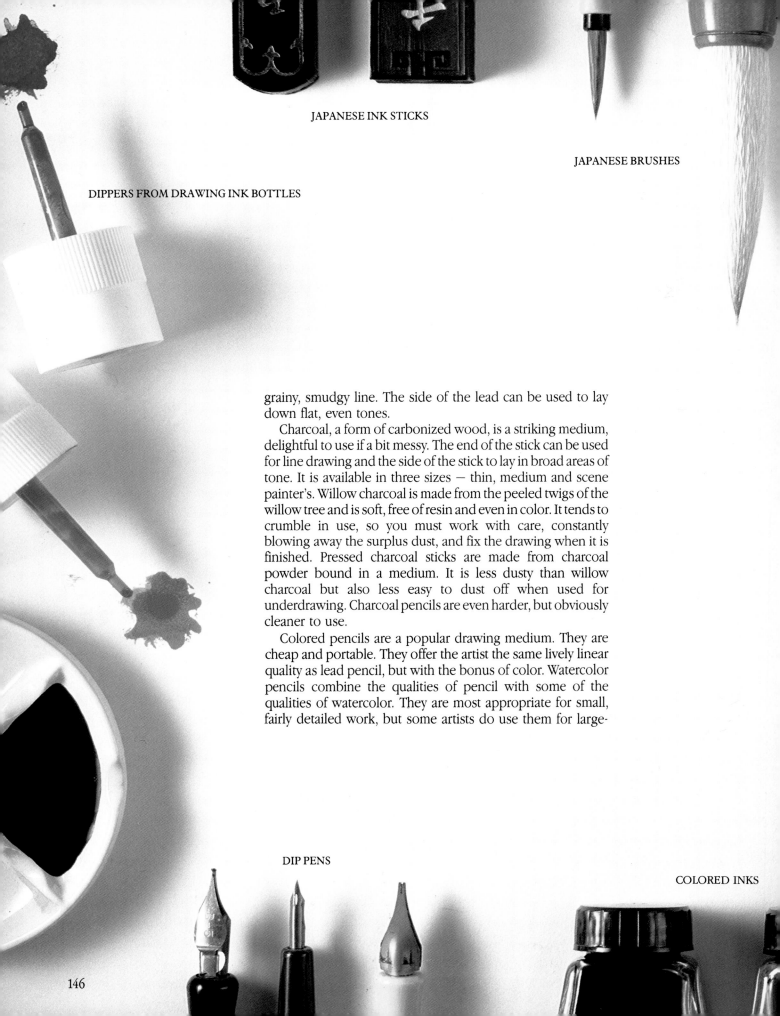

JAPANESE BRUSHES

DIPPERS FROM DRAWING INK BOTTLES

grainy, smudgy line. The side of the lead can be used to lay down flat, even tones.

Charcoal, a form of carbonized wood, is a striking medium, delightful to use if a bit messy. The end of the stick can be used for line drawing and the side of the stick to lay in broad areas of tone. It is available in three sizes — thin, medium and scene painter's. Willow charcoal is made from the peeled twigs of the willow tree and is soft, free of resin and even in color. It tends to crumble in use, so you must work with care, constantly blowing away the surplus dust, and fix the drawing when it is finished. Pressed charcoal sticks are made from charcoal powder bound in a medium. It is less dusty than willow charcoal but also less easy to dust off when used for underdrawing. Charcoal pencils are even harder, but obviously cleaner to use.

Colored pencils are a popular drawing medium. They are cheap and portable. They offer the artist the same lively linear quality as lead pencil, but with the bonus of color. Watercolor pencils combine the qualities of pencil with some of the qualities of watercolor. They are most appropriate for small, fairly detailed work, but some artists do use them for large-

DIP PENS

COLORED INKS

146

NIB UNITS FROM
ROTRING RAPIDOGRAPHS

SMALL SYNTHETIC ROUND

COLORED PAPERS

SYNTHETIC FLAT

scale work. These pencils can be used in two ways — either dipped in water before being applied to the surface or worked into the finished pencil drawing with a brush and water. If you use a lot of watercolor pencils, you will need stretched paper.

Pen and ink has been popular with artists for centuries and is capable of a variety of techniques and finishes. Simple dip pens consist of a holder and a nib. They produce flowing lines which can be made to swell and thin, creating contours that suggest the solidity of the form. They are popular because they are cheap, and there is a huge range of nibs to choose from. Other more traditional drawing tools such as reed and bamboo pens and quills are also popular and worth trying. Fountain pens have the advantage of carrying a reservoir of ink. Nibs are interchangeable and some are specially designed for sketching and drawing. Having selected a pen you then have to choose an ink and again there are several on the market. Both waterproof and non-waterproof drawing inks are available in a range of colors.

Felt and fiber-tipped pens are another alternative much favored by designers and graphic artists. Each has different characteristics — some are water-based and are therefore

WATERCOLOR
PAPERS

SKETCHING NIBS FROM FOUNTAIN PENS

DRAWING PAPER

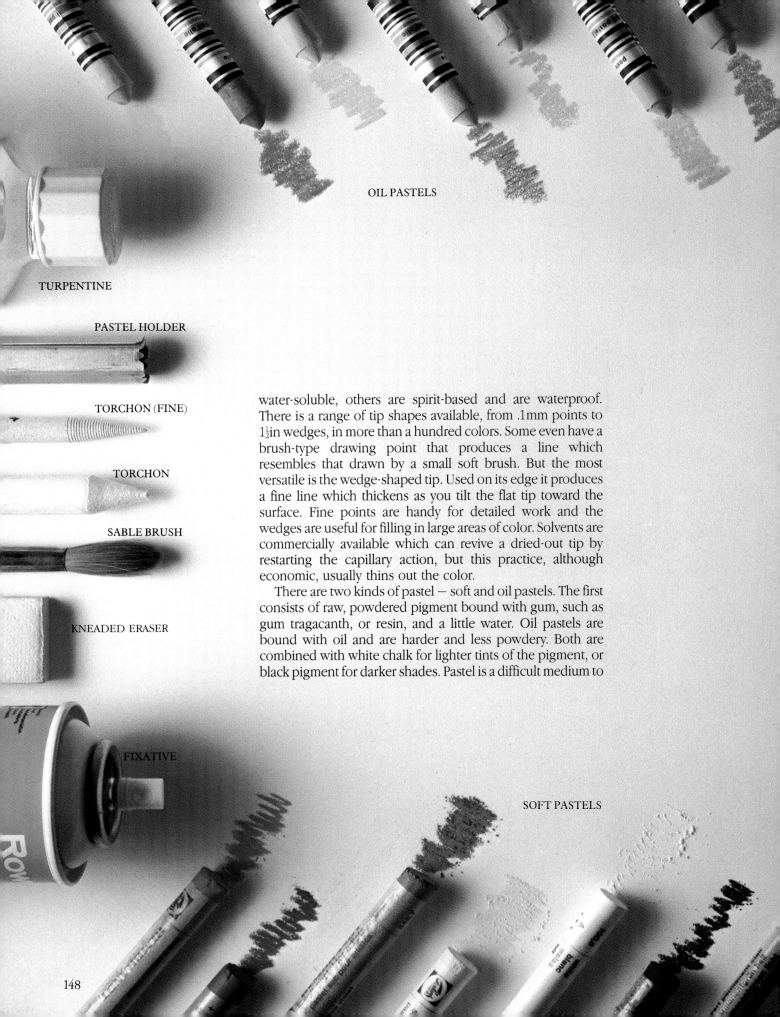

OIL PASTELS

TURPENTINE

PASTEL HOLDER

TORCHON (FINE)

TORCHON

SABLE BRUSH

KNEADED ERASER

FIXATIVE

SOFT PASTELS

water-soluble, others are spirit-based and are waterproof. There is a range of tip shapes available, from .1mm points to 1½in wedges, in more than a hundred colors. Some even have a brush-type drawing point that produces a line which resembles that drawn by a small soft brush. But the most versatile is the wedge-shaped tip. Used on its edge it produces a fine line which thickens as you tilt the flat tip toward the surface. Fine points are handy for detailed work and the wedges are useful for filling in large areas of color. Solvents are commercially available which can revive a dried-out tip by restarting the capillary action, but this practice, although economic, usually thins out the color.

There are two kinds of pastel — soft and oil pastels. The first consists of raw, powdered pigment bound with gum, such as gum tragacanth, or resin, and a little water. Oil pastels are bound with oil and are harder and less powdery. Both are combined with white chalk for lighter tints of the pigment, or black pigment for darker shades. Pastel is a difficult medium to

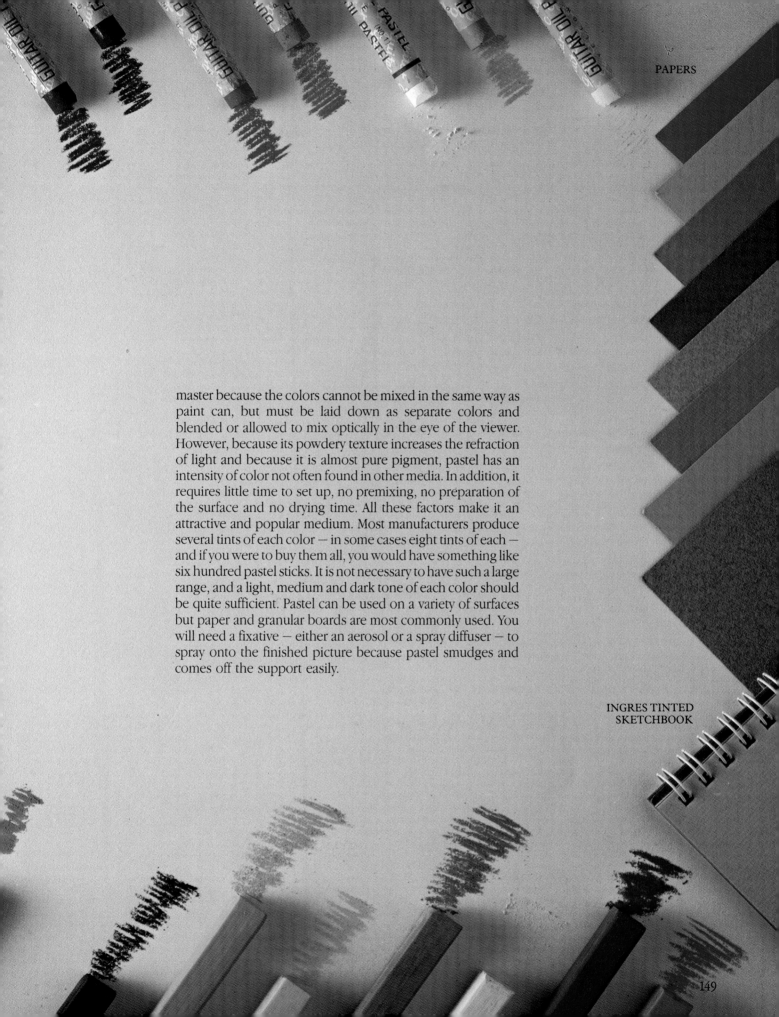

master because the colors cannot be mixed in the same way as paint can, but must be laid down as separate colors and blended or allowed to mix optically in the eye of the viewer. However, because its powdery texture increases the refraction of light and because it is almost pure pigment, pastel has an intensity of color not often found in other media. In addition, it requires little time to set up, no premixing, no preparation of the surface and no drying time. All these factors make it an attractive and popular medium. Most manufacturers produce several tints of each color — in some cases eight tints of each — and if you were to buy them all, you would have something like six hundred pastel sticks. It is not necessary to have such a large range, and a light, medium and dark tone of each color should be quite sufficient. Pastel can be used on a variety of surfaces but paper and granular boards are most commonly used. You will need a fixative — either an aerosol or a spray diffuser — to spray onto the finished picture because pastel smudges and comes off the support easily.

INGRES TINTED
SKETCHBOOK

Lion's Head

Here the artist mixes media and produces an image which combines drawing and painting. The study was worked up from a series of sketches made in the zoo and from her knowledge of the subject.

Pastel is a flexible medium which can be used to create subtle blended veils of color, or broader, more painterly effects. Here the artist wanted to exploit its textural qualities, using smooth blended tones to describe the velvety texture of the lion's face, and vigorous strokes of color to draw its heavy mane. Pastels can be used in many ways. By varying the amount of pressure applied to the stick the artist can create a variegated line, thin in parts and swelling in others. By breaking the stick and flicking on the color a crisper line is achieved. The blunt end of the stick applied to the surface with firm, even pressure forces the color into the grain of the paper, creating areas of dense flat color. By laying color with the side of the stick, the artist creates areas of broad grainy, color.

Here the artist has combined media in a surprising way. Her support is a sheet of Ingres paper, chosen for the color which provides a useful middle tone and shows through the final drawing, holding all the other colors together. She works into this with a strong watercolor wash, wetting the paper and allowing the color to run into the wetted areas, establishing the darker tones of the subject. This allows her to work light over dark, particularly useful when it comes to building up the texture of fur. The shadows in the hair are created by moving the wash around, allowing it to run freely and form puddles.

At this stage the painting was left to dry. The artist then began to work with soft pastels, using a limited range of colors to prevent the picture from looking too fussy. The final image is an accurate and sympathetic portrait of a splendid animal. The artist has used the media with imagination. By choosing a tinted paper which helps the final image, and by establishing the broad tonal areas with watercolor, she is free to use the pastel descriptively to convey the texture, form and direction of the hair of the mane, and expressively to convey the excitement and energy of the subject.

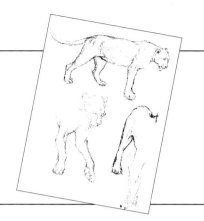

1 The portrait of a lion on these pages was developed from a series of sketches made in the zoo *right*.

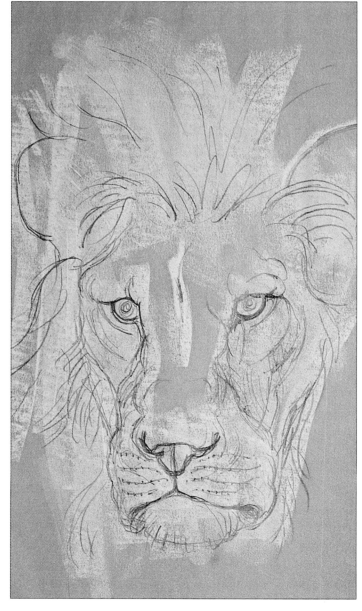

2 The artist made a detailed preliminary drawing. She transfers the basic lines of the composition to the support by chalking the back of the drawing and tracing over it lightly with a pencil. It is important not to use too much pressure or you will make indentations on the support. The pastel will not cover these, leaving a ghost image. The drawing was made on tracing paper, which is why you can see both the drawing and the chalk on the other side *right*.

3 The drawing is transferred to a sheet of sand colored Ingres paper, chosen because it provides a useful middle tone. The tracing is very light — you can still see some of the fine white lines *below*. The artist strengthens the image by going over the traced lines with a conté pastel crayon. She then develops the drawing using her preliminary drawing and other reference.

4 The artist now mixes a watercolor wash of yellow ocher, burnt sienna and lamp black. She uses this to establish the main dark tones, wetting the paper and running the wash into the wetted areas *right*.

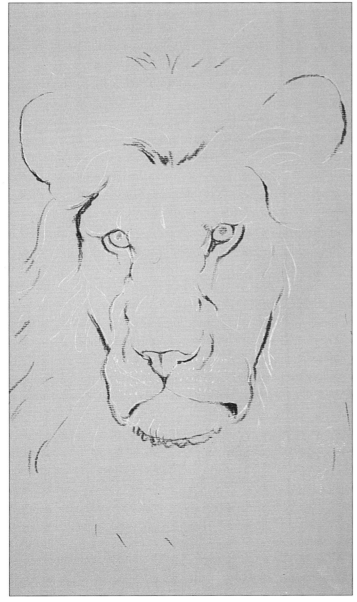

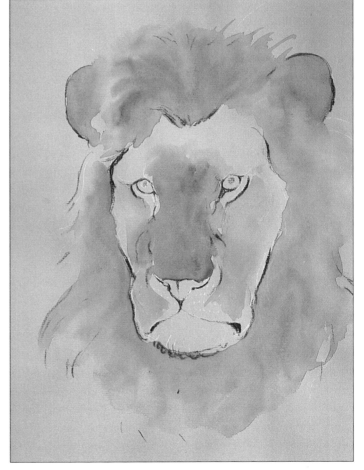

5 The combination of watercolor and pastel allows the artist to work light over dark, and is a useful technique for describing fur and hair. Here the artist has indicated the shadows in the hair by moving the wash around, allowing it to run freely and to form puddles in some areas *above*.

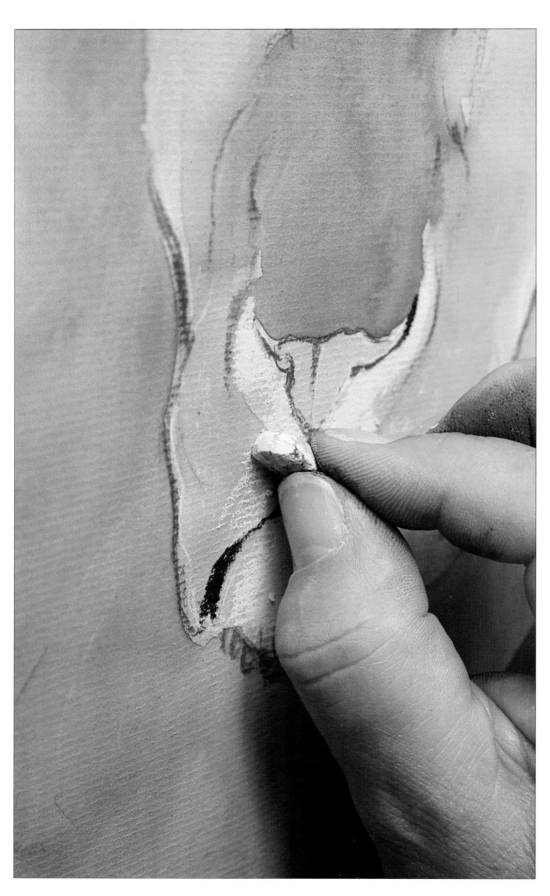

6 The watercolor wash is allowed to dry completely before the artist progresses to the next stage. She then starts to work over the underpainting in pastel, establishing the strongest tones first. This gives her a key for the mid-tones and for later details. She is using Rembrandt soft pastels. Yellow ocher/227-9 is used for the light tone *left*.

7 Pastel can be applied in many ways — with the tip of the stick, with a sharp broken edge or with the side of the stick. Here the artist uses the side of a small stump of Mars violet/536-3 to touch in the tuft of hair on the top of the head *right*.

8 The same tint of Mars violet is used for the shadow in the ears. The eyes were put in with orange/235-3 and a cadmium yellow *right*.

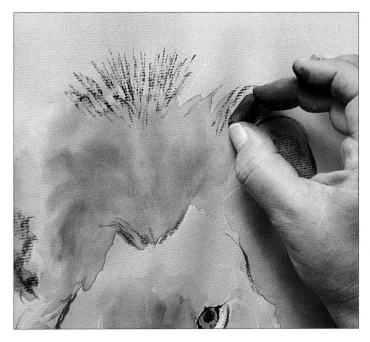

FIXING PASTEL

Pastel is rather delicate, because the pigment is powdery and has very little medium to bind it. The color sits on top of the support and can very easily be dislodged or smudged. The easiest way to fix pastel is with a commercial fixative sold in an aerosol can. A fine mist of fixative sprayed over the image will protect it from damage. The image can be fixed as the work progresses, allowing the artist to work fine details into existing color without one contaminating the other. It should also be given a final light spray of fixative when it is finished.

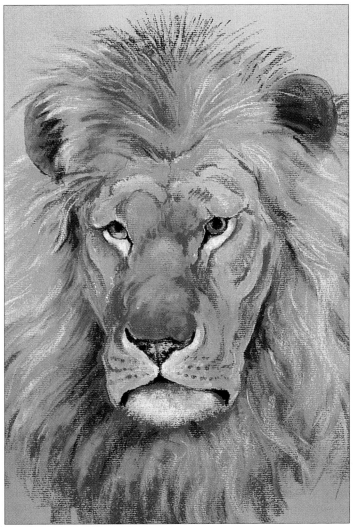

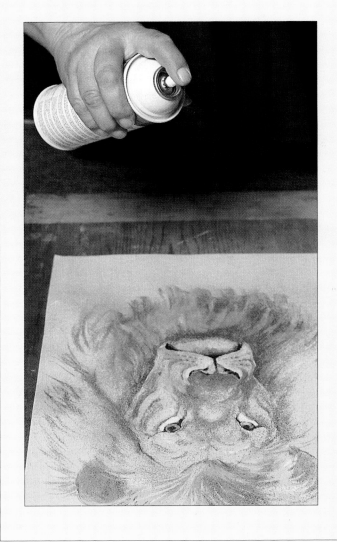

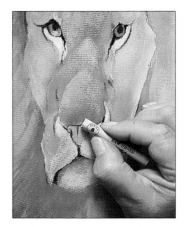

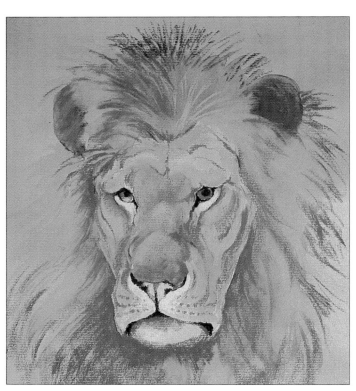

9 The artist starts to apply broader areas of color to the mane and parts of the face using yellow ocher/227·5. She uses a darker tint of yellow ocher and raw umber for the darker tones in the mane and on the face *above*.

10 Using the same dark yellow ocher and raw umber the artist continues to work into the mane and develops the loose folds of skin on the face *left*.

11 The artist uses white pastel to add highlights in the hair and on the face. Notice the way the white is applied as a light film of broken color on the chin *below*. After fixing the drawing the artist decides to lighten the outer edges of the mane using yellow ocher pale and a little white. She also develops the darkest shadows in the mane and in the ears using a dark tint of raw umber. These final dark touches give increased depth to the final image, and bring it to life.

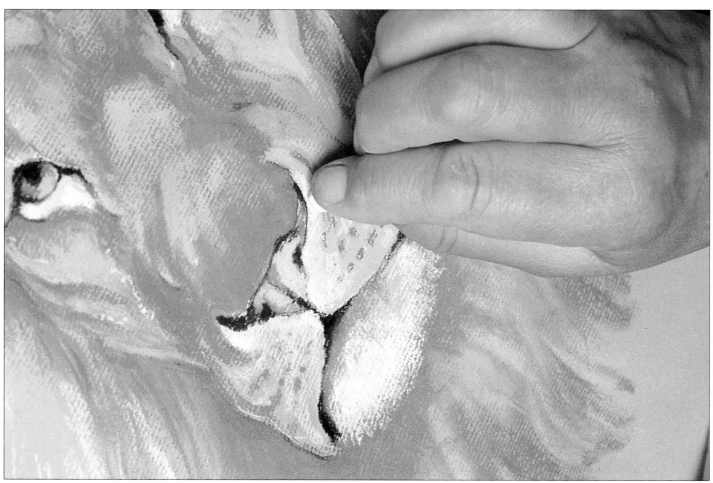

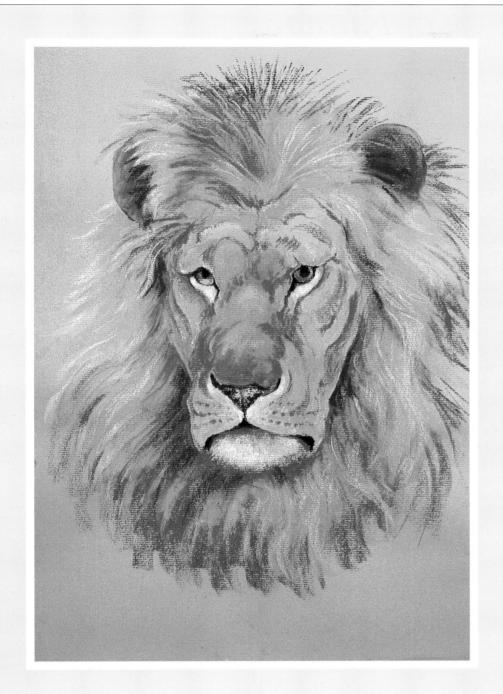

Lion's Head

What the artist used

The support was a sheet of sand colored Ingres paper 18×12in. She used an HB pencil, a conté pastel crayon, a set of Rembrandt soft pastels, and Artists' watercolors in the following colors: yellow ocher, burnt sienna and lamp black. She also used an aerosol fixative.

Rhino

The artist chose fiber pen for this drawing of a pair of rhino because the hard, rather mechanical line suited their blocky, bulky forms and the finely hatched lines reflected the quality of their thick hides. The pen produces a fine, even line which can be varied by tilting or by holding it loosely so that it skims the paper surface producing a scratchy, broken line. These pens are light and cheap, and contain a reservoir of ink so that you do not have to carry a pot of ink. They do not blot and the ink does not become clogged in the nib. The tips do become slightly softer with age, but the effect can be quite pleasing and you could use both new and worn pens in the same sketch or drawing to increase the variety of marks.

The artist was interested in the solid sculptural qualities of the subject, the two animals being seen as one, creating an almost abstract form. He has explored the possibilities of the pen with imagination and sensitivity, and evolved a vocabulary of marks to describe the different areas. Tones are created using a system of hatching and cross-hatching, the darker the tone the more densely the lines are laid — the highlight areas are left completely white.

Tone is a difficult concept to cope with, but try thinking of it as having two aspects. The tone of a color is its lightness or darkness, every color has a tone and colors of different hues may have the same tone. But the tone of a color is affected by the amount of light which it receives, and it is this aspect of tone which allows us to see the forms of objects — forms are only visible when revealed by light. Thus it is possible to make two completely different tonal drawings of an object. You can ignore the tone of the color and regard the objects as having just a light or dark side, a useful way of exploring the form and modeling of a subject. Alternatively you can give each object its relative tonal value, so that in a light object the difference in tone between the light and the dark will be greater than in a darker object.

In this drawing the artist has been able to treat the tones fairly simply because the animals are a uniform light color and the paper is allowed to stand for the upper surfaces which receive the maximum amount of light. A way of simplifying the tones of a subject is to peer at them through half-closed eyes.

1 This drawing was developed from a series of sketches and from photographic reference. This sketch, *right*, was made at the zoo.

2 The artist starts by making a few marks which place the animals within the picture area, but he does not make a complete outline drawing. He is interested in the forms, and in capturing the blocky bulk of the animals. He looks for the darkest tones — the inside of the ear and the shadow area between the head and torso. These dark tones are built up by a careful system of hatching, laying down closely spaced parallel lines, working first in one direction and then going over them in another, repeating the process until he has achieved the required density of tone *right*.

3 In the detail, *below*, we can see just how complicated a web of marks the artist has built up for this, the darkest part of the drawing. Each line is slightly thicker at the beginning because it is in contact with the paper for slightly longer than other parts of the line.

CREATING TONE AND TEXTURE WITH FIBER PEN

Below we see a range of marks and effects that can be achieved with a fine fiber pen. This is just one of a new range of pens which are now available to the artist, each with their own special qualities and marks — there seems to be a new one on display every time you visit an artist's supplier. This particular pen produces a hard, even line which resembles in many ways the marks made by a stylo-pen but the fiber pens are considerably cheaper and much easier to use. Whenever you start to use a new drawing instrument it is useful to spend some time exploring its possibilities in this way.

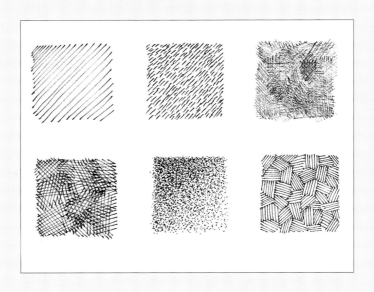

4 The artist proceeds to develop the forms, looking for the dark and middle tones, allowing the white of the paper to stand for the lightest tones. He works from the inside outward, so that the contours emerge from the complex pattern of lights and darks. The resulting image, *right*, has more solidity than one which is fitted within an outline.

5 The dark background is laid in with a dense mesh of pen marks, the transition between light and dark creating the outline of the second rhino *below*.

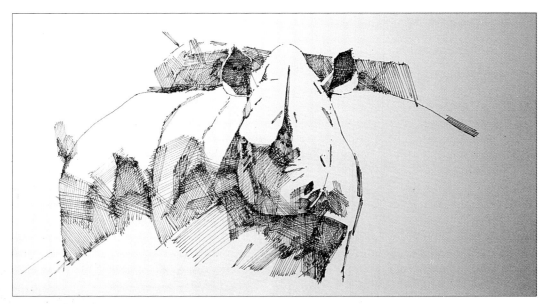

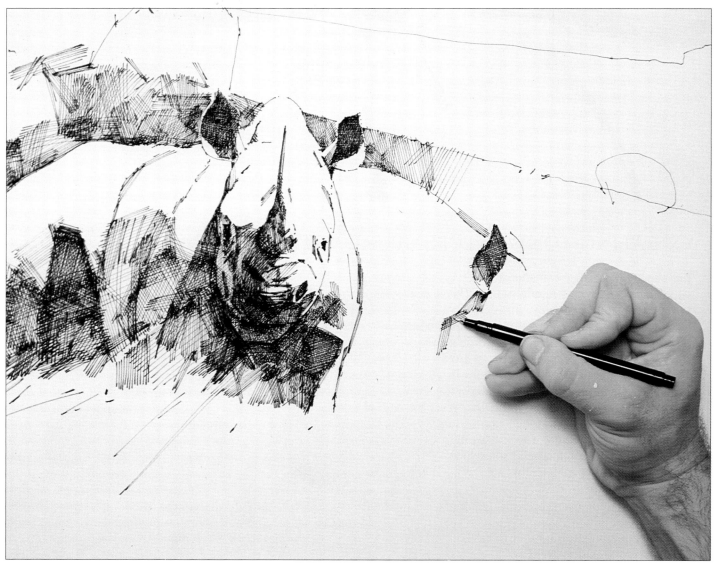

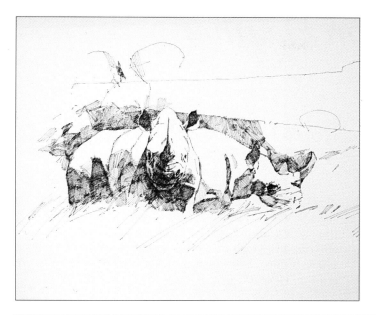

6 Working in the same way the artist develops the profile head of the second animal. Again he concentrates on the way the light strikes the forms, seeing the animals as a series of flat planes *left*. He completes the drawing by scribbling loose marks in the foreground. These serve two functions they suggest the grassy vegetation and bring the foreground up toward the picture plane, thus creating a sense of space and recession in the drawing.

What the artist used

The support was a sheet of drawing paper $8\frac{1}{2} \times 11$in on which he drew with an ultra-fine fiber pen.

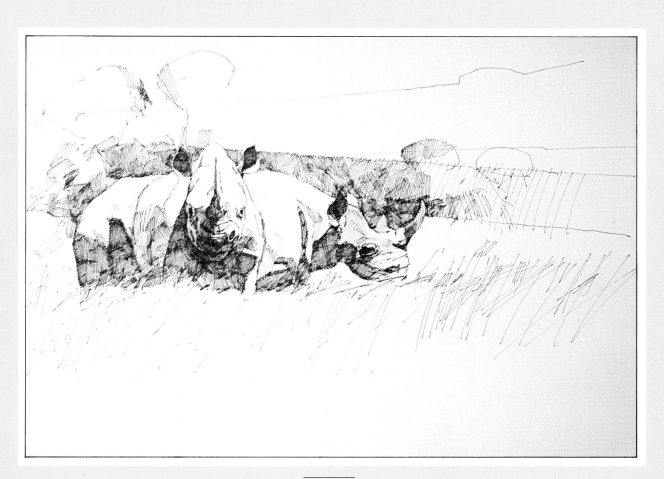

Rhino

Dragonfly on Heather

Watercolor is available in several forms — in pans, tubes and in a fluid form in bottles. Bottled watercolors are concentrated and come complete with droppers for transferring the paint to the palette or pot for mixing. Watercolor in any of these forms can be used for all the usual watercolor techniques but they can also be used for drawing with pen or brush. Here the delicate nature of the subject suggested this linear approach.

This drawing was made from a dead specimen in the artist's collection. He made a quick sketch with a soft pencil to sort out the composition, marking the position of the insect with a cross. Then, using the same fine pencil, he drew the dragonfly, studying the subject carefully and judging the angles and proportions by eye. This was a critical stage for he had to be sure that the drawing was accurate before he progressed to pen and ink when it would be impossible to make changes without spoiling the clean lines of the image. When he had made all the necessary adjustments and was quite sure that the drawing was correct he drew over the pencil lines with a fine dip pen and dilute black drawing ink. He found the drawing paper a bit of a problem because the nib of the pen caught on the paper surface — a smooth art board would have been more sympathetic to this particular technique.

The main part of the drawing was developed with a fine brush and a pen and a variety of line, stippling and solid color. The delicate tracery of the insect's wings are captured with a mesh of fine lines, and the marks on the body are carefully chosen to suggest form and the different textures. The drawing captures the breathtaking delicacy of the insect and is, at the same time, an accurate and informative illustration of a fascinating creature.

USING A FINGER STOCK AS AN ERASER

Erasing is a problem for the artist and in an ideal world it would not be necessary. It can destroy the surface of the paper and with a technique such as this which relies on the quality of the line it is important to minimize the amount of erasing. Here the artist is using a finger stock or rubber thimble, like those used in offices, to rub out some pencil lines. He finds it more gentle and effective than any other eraser.

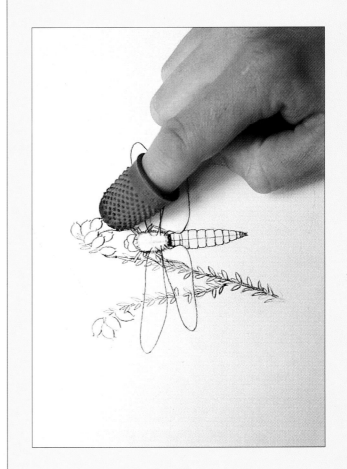

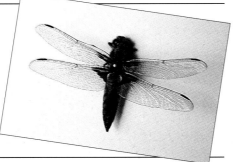

1 The artist had a specimen to draw from — obviously the best way of producing an accurate drawing of such a small and complex subject *right*.

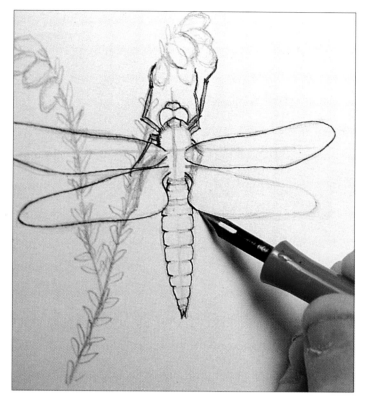

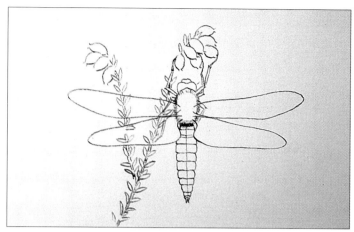

2 The artist starts by making a simple sketch in which he sorts out the composition, the position of the insect in relation to the sprig of cross-leaved heather, and the relationship of the image to the edges of the picture. Next he draws onto the support in pencil, going over the basic outline with a fine-nibbed drawing pen *left*.

3 He erases the pencil lines *above*.

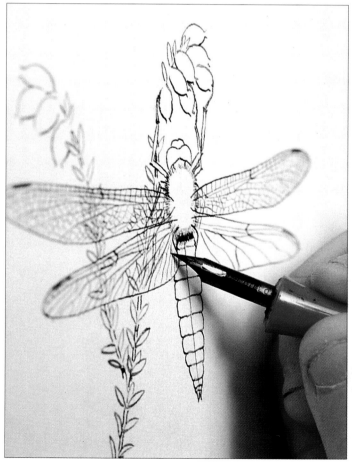

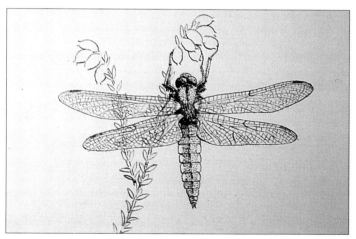

4 Using an H pencil he puts in the venation on the wings. With the same fine dip pen he draws over the pencil lines using dilute black ink. When the ink is dry he erases the pencil marks *left*. The nib of the pen is inclined to catch on the drawing paper, so a smooth artboard would be better for such a detailed drawing.

5 The body of the insect is described using a system of fine hatched strokes and stippling. Both systems create form through shading but also suggest the differentt extures of the dragonfly's body. Hatched strokes are used for the central part of the body and stippled dots for the tail *above*.

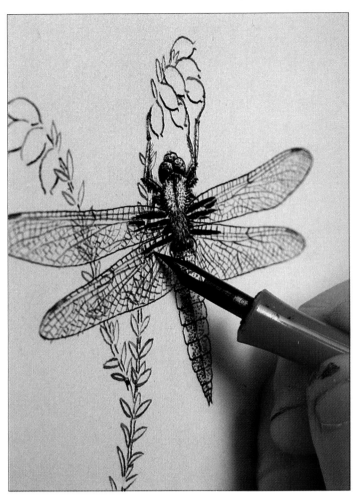

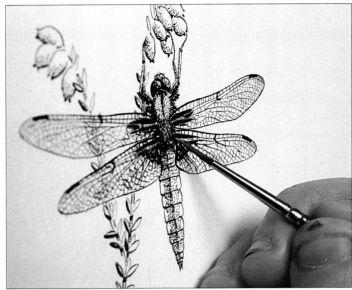

6 By varying the density of the dots and lines it is possible to suggest the shading around the body — the darkest area around the base of the wings is put in as solid color *left*.

7 The artist starts to 'fill in' the color using a fine brush and watercolor. A mixture of burnt umber and yellow ocher is used for the base of the wings *above*.

8 The same mixture of burnt umber and yellow ocher is used for the body of the insect. The stem of the heather is olive green and the flowers are

a mixture of crimson and burnt umber. For the tail of the dragonfly the artist mixed a blue-gray from Payne's gray and white *below*.

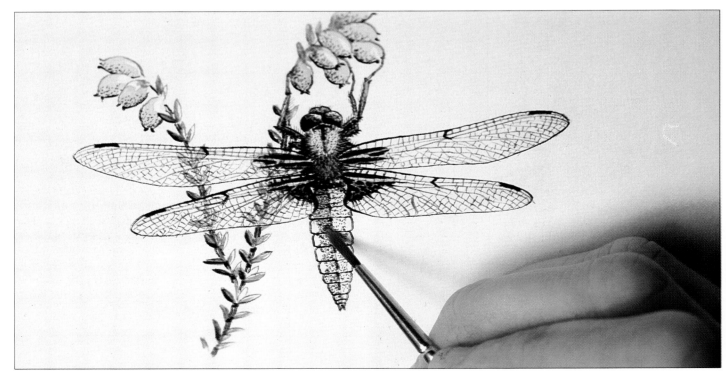

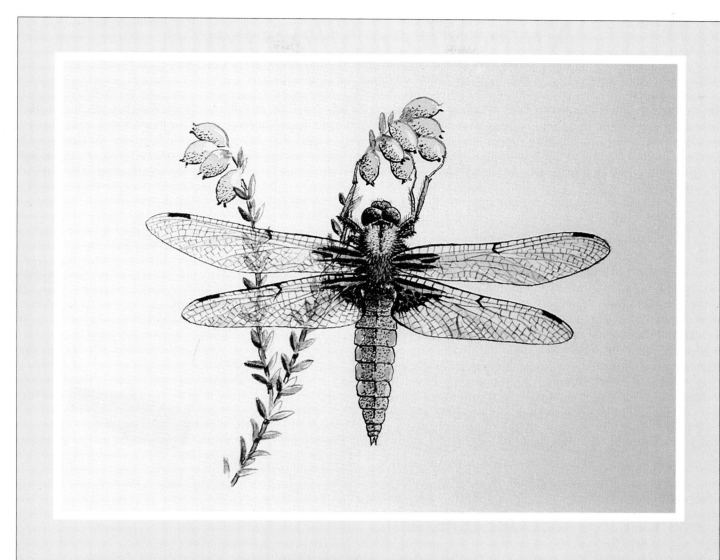

Dragonfly on Heather

What the artist used

The support was a sheet of drawing paper 5½×8½in. He used a B and an H pencil, a fine nibbed dip pen and black ink, a No. 0 sable brush and a finger stock for an eraser. He used Artists' quality pan watercolors in burnt umber, yellow ocher, Payne's gray, crimson and olive green.

Nuthatch on Silver Birch

The nuthatch is a small sprightly bird, which is often seen walking up a tree trunk or, as here, walking vertically down. It has plain gray upper parts, buff to orange underparts and a dark eye stripe which gives it a rather sinister appearance. For this drawing the artist used the skin of a dead bird, a twig of silver birch and a lifetime's experience. He has used this material to produce a drawing which depicts the bird in an instantly recognizable situation and pose, and captures the bird's rather jaunty appearance.

The artist used colored pencil because it is a cheap and portable medium, allowing him to investigate color, tone and texture with a minimum of materials. Many of us associate colored pencil with school and consequently underestimate its value for the artist. It is a very useful medium, particularly popular with illustrators, animators and other artists who use a tight, meticulous technique. Water-soluble pencils are now available and these give the artist the linear qualities of pencil together with the washy, blended effects of watercolor.

As with any medium, colored pencil is capable of a great range of marks and textures and will reveal itself in different ways in the hands of different artists. Here the artist has exploited the linear quality of the pencil to draw the outlines of objects such as the twigs and leaves of the silver birch, with closely laid lines used to describe the fine texture of the plumage. To get the most out of the medium you must learn to use it, and as there is no short cut to familiarity you must use it in order to learn about it. While you should always be in control of your medium, you should nevertheless be aware of its possibilities and its limitations. This drawing is a fine example of the artist working with the medium rather than against it.

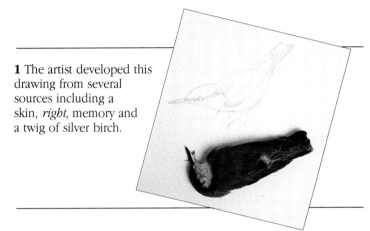

1 The artist developed this drawing from several sources including a skin, *right*, memory and a twig of silver birch.

EXPLORING COLORED PENCIL

Here we see some of the variety of marks that can be achieved with colored pencil. You can also see some of the techniques which can be used to create a range of subtle colors — by hatching, cross-hatching, and overlaying different colors it is possible to create quite subtle modulations of color and tone.

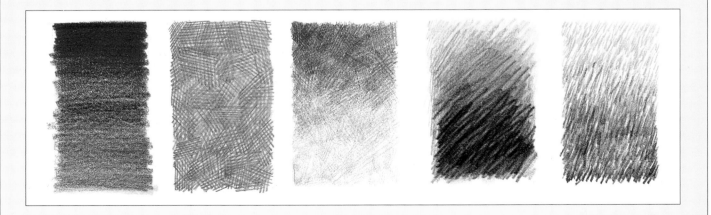

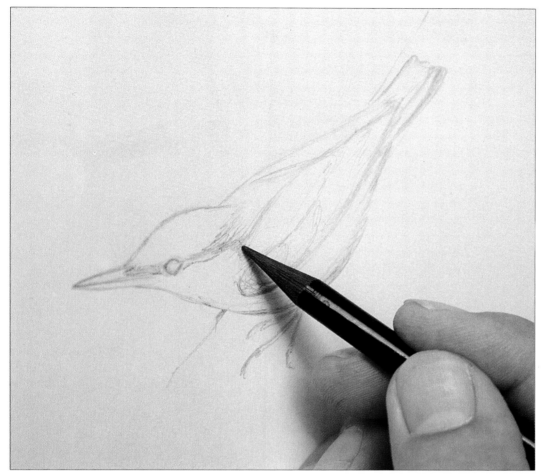

2 He starts by making a fairly detailed pencil drawing which indicates the outline and general forms as well as details such as the wings and the main groups of feather. His knowledge of the subject enables him to capture not only details such as shape, size and plumage, but also those indefinable characteristics which set each species apart *left*.

3 He uses two shades for the blue back feathers, a pale blue and a pinky blue. The colors are laid on lightly with fine hatched lines which follow the direction of the feathers. By using two colors he avoids a flat appearance, and gives the plumage a lively, natural feel. The eye stripe and the darker tones in the underparts are indicated with a lightly applied black pencil. He uses yellow ocher for the buff underparts *below*.

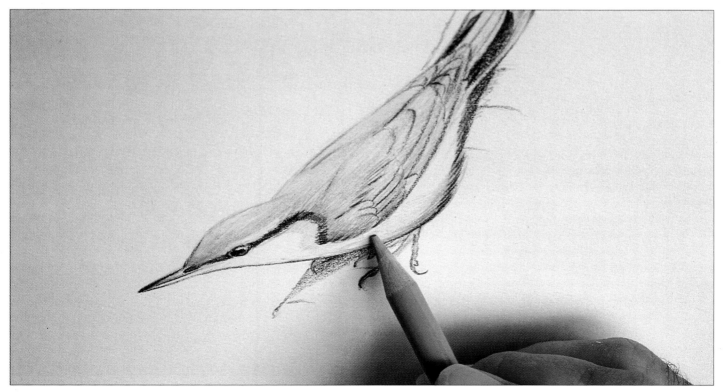

4 He works over the light underparts in lemon yellow. Again the two colors give a livelier result than a single color. The artist has used colored pencil simply and directly, the color being laid on in a very thin layer, the direction of the strokes dictated by the nature of the substance they describe. It is also possible to used colored pencil to create a variety of effects and to build up quite dense color. The artist completes the drawing of the bird by redefining the tail feathers with a black pencil *right*.

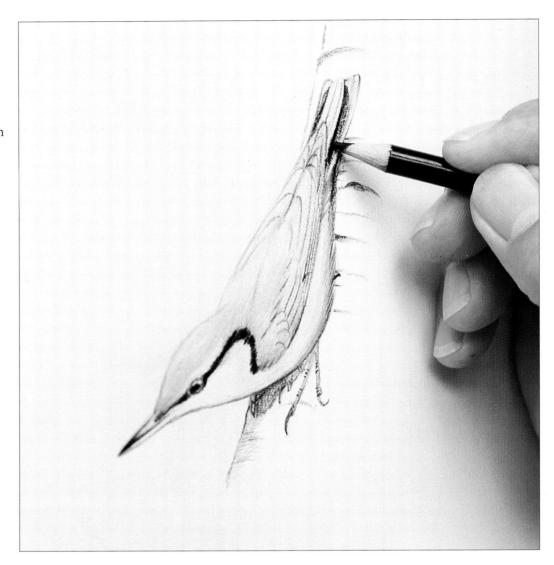

5 In the detail, *right*, we see the carefully controlled way in which the artist has applied the color, even in these background areas. The picture is about lifesize and gives you an idea of how the drawing looked to the artist as he worked on it.

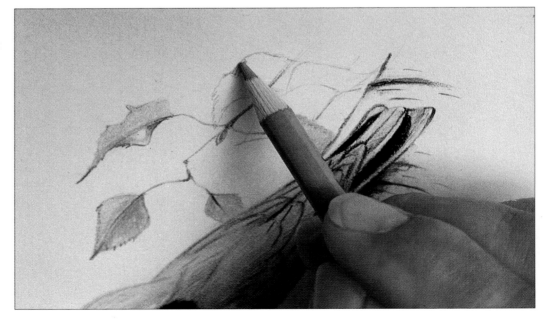

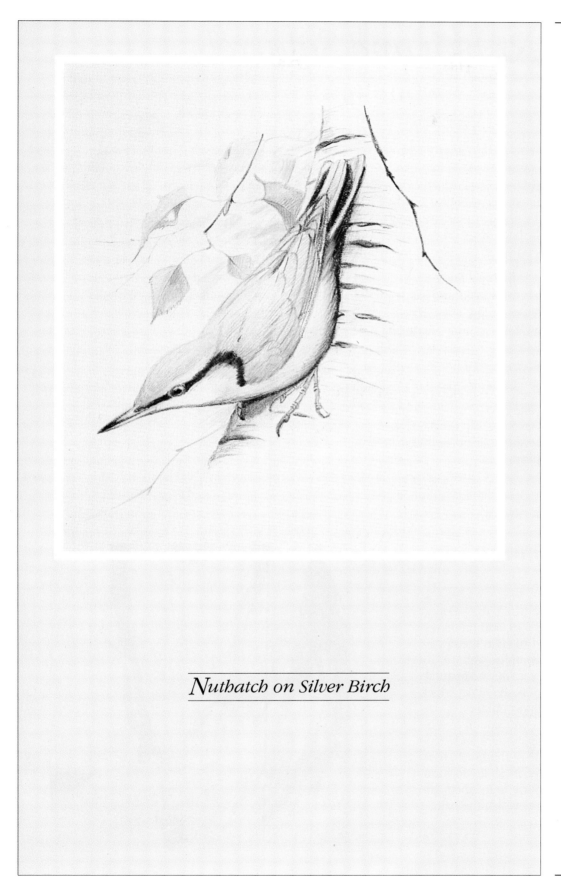

Nuthatch on Silver Birch

What the artist used

He used a sheet of drawing paper 8×5in, a graphite stick and a set of Rowney colored pencils. The colors he used were black, yellow ocher, lemon yellow, pale blue and pale green.

Rabbit and Squirrel

In these simple drawings the artist was exploring the quality of the marks that could be achieved from a single brush. The texture of the paper, the wetness of the paint and quality of the implement used all contribute to the final effect. Other important factors are the artist's feel for line, sensitivity to the medium and willingness to experiment and take risks. She has chosen simple subjects and used the brush in a variety of ways.

In the drawing of the squirrel, the back of the body is laid in as a very wet wash, which is darkened by overlaying more washes to create a rich texture. She has not established a definite outline, for this can be too limiting, resulting in an image which appears stiff and lifeless. By merely indicating the position of the animal and then allowing the forms to grow from the inside out, she creates a lively and convincing drawing. The tail is a particularly good example of this — if she had drawn an outline it would have appeared too solid, and would have lost its attractive fluffiness.

In the drawing of a rabbit she has introduced a very expressive line, using a quill pen. The quill is one of the most pleasing of all drawing tools, and creates a lovely calligraphic line. Quill pens are difficult to get hold of but sets can be bought at most good artist's suppliers.

1 The artist worked from photographic reference to create this drawing *right*. She was not seeking to create a scientifically accurate illustration, rather she wanted a simple subject which would allow her to experiment with the medium.

2 In this drawing the artist is exploring the qualities of a quill pen, a delightfully expressive drawing tool which is often overlooked by artists, both professional and non-professional. In the detail, *right*, we can see some of the varied lines that can be achieved, and the slightly splattery effect which is created when the quill catches on the paper.

TEXTURE WITH BRUSH AND WASH

In this large detail we can see where the paint has been applied as loose washes, and fine lines with the tip of an almost dry brush. In the upper part the artist has built up a complex web of marks which together create yet another textural effect. Notice also the grainy, broken effect which reflects the texture of the support. All the materials make an important contribution to the quality of the final image — the texture and quality of the paper, the shape of the brush, the material from which it is made, its ability to form a point and the amount of spring in its fibers, the kind of paint and the degree to which the paint has been diluted.

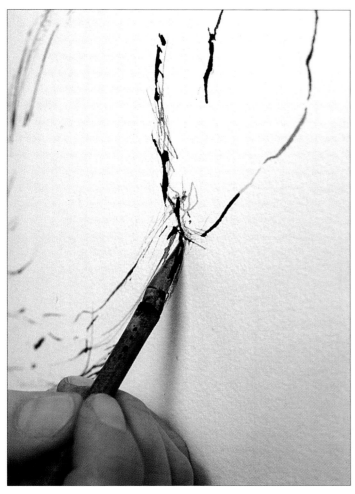

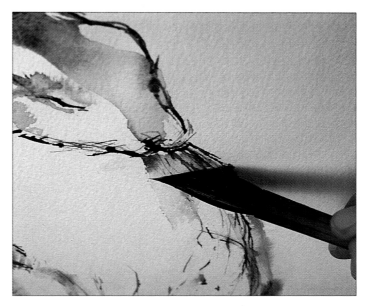

3 The artist uses a Chinese brush to lay in a dilute wash *above*, again looking for the interesting mark, for the way the tool, the color and the texture of the paper interact.

4 The artist uses the very tip of the brush to create a more controlled line *below*. In the final drawing on page *171* you can see the variety of marks which the artist has elicited from the tools at her disposal.

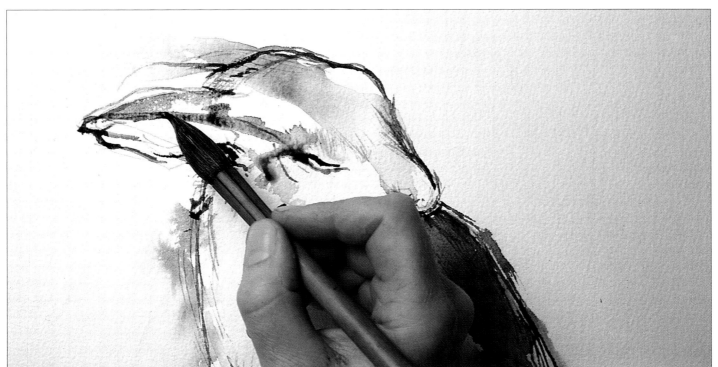

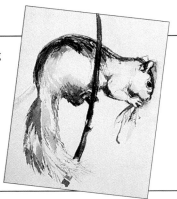

5 As with the previous drawing the artist worked from photographic reference to make this sketch, looking for simple subjects which would allow her to work freely *right*.

6 The artist starts by laying in a wet wash with which she establishes the back of the animal. Again she is exploring the quality of the marks and uses the entire brush with a sweeping movement in some places, and the pointed tip in others *below*.

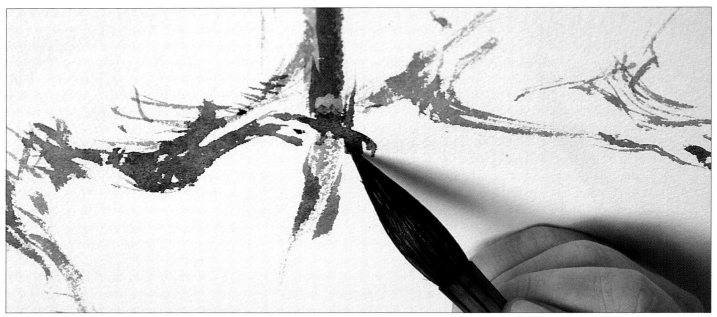

7 The artist does not draw an outline, but uses a series of loose marks to define the form. The image emerges naturally, and has a lively quality which may be absent if you proceed directly to the outline *right*.

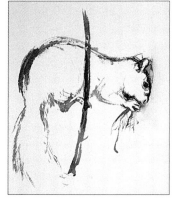

8 In the detail, *right*, we see the variety of lights and darks which the artist has managed to achieve. Many of the marks are a product of the interaction of the soft Chinese brush and the textured paper. The degree of wetness of the paint is also an important factor.

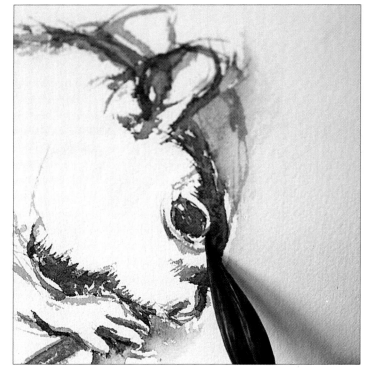

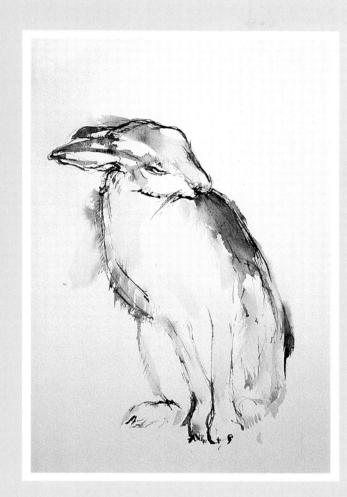

Rabbit and Squirrel

What the artist used

The support was a sheet of Rough watercolor paper $16\frac{1}{2}\times11\frac{5}{8}$in. The drawing was made with a quill and a Chinese brush, using a mixture of sepia and black watercolor, and black ink.

Glossary

ACRYLIC A comparatively new paint in which the pigment is suspended in a synthetic resin. It is quick-drying, permanent and colorfast.

ALLA PRIMA Direct painting in which the picture is completed in one session without any underpainting or underdrawing.

BLENDING The effect that results when wet color runs. Sometimes used deliberately for its marbled effect.

BLOCKING-IN The initial stage of a painting when the main forms and composition are laid down in approximate areas of color and tone.

CLASSICAL METHOD A painting technique which involves making a monochrome underpainting before adding color.

CLAVICLE The collarbone. Left and right clavicles lie horizontally from the front base of the neck to the shoulders.

COMPOSITION The arrangement and combination of different elements to make a picture.

CONTÉ Drawing materials made from graphite, clay, paste and water and compressed into sticks.

CONVERSATION PIECE A portrait of two or more people depicted in appropriate surroundings, often domestic.

COVERING The covering power of a paint refers to its opacity.

CRANIUM (skull) The bony framework of the head.

CROSS-HATCHING A method of building up areas of shadow with layers of criss-cross lines rather than with solid tone.

DRAPE A cloth which is usually used as a background for the sitter.

FIXATIVE Thin varnish which is sprayed on drawing media, especially charcoal and pastel, to prevent smudging and protect the surface.

FUGITIVE A term given to dyes or paints whose color is short-lived, either because of natural defects or natural forces such as sunlight.

GLAZING Painting a transparent film of color over another pigment.

GOUACHE An opaque watercolor similar to poster paint.

GRAPHITE A carbon which is used with clay in the manufacture of lead pencils.

GUM ARABIC Used with watercolor and inks to give body and sheen. Obtained from a species of acacia.

HATCHING A shading technique which uses parallel lines instead of solid tones to build up form.

HUE A term used for a pure color found on the spectrum, ranging through red, orange, yellow, green, blue, indigo and violet.

IMPASTO The thick application of paint or pastel to the picture surface in order to create texture.

LOCAL COLOR The actual color of the surface of an object without modification by light, shade or distance.

MANDIBLE Jawbone framing the structure of the mouth.

MASKING The principle of blocking out areas of a painting to retain the color of the support. This is usually done with tape or masking fluid, and leaves the artist free to paint over the masked areas. The masks are removed when the paint is dry to reveal the areas underneath.

MEDIUM In a general sense the medium is the type of material used, such as oil paint or charcoal. More specifically, a medium is a substance mixed with paint or pigment for a particular purpose or to obtain a certain effect.

MIXED MEDIA The technique of using two or more established media, such as ink and gouache, in the same picture.

MODEL STAND A raised platform used by portrait painters.

MONOCHROME A painting done in just one color, plus black and white.

NEGATIVE SPACE The space around the subject rather than the subject itself.

OPACITY The ability of a pigment to cover and obscure the surface or color to which it is applied.

ORBICULARIS OCULI Muscle that surrounds the cavity of each eye which allows the eyelids to close gently or tightly.

ORBICULARIS ORIS Muscle that surrounds the mouth.

PALETTE The term describes both the flat surface used by the artist to put out and mix colors and the color selection used by the artist.

PIGMENT The actual coloring substance in paints and other artists' materials.

PLANES The surface areas of the subject which can be seen in terms of light and shade.

PRIMARY COLORS In painting these are red, blue and yellow. They cannot be obtained from any other colors.

RENDER To draw or reproduce an image.

SECONDARY COLOR A color mixed from two primary colors. Orange, green and violet are the secondary colors.

SIZE A gelatinous solution such as rabbit skin glue which is used to prepare the surface of the canvas or board ready for priming or painting.

STERNOCLEIDOMASTOID Muscle which connects the mastoid areas behind the ear to the clavicle, thus providing an important link between the head and body.

SUPPORT A surface for painting or drawing on, usually canvas, board or paper.

TERTIARY COLOR A color obtained by mixing a primary and secondary color together.

TORCHON A rolled paper stump, or bought equivalent, used for blending charcoal and pastel.

UNDERPAINTING The preliminary blocking-in of the basic colors, the structure of the picture and its tonal values.

WASH An application of ink or watercolor, diluted to make the color spread transparently.

WATERCOLOR CONCENTRATE Very strong watercolor pigment which is diluted with water before use.

WET-OVER-DRY The application of watercolor on a completely dry surface causing the sharp overlapping shapes to create the impression of structured form.

WET-INTO-WET The application of watercolor on a surface which is still wet to create a subtle blending of color.

Index

Credits

Quarto would like to thank all those who have helped in the preparation of this book. We would like to thank all the artists, with special thanks to Daler-Rowney for their patience and generosity in donating materials and items of equipment.

Contributing artists
pp *26, 29, 36-37*, Gill Elsbury; pp *42 (bottom left), 46, 116, 112-125, 136-139, 150-155*, Sally Michel; pp *62-65, 82-87, 132-135, 156-159*, Ian Sidaway; pp *2-3, 10, 39, 49, 66-69, 96-99, 140-141*, Stan Smith; pp *42 (top right), 45, 106-111, 142, 160-163*, Richard Tratt; pp *18, 22-25, 28, 42 (bottom right), 47, 58-61, 92-95, 112-115*, Maurice Wilson; pp *35 (right), 168-171*, Jane Wisner; pp *6, 11, 31, 32, 35 (left), 40-41, 42 (top left), 44, 54-57, 76, 88-91, 102-105, 126-131, 164-167*, Ken Wood.

Other illustrations
p *8*, Snark; p *9 (top)* Ronald Sheridan Photo-Library, *(bottom)* Donald Jackson; p *20* Royal Borough of Kingston-upon-Thames Central Library, Museum and Art Gallery; p *21* Mary Evans Picture Library; pp *50-53, 78-81, 118-121, 144-149*, photography by David Burch.